PLANETOCEAN

'Individually we are a drop, together we are an ocean.'

RYUNOSUKE SATORO, JAPANESE POET

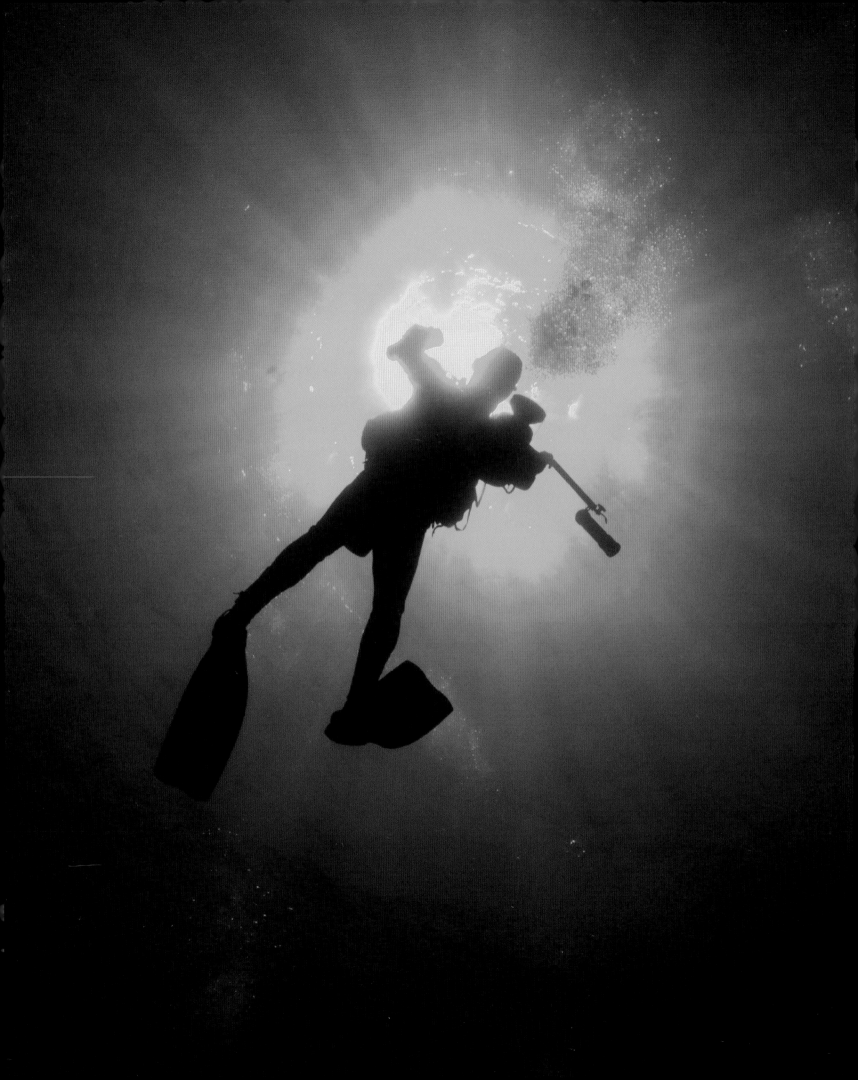

PLANETOCEAN

PHOTO STORIES FROM THE
'DEFENDING OUR OCEANS' VOYAGE

BY SARA HOLDEN

GREENPEACE New Internationalist

Planet Ocean: Photo Stories from the 'Defending Our Oceans' Campaign
First published in the UK in 2007 by
New Internationalist™ Publications Ltd
55 Rectory Road
Oxford OX4 1BW, UK.

www.newint.org

First published in the Netherlands in 2007 by
Greenpeace International
Ottho Heldringstraat 5
1066 AZ Amsterdam
The Netherlands
www.greenpeace.org

Design by Ian Nixon/New Internationalist, Toby Cotton/Greenpeace International

All dollar figures used throughout the book are US dollars.
All information in this book is correct to the best of our knowledge at the time of going to print.

This product is manufactured on paper certified in accordance with the guidelines of the Forest
Stewardship Council for responsible forestry managemant. SGS-COC-1425 (valid until 22 June 2008)

British Library Cataloguing-in-Publication Data.
A catalogue record for this book is available from the British Library.

Library of Congress Cataloguing-in-Publication Data.
A catalogue record for this book is available from the Library of Congress.

ISBN-13: 978-1-904456-79-7

ACKNOWLEDGMENTS

With thanks to my friends and colleagues at Greenpeace during the writing of this book, for their criticism when warranted and support when needed: Mike Townsley, Karen Sack, Kate Morton, Richard Page, Paul Johnston, David Santillo, Toby Cotton, John Novis, Steve Erwood, Franca Michienzi.

For the guiding hand and tolerating my lack of deadline discipline, I thank Troth Wells, David Ransom, Daniel Raymond-Barker and Ian Nixon at New Internationalist Publications.

Particular thanks go to all the photographers, cameramen, campaigners, webbies, and captains and crews of the Esperanza, Arctic Sunrise and Rainbow Warrior; Adele Major, Stan Vincent, Shane Rattenbury, Cristina San Vicente, all land teams across the Greenpeace world, and for all the Ocean Defenders, for making the journey and this book possible.

Finally, a very special thank you to Rose Young, a life force like no other, who steered this expedition from beginning to end and kept all of us afloat.

'How inappropriate to call this planet Earth, when clearly it is Ocean.'

ARTHUR C CLARKE, AUTHOR AND INVENTOR

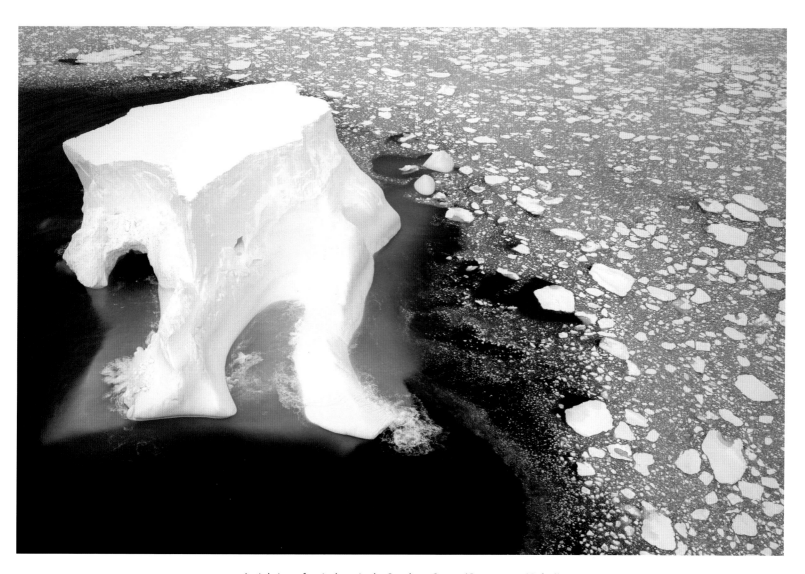

Aerial view of an iceberg in the Southern Ocean (Greenpeace / Beltrá)

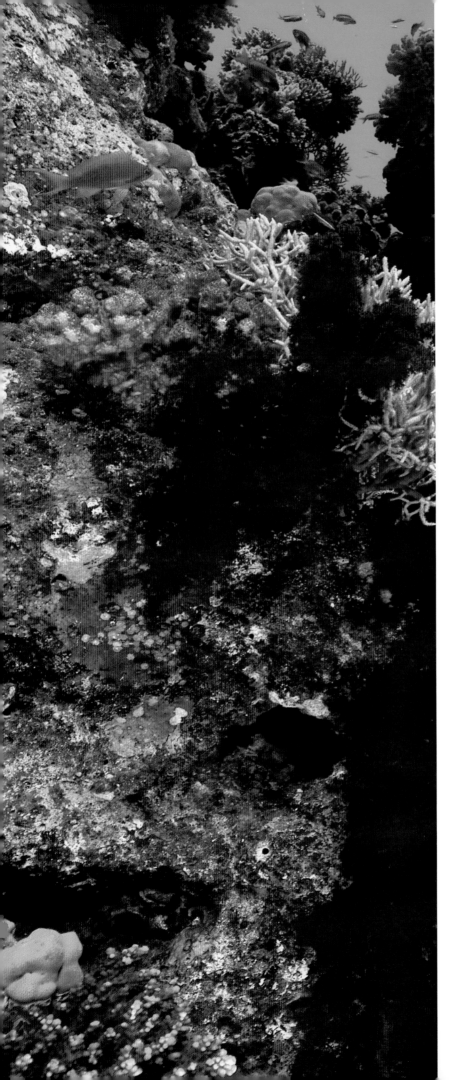

CONTENTS

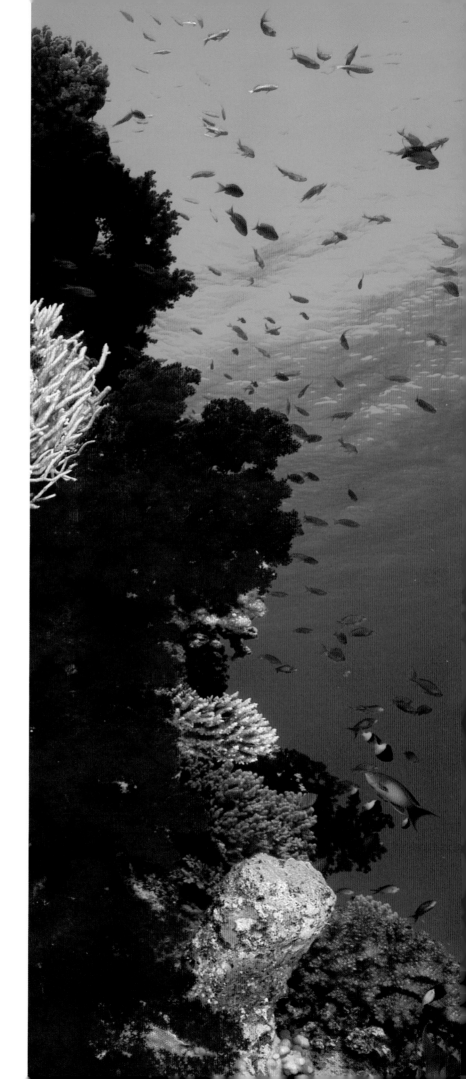

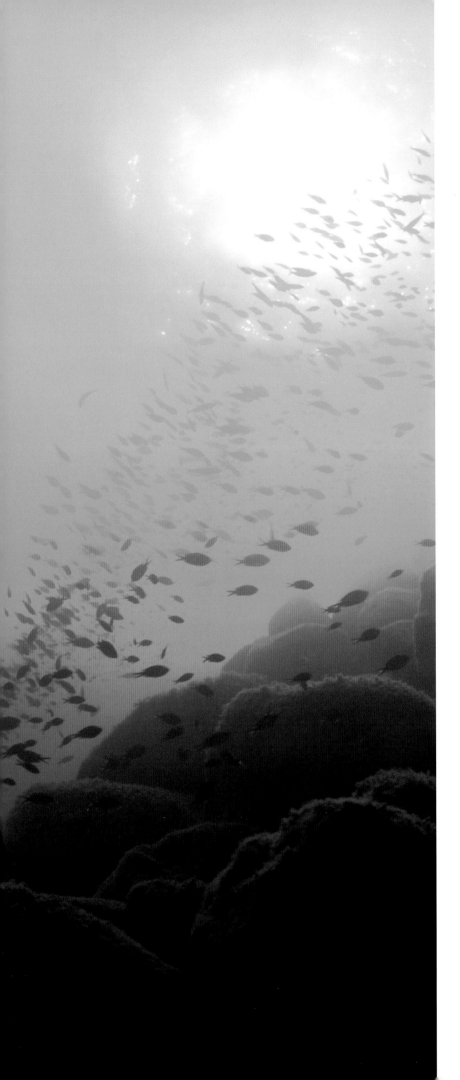

PREFACE

While many of us love the ocean, it's hard to imagine what is happening just beyond our beaches, and hard to picture the scale of destruction and the impact that it's having. Our challenge at Greenpeace was to make what lay beyond the horizon a reality on shore – to make the invisible, visible and at the same time show how a global network of marine reserves covering 40 per cent of the world's oceans could be key to protecting them for future generations.

The answer was both simple and incredibly daunting. We wouldn't bring the oceans back to land; we would take the people to the oceans. Equipping our ship, *Esperanza*, with the latest communications technology Greenpeace embarked upon its most ambitious ship expedition the organization has ever undertaken, vowing to tell a different story every day through a dedicated website, not just about the crisis in our oceans, but also the wonder and beauty of them.

In this way, the Defending Our Oceans campaign was born.

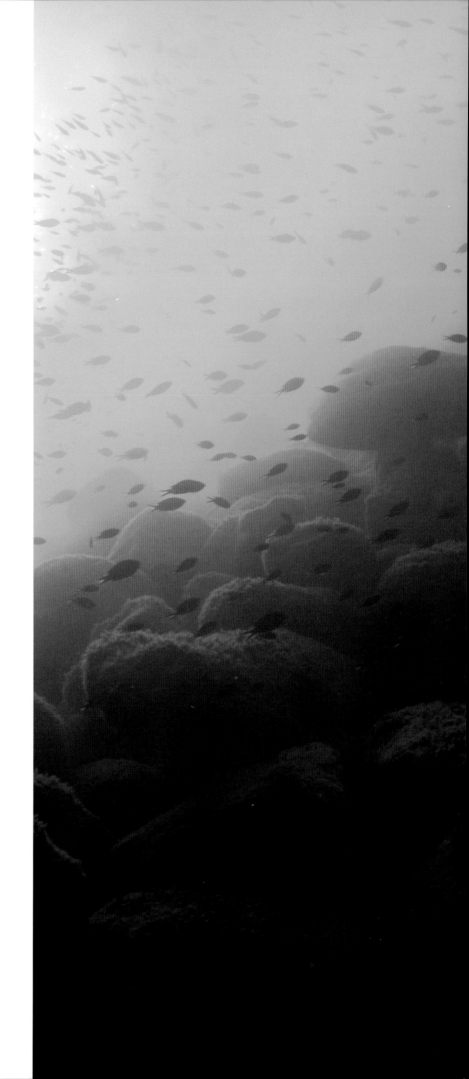

Since that day the Greenpeace ship *Esperanza* has sailed
four of the five oceans, for 16 grueling months, witnessing scenes
that few have seen and some that many would like to cover up.
Through our webcam, website and with the power of the images
and storytelling we opened a new window onto the sometimes
secret world of ocean life. From around the globe people have
joined with Greenpeace to take action against ocean destruction
and in support of the global network of marine reserves. More
than a million people have read the stories from the expedition.
World-class photographers documented every mile sailed.

Planet Ocean tells the story of our oceans and is a snap-shot
of an amazing journey.

Sara Holden
Communications Coordinator
Greenpeace International
Amsterdam

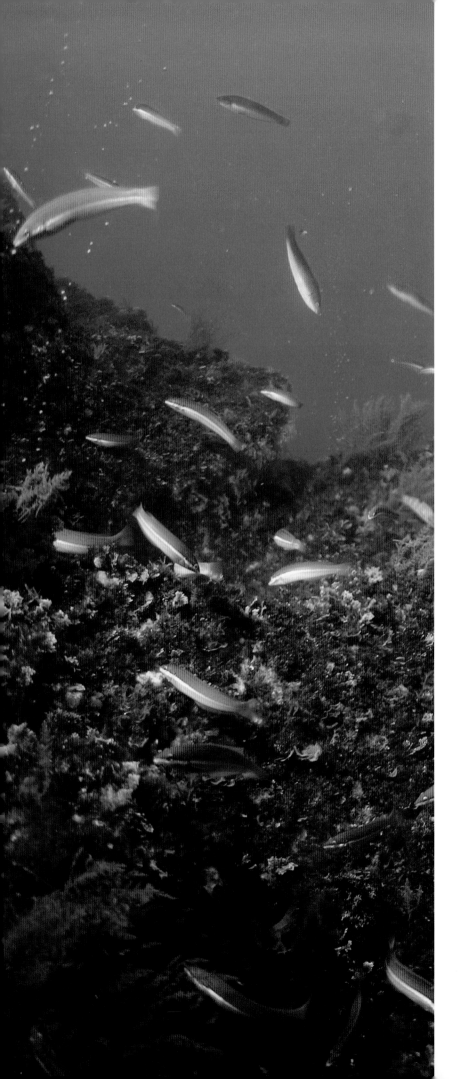

FOREWORD

I write this from my village home on the West Coast of India – where the waters of the Arabian Sea lap the shores of peninsular India. My life has been lived close to the seas. I have watched with dismay the relentless assault on our oceans and our marine resources. I can no longer point out the dolphins in our bay to my grandchildren. It was with deep sadness that many of us bore witness to the mass graves of Olive Ridley Turtles along our eastern seaboard last year; victims of trawler fishing and of off-shore drilling for oil and gas.

For over three decades Greenpeace ships have sailed the oceans to bear witness to the increasingly predatory actions of humankind. 'Defending our Oceans' has been an inspiring experience. Not only did the expedition highlight the wide range of practices that threaten our marine environment. More importantly, it looked for solutions, and sought ways to involve the public in new and exciting ways of effecting change; to engage those people who draw their sustenance from the seas, while calling for action from politicians and decision-makers. Greenpeace can act as a watchdog – alert the world and awaken its sleeping consciousness to the dreadful degradation of our oceans, but in the long run it will take a combined effort to implement real solutions.

At the heart of the Defending our Oceans is the call for 40 per cent of our oceans to be set aside as marine reserves, areas free from industrial exploitation, extraction and activity. Areas in which the oceans can recover and be replenished.

What better way of capturing the inspiring experiences and the images from the 16-month-long journey through four of the world's five oceans, than this collection of stunning images in *Planet Ocean*: a collection which provides a colorful and sometimes poignant insight into some of the threats facing our oceans globally.

Enjoy the colors and the incredible sights from the Defending our Oceans expedition – let them inspire you to become a Defender of your Oceans, wherever you might be. We have just one Mother Earth; let us remember that 70 per cent of its surface is covered by water. Our ancient civilizations and sacred texts composed hymns of praise and thanks to the Gods and Goddesses of the Oceans. It is this wisdom that we need to retrieve and pass on to future generations.

Lalita Ramdas
Board Chair of Greenpeace International

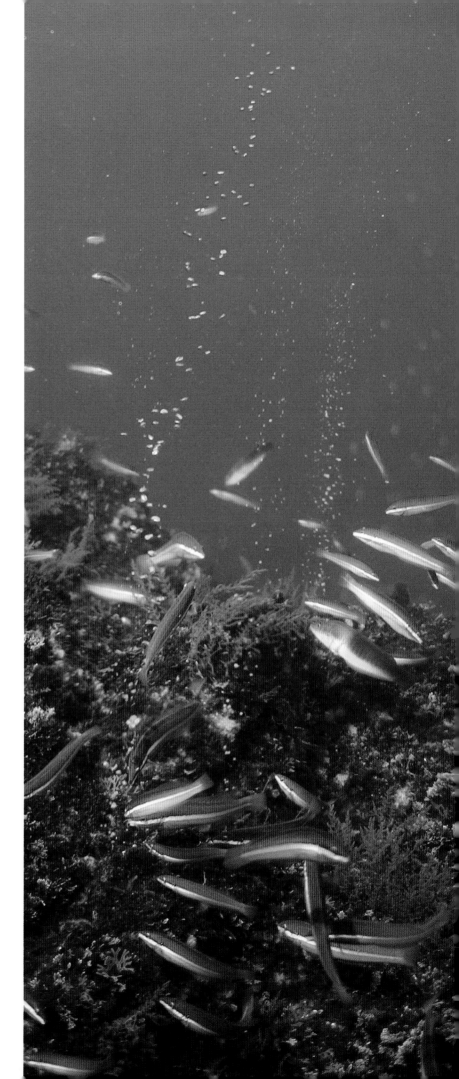

INTRODUCTION

We are born of the oceans; it is where it all began. When the first slimy life forms slithered out of the seas and began the process of evolution on land 400 million years ago, life below the waves was already well established, stretching back around three billion years.

While we may have progressed from the primeval soup, life on Earth still comes from the oceans. They cover three quarters of our planet, are the engines driving our weather systems, a ready-made food store for billions on land and at sea and give sanctuary to a staggering 80 per cent of the life on planet Earth. Lying beneath the waves is the highest of the world's mountains and the tallest waterfall. From the greatest of creatures – majestic blue whales, to the largest living thing on Earth – the Great Barrier Reef, and the smallest of cells – billions of bacteria, our oceans are teeming with life.

With such an intimate connection, it is little wonder then that a stroll by the ocean awakens every sense. Watch and listen to the rhythm of the waves, taste the salty spray on your lips, and feel the cooling breeze on your skin. Standing by the shore, take a couple of deep breaths. Every second breath you take comes from the oceans. They give us half the oxygen we need to survive. Imagine that. Hold your breath, just for a moment. Imagine the oceans. Without them Earth would be just another lifeless orb revolving in the universe.

It is strange to think that something that is the fount of our very beginnings and remains the life force of our planet is still such a mysterious world, almost completely unknown to humans.

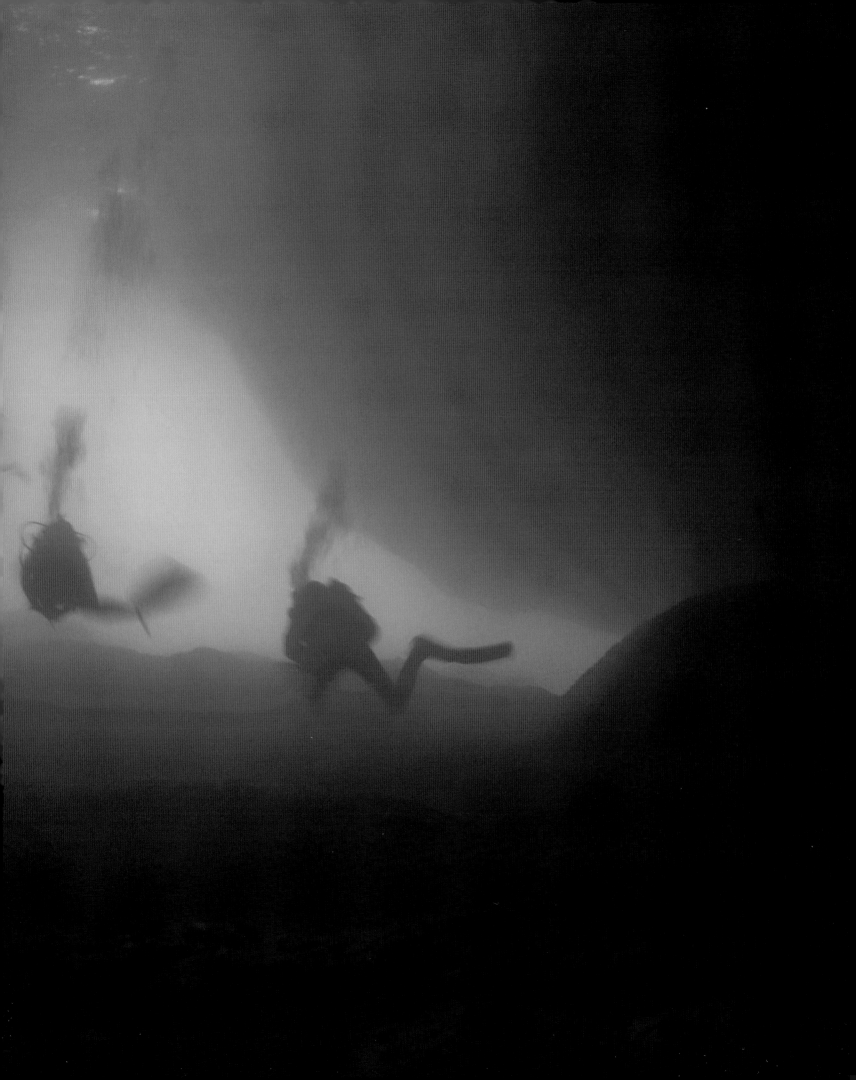

Ninety per cent remains unexplored and there are more maps of the moon than there are of the oceans. And while with a powerful telescope we can see the cratered, mountainous surface of the moon, even with the most powerful machinery it is still a rarity to glimpse the surface of the Earth – the ocean floor.

There are fish that thrive in the dark waters near the bottom that have lived more years than we have spent understanding their habitat. A 150-year-old orange roughy fish alive today has survived 30 US Presidents, 39 British Prime Ministers and 11 Popes. In that span we have gone from horse and cart to walking on the moon, but it is only in the last 70 years that we have had

Every color of the rainbow shimmers in the dappled sunlight of the shallow waters. From the fresh green Sarpa salapa *(right) to the yellow, blue and orange* Thalassoma pavo *(above) and the blue, pink and yellow* Serranus scriba *(left).*

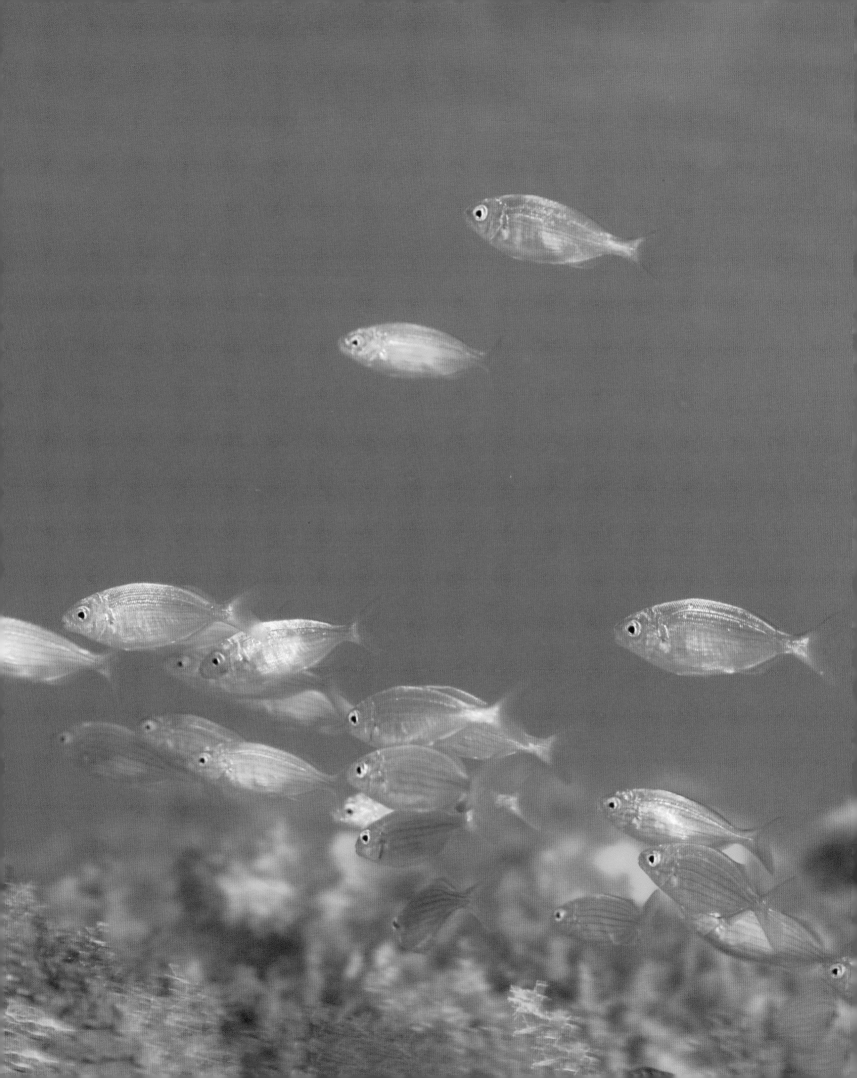

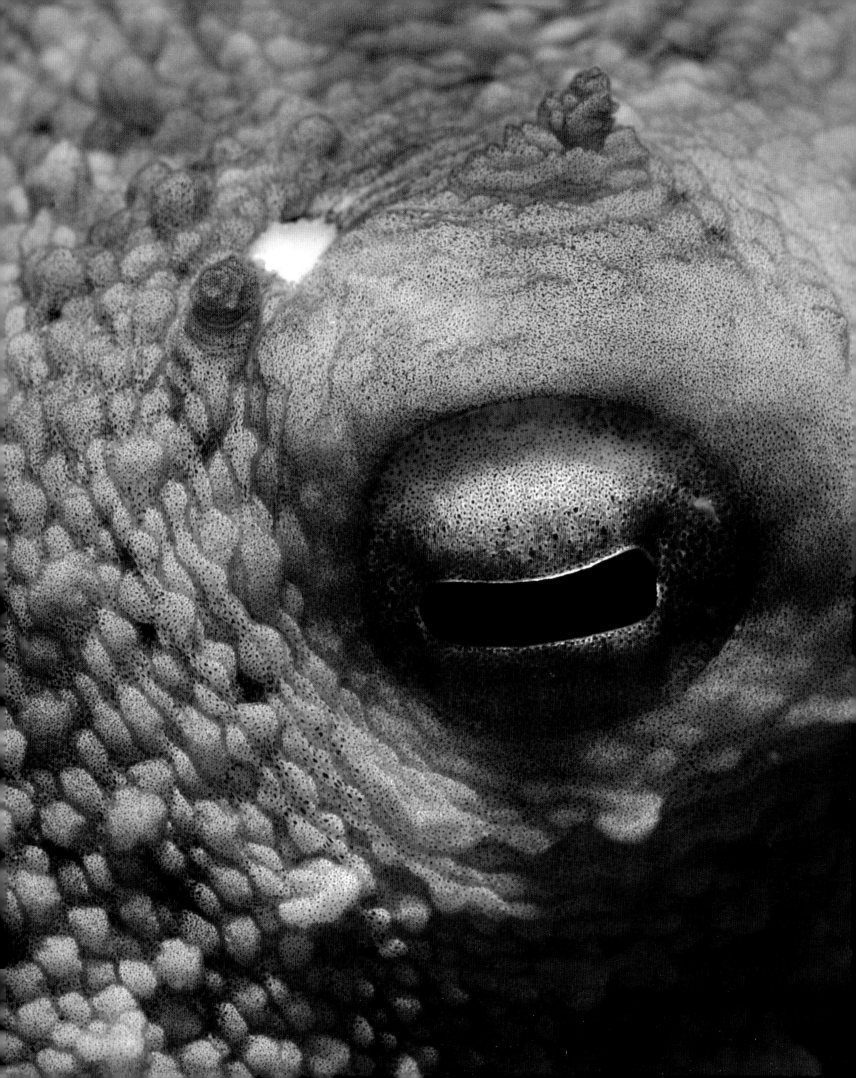

A close up of an octopus eye (left). Octopus have great eyesight, but are also deaf. They activate special colored skin cells to change color when they need to camouflage themselves (above) or impress a possible mate.

For others hiding also comes naturally. Spot the sand goby in the midst of the pebbles (right).

the technology to truly understand the sheer scale of the grand canyons, vast mountain chains, waterfalls, volcanoes, forests of coral higher than ten storey buildings and underwater caves deep below us.

On the bottom

The ocean floor is certainly not a sandy featureless desert, nor is it devoid of life as was once assumed. Far from being the dark frozen emptiness, the deep ocean is full of extreme life forms and activity. Fascinating fish that never see light and rarely eat, live alongside the hideously named snot eels or hagfish, which feed on the sinking remains of other sea creatures. Bacteria bloom in their billions and the base of the whole food chain is anchored here.

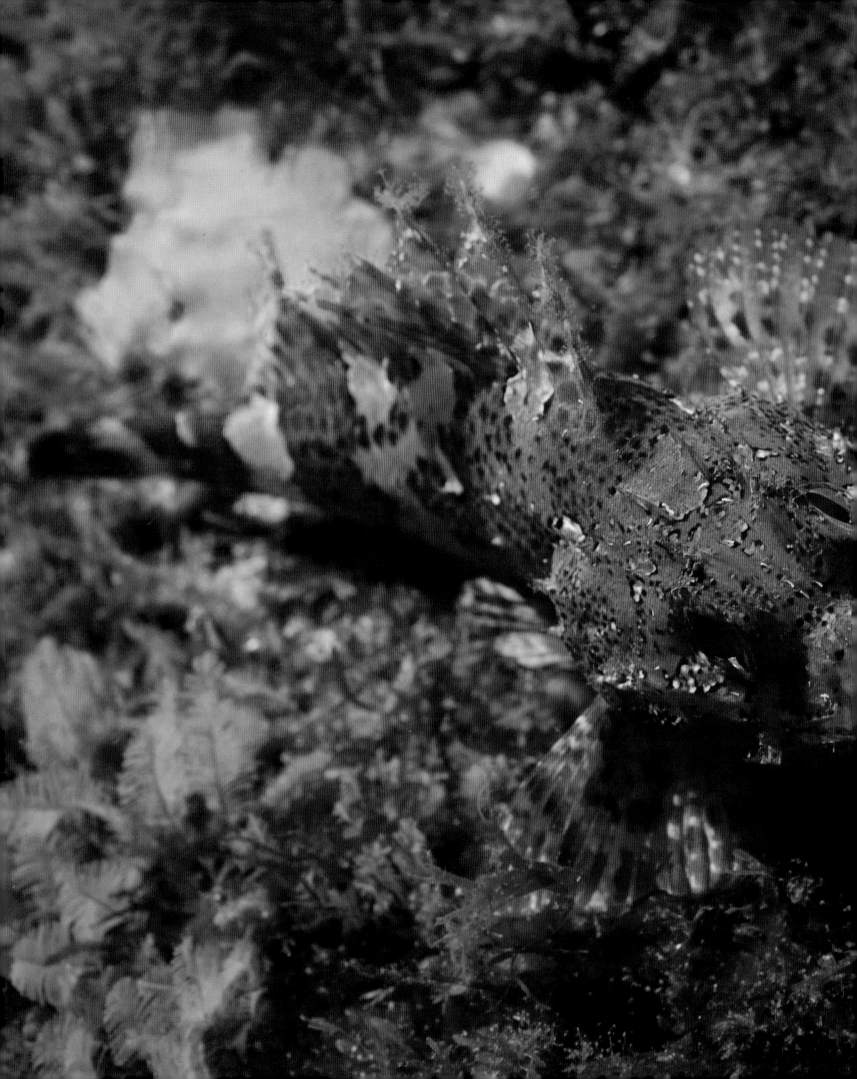

Looking like mini-volcanoes, hydrothermal vents spew water at temperatures up to 400°C/750°F, the temperature of molten lead. It is only the extreme pressure of the deep water that stops the outflows from boiling. Far from killing living creatures with their extreme heat, the vents actually are home to many varied life-forms. Mineral deposits build up around them, turning them into vast columns, on which a huge range of creatures depend and flourish. The fastest growing animals in the sea – tube worms – firmly plant themselves next door, their delicate, flower-like tentacles swaying in the currents.

Half of the animals that scientists have collected from waters deeper than 3,000 meters – about two miles – are new species, and many remain to be identified and observed in their natural state. Both giant and colossal squid, food and foe for the great-toothed whales, survive in the deepest ocean and yet have never been seen alive. They are but one of the many mysteries of the deep.

Mountain ranges

Rising from the frigid depths and weaving its way across all the major oceans is the Mid Ocean Ridge. At 65,000 kilometers/40,000 miles long, stretched tight it could girdle the

The Maderia rock fish can mimic virtually any color in order to blend in (left), while the scorpion fish peeking out of a coral hole (above) hardly stands out at all in this riot of color.

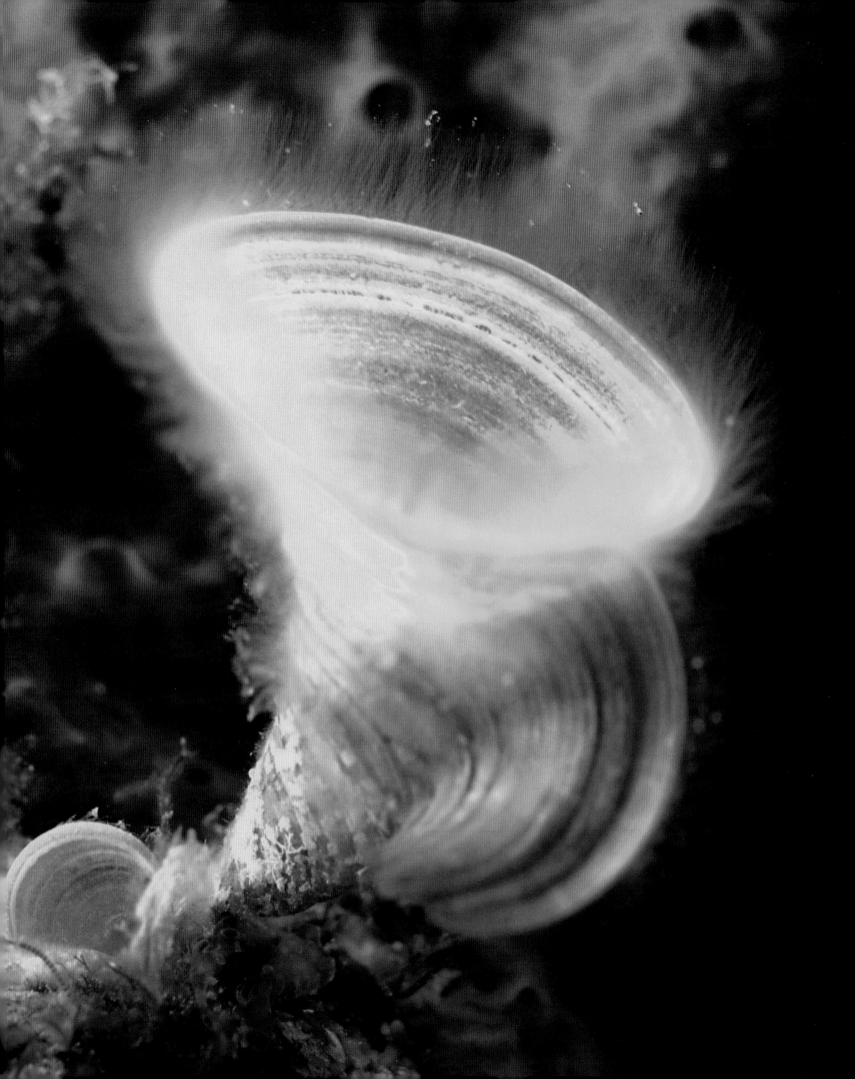

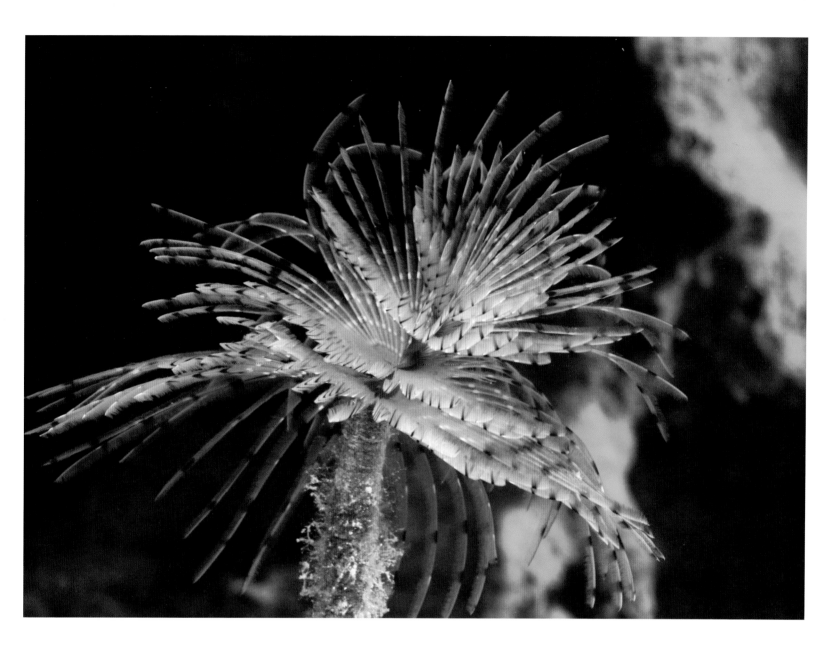

Earth one and a half times. It is the world's longest mountain chain. The currents that flow around all ocean mountains create nutrient rich mixed water, which in turn supports many small plants and animals. The formations make a stable base on which other animals can anchor and feed off these tiny creatures. These ocean mountains are a magnet during the breeding season and shelter for the offspring produced. They are, in short, supermarket, dating agency, nursery, base camp and restaurant to an unimaginable number of creatures.

Away from the shelter of the mountains in the wide ocean are superhighways for migrating species. Fish, mammals and birds criss-cross the water, showing incredible speed and endurance. The gray whale migrates more than 16,000 kilometers/10,000 miles each year, the longest known migration of any mammal. Feeding and breeding

It is not only reptiles that gain grace and elegance under the water. Only in the ocean could worms, slugs and algae be this beautiful. Seen here, a delicate tube worm almost half a meter tall (above) and beautiful algae against an orange sponge (left).

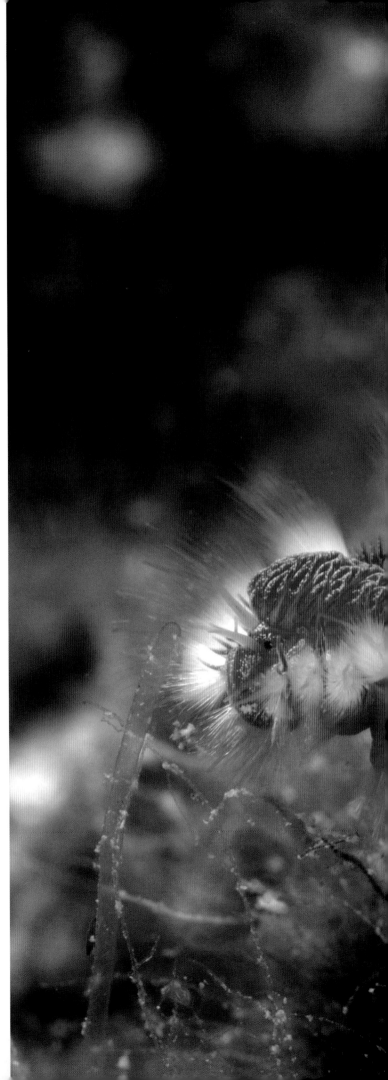

as they go, all the different species are interconnected, creating an intricate web of life.

Hidden world

The sheer scale of the oceans used to give them natural protection from exploitation, as much of it was out of reach to humans and their machines. But this is no longer the case. Industrial vessels, bristling with technology – sometimes even with air support to radio back the positions of schools of fish – can track and take vast quantities of ocean life in a single haul. Habitats are swept away by giant nets large enough to fit jumbo jets across their leading edge, long lines with thousands of baited hooks stretch for 100 kilometers/60 miles or more behind boats, snaring birds, sharks and turtles. Many types of fishing gear take and kill all manner of sealife besides those they are targeting for commercial gain. Coastal communities are losing out to industrial fleets and our oceans have become an unseen battleground beyond the horizon. Planet Ocean brings the drama of the deep back to shore, through the lenses of photographers working with Greenpeace on a unique 16-month expedition to explore the beauty and also the threats to this vital habitat that will ultimately impact upon us all.

This is the story of Planet Ocean.

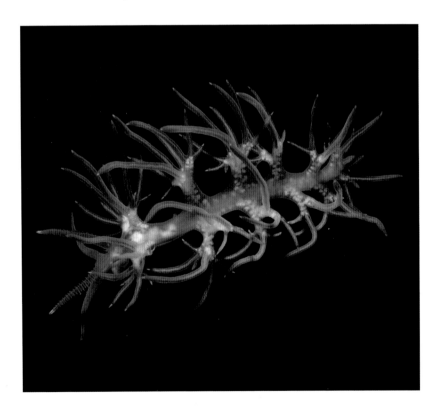

The sea slug or 'nudibranch' free floating in the ocean (above), and a hemodice *fireworm (right) – which may look cute and furry, but its bristles can be highly toxic.*

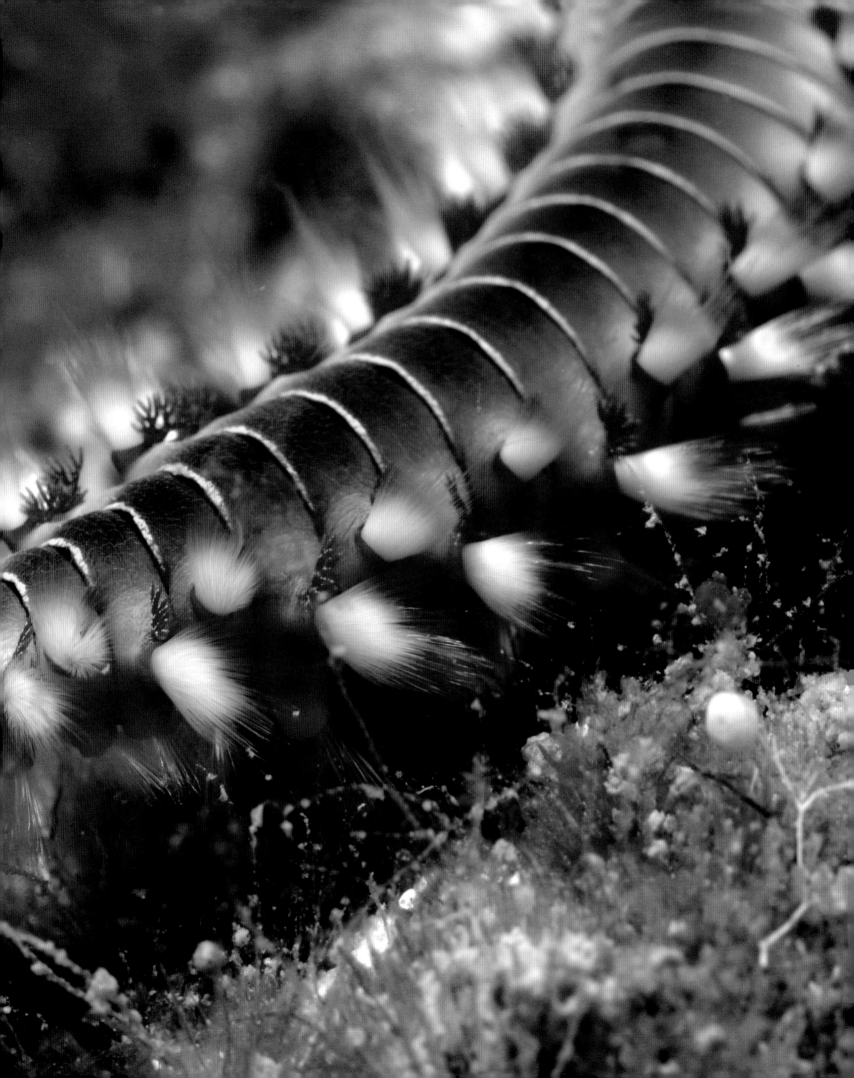

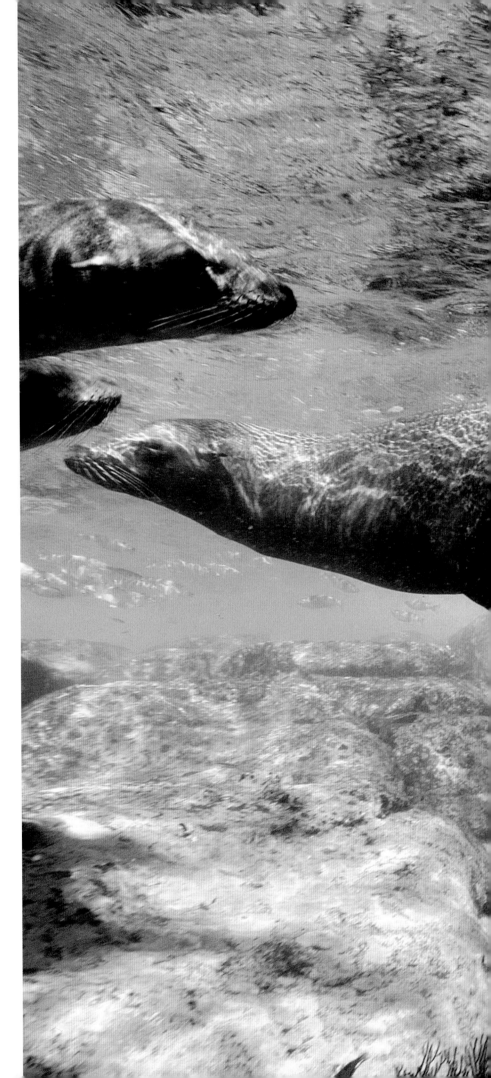

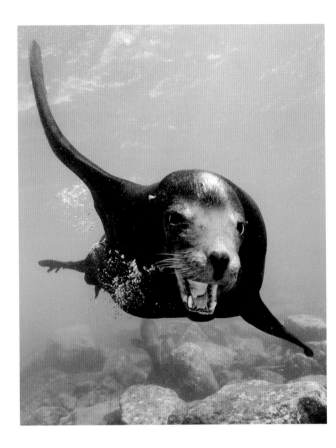

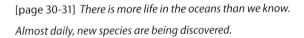

One of the more social marine mammals, sea lions gather in large groups and are known for their curiosity and playful behavior. This can also work against them though, making them favorites for aquariums and even for use with the military.

[page 30-31] There is more life in the oceans than we know. Almost daily, new species are being discovered.

[page 32-33] Turtles evolved at the time of the dinosaurs. Color blindness limits their vision during the day as they 'fly' through the water, but they come into their own in the dark, with acute night vision. Sea turtles 'cry' salt tears to rid their bodies of excess salt.

[page 34-35] Fish swimming freely in a marine reserve. The longer the fish are left to mature, the more offspring they are likely to produce each year.

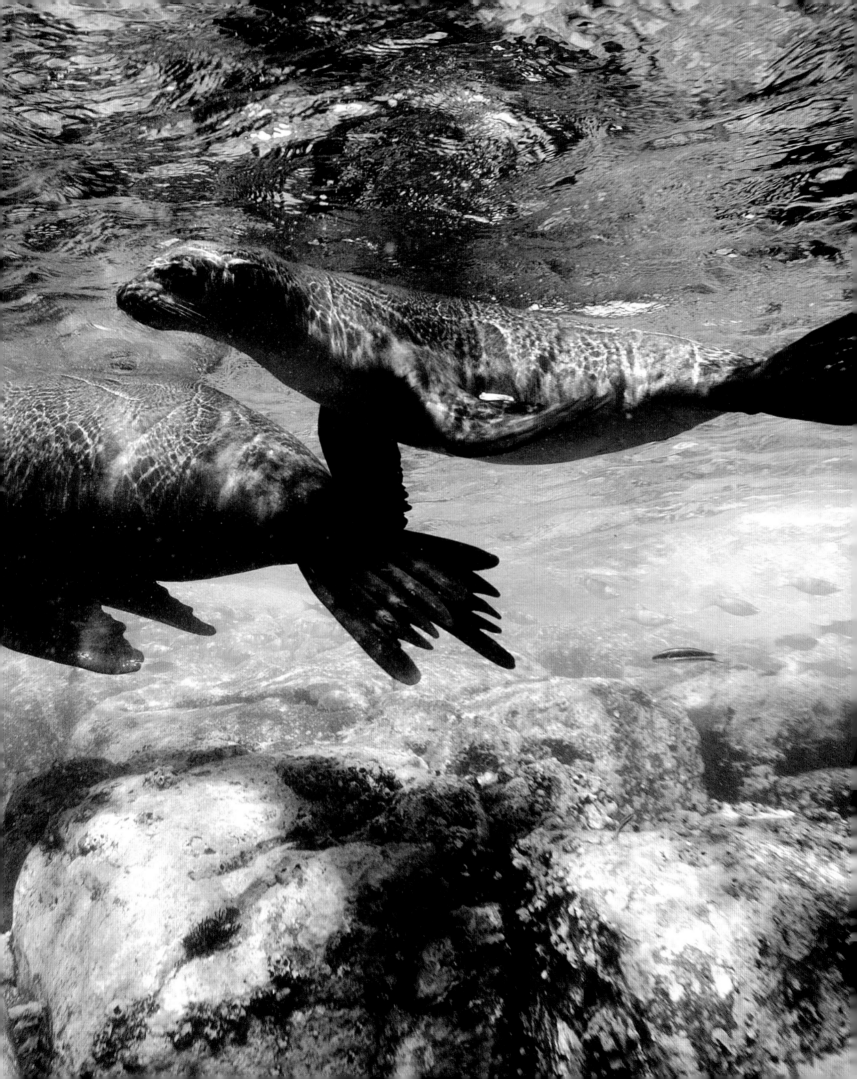

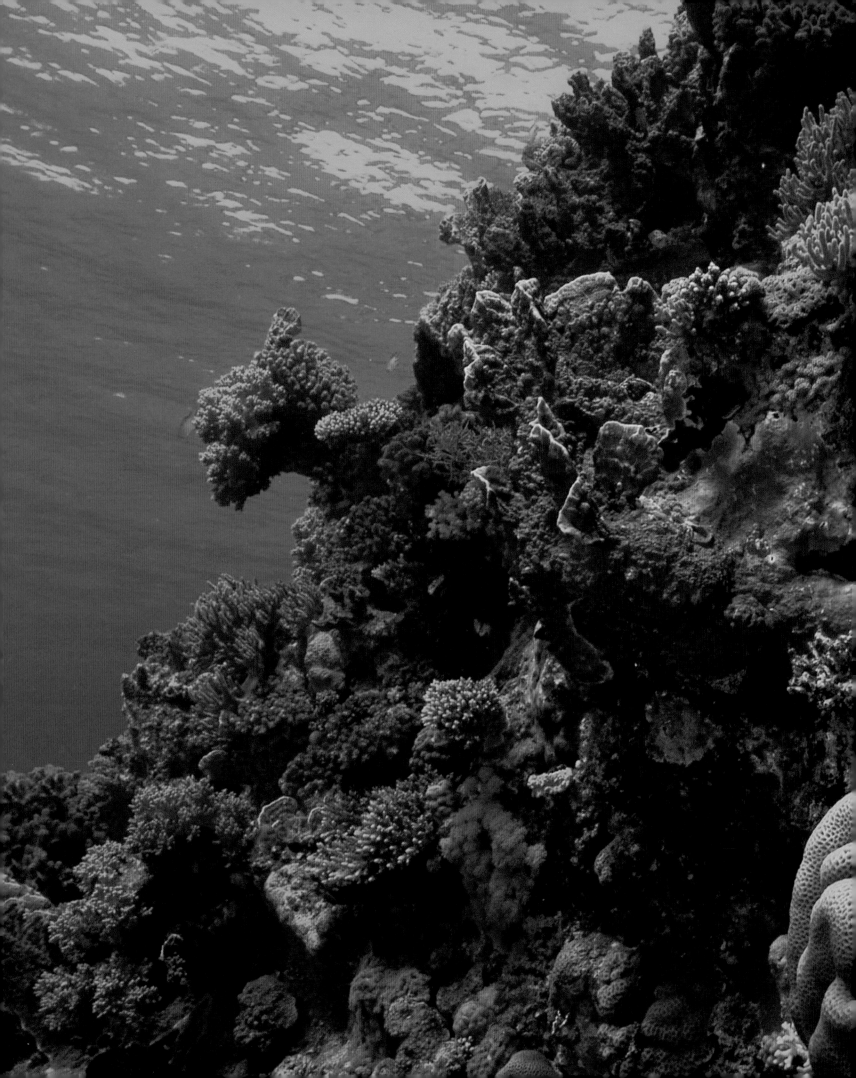

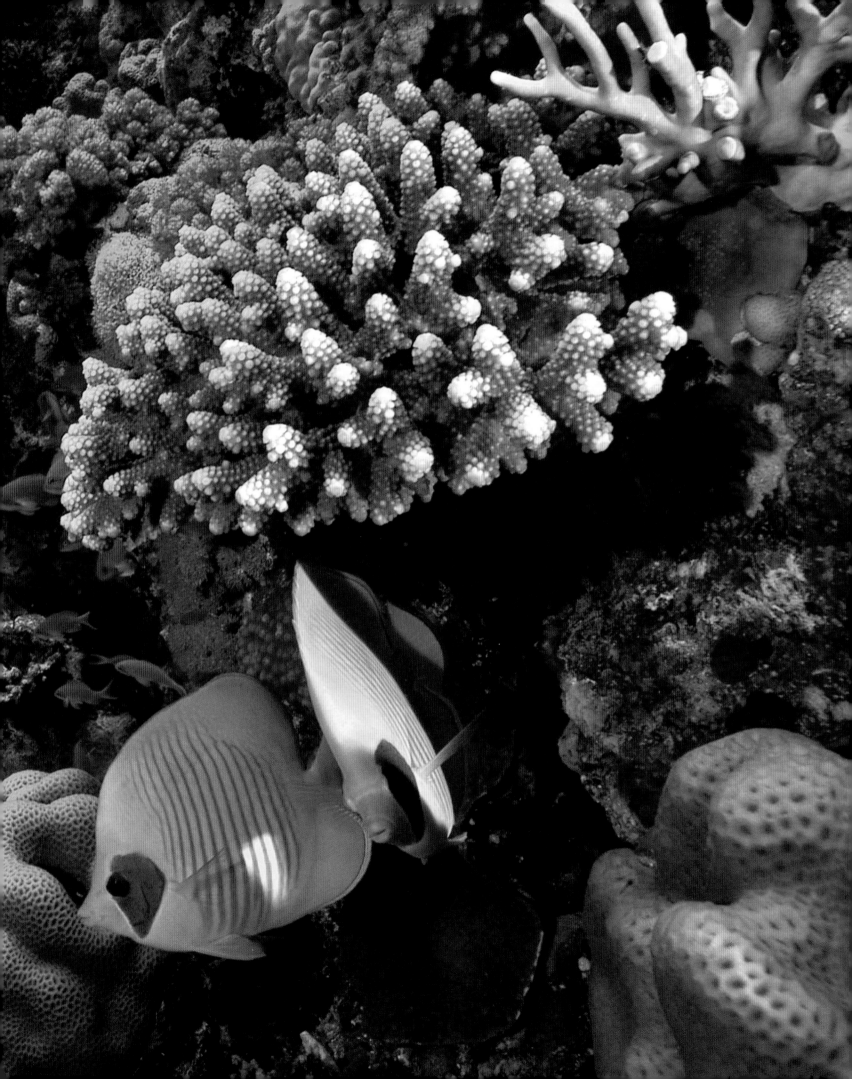

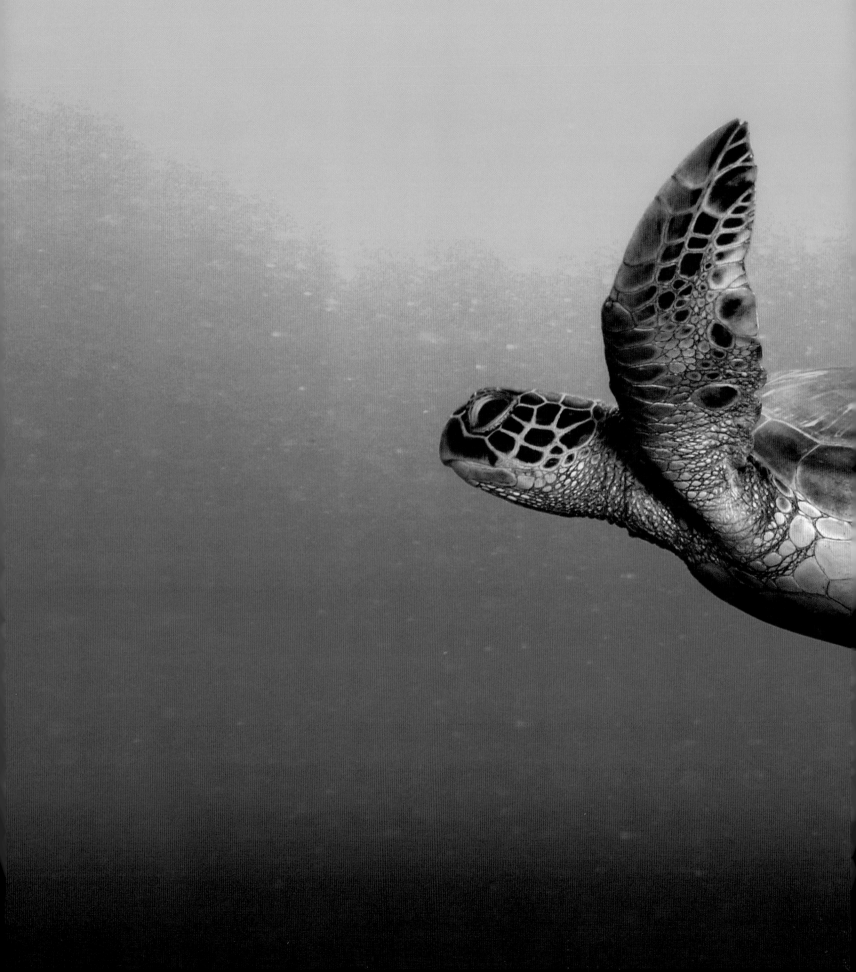

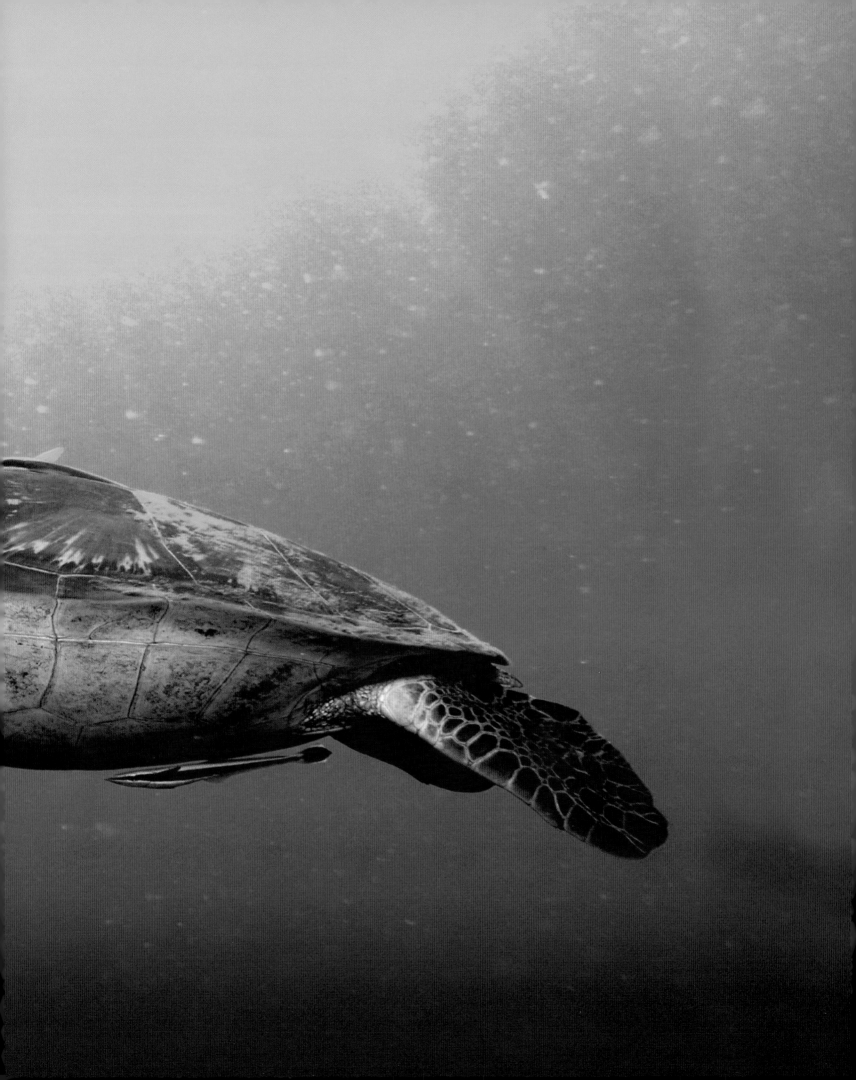

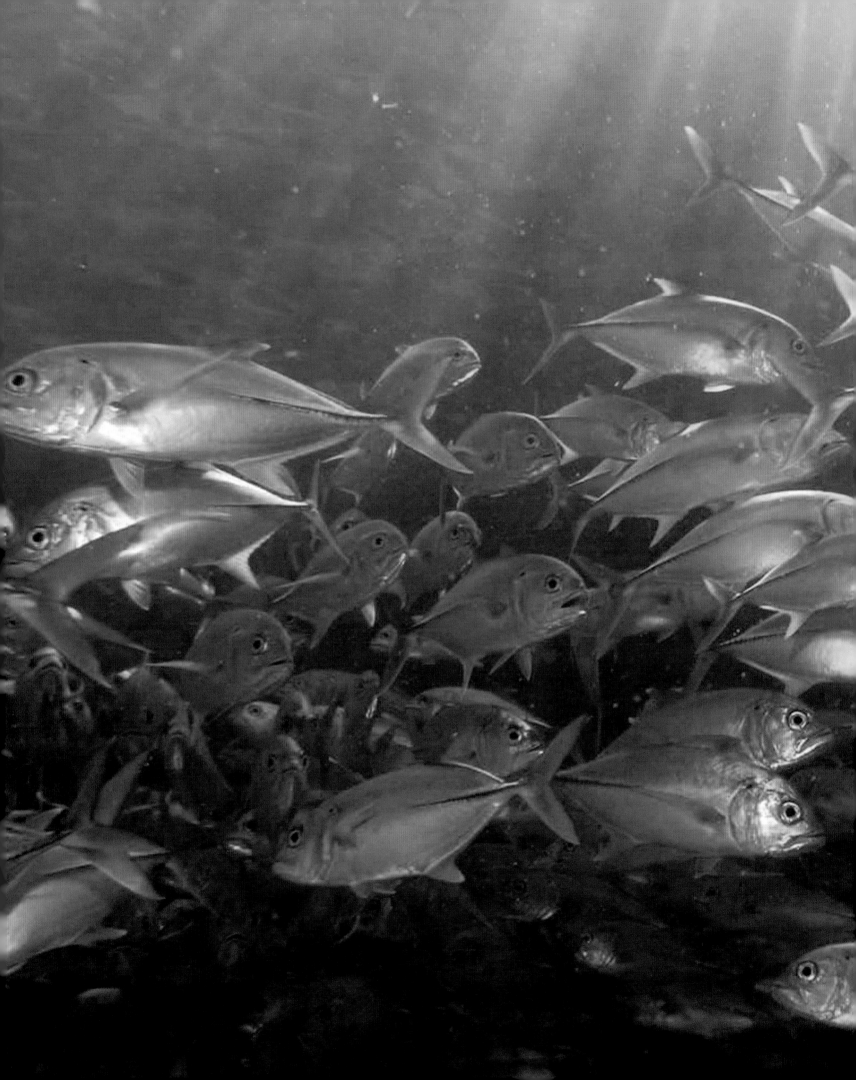

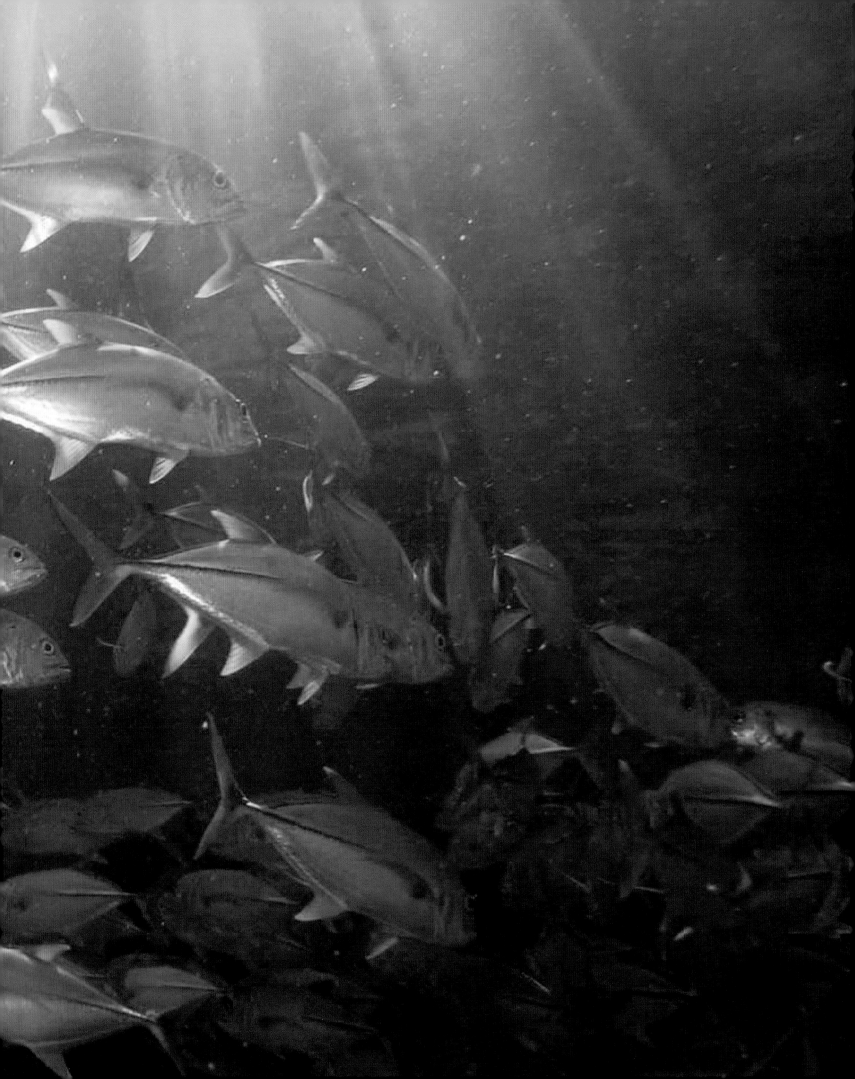

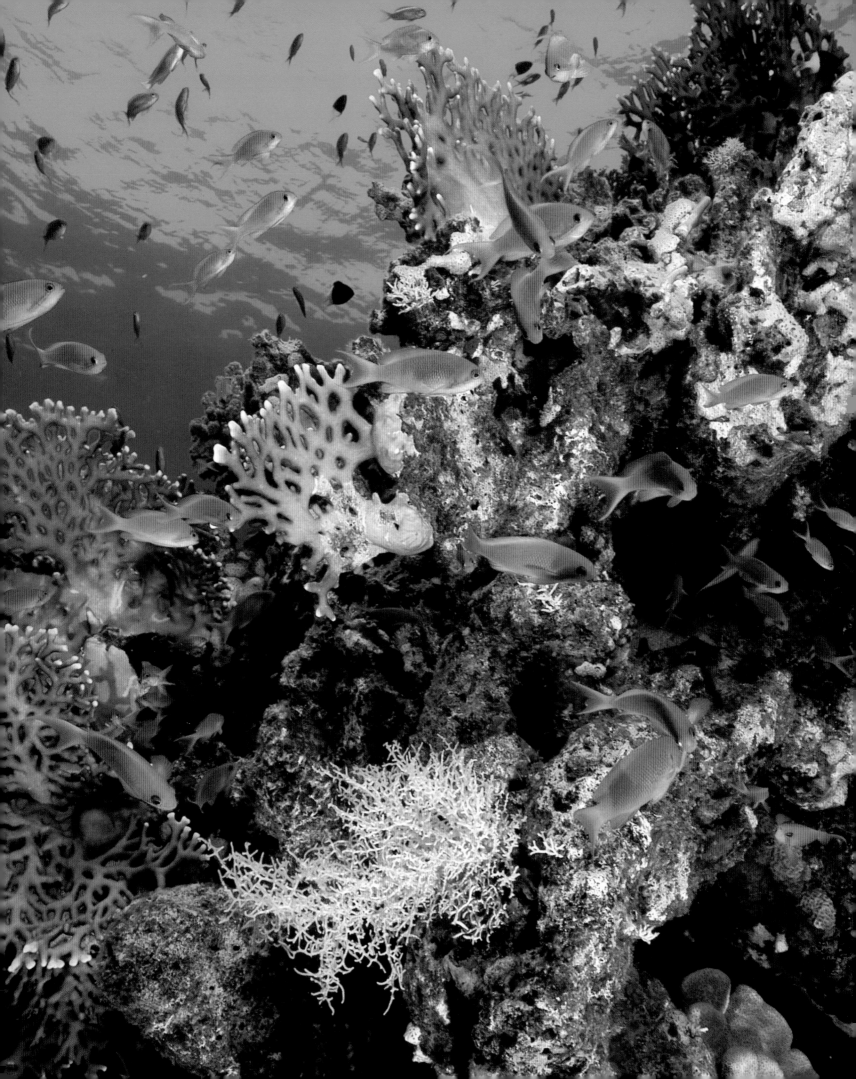

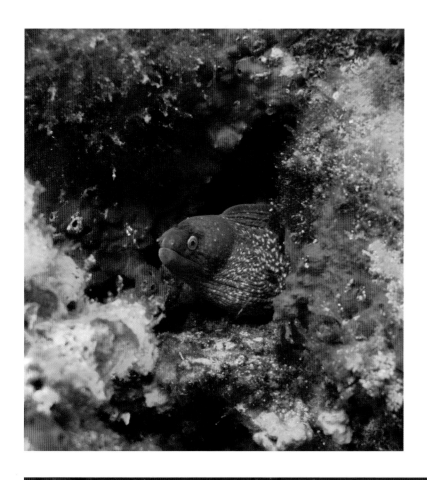

Corals, seen here in the Red Sea, perform a range of vital functions. As they grow over hundreds of years into spectacular formations, they provide shelter, feeding and breeding grounds and act as a natural coastal protection.

The shelter corals offer also makes them a perfect hiding hole for moray eels among others (near left), but also a magnet for predators like lion fish hunting for smaller prey amongst the formations (below).

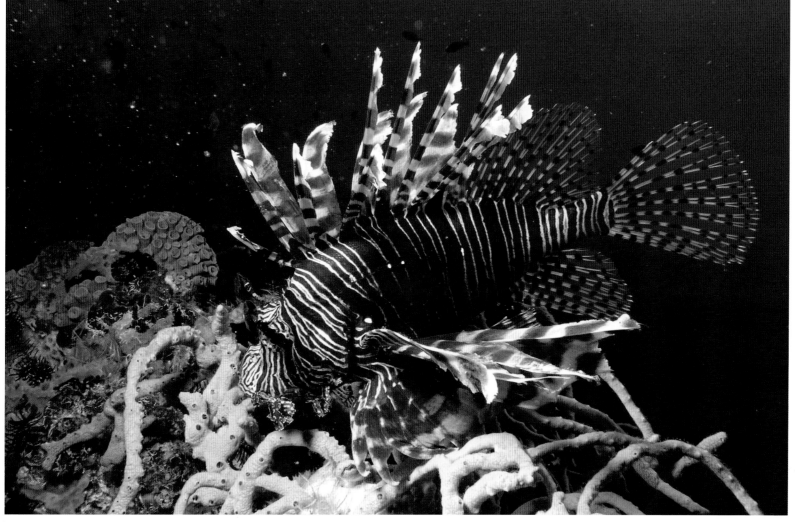

Coral and rocks on the seabed can provide good cover for marine life. Here a Macropipus swimming crab hides amongst the dead Posidonia debris on the seabed.

[page 40-41] All shapes and sizes can be found below the waves. The tropical flutemouth fish spears its way through open water.

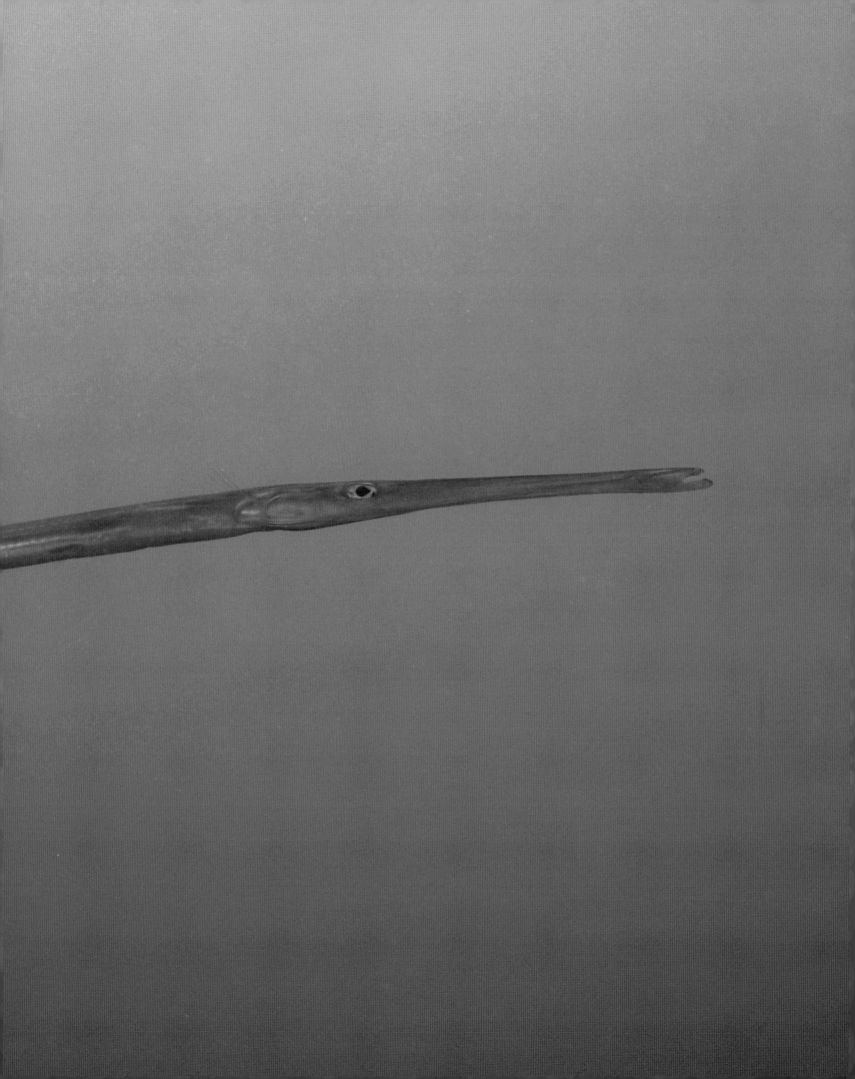

CHAPTER 1

BREATHING OCEANS

The oceans are a powerful force that supports life on Earth. Half the oxygen we need to survive comes from the oceans. Without oceans the land would be barren. They power the winds, feed the clouds with moisture and nourish the land; water drawn up into the atmosphere, that falls again as rain is key to keeping our planet alive. They help regulate the temperatures through the powerful currents that move warm and cold waters north and south.

The top three meters (10 feet) of the seas hold as much heat as our entire atmosphere. The vast open watery space between the landmasses, home to so many living creatures, is also what warms us, cools us, feeds us and keep us breathing on the land.

Not only do the oceans give us the air we breathe, they also act as a giant sponge soaking up pollution. Air pollution – from industry and transport for example – is thought to be responsible for over one third of the toxic contaminants that end up in oceans and coastal waters.

Our oceans also soak up much of the carbon dioxide (CO_2) released through the burning of fossil fuels. They act as a huge reservoir for dissolved CO_2, containing 50 times more than the atmosphere itself. But even the largest, most absorbent of sponges becomes saturated eventually. The impacts of climate change from ever-growing greenhouse gas emissions to the atmosphere, combined with the increasing acidity of the sea as the excess CO_2 dissolves in surface waters, mean that fossil fuel emissions are changing the very nature of the oceans and the life below the waves.

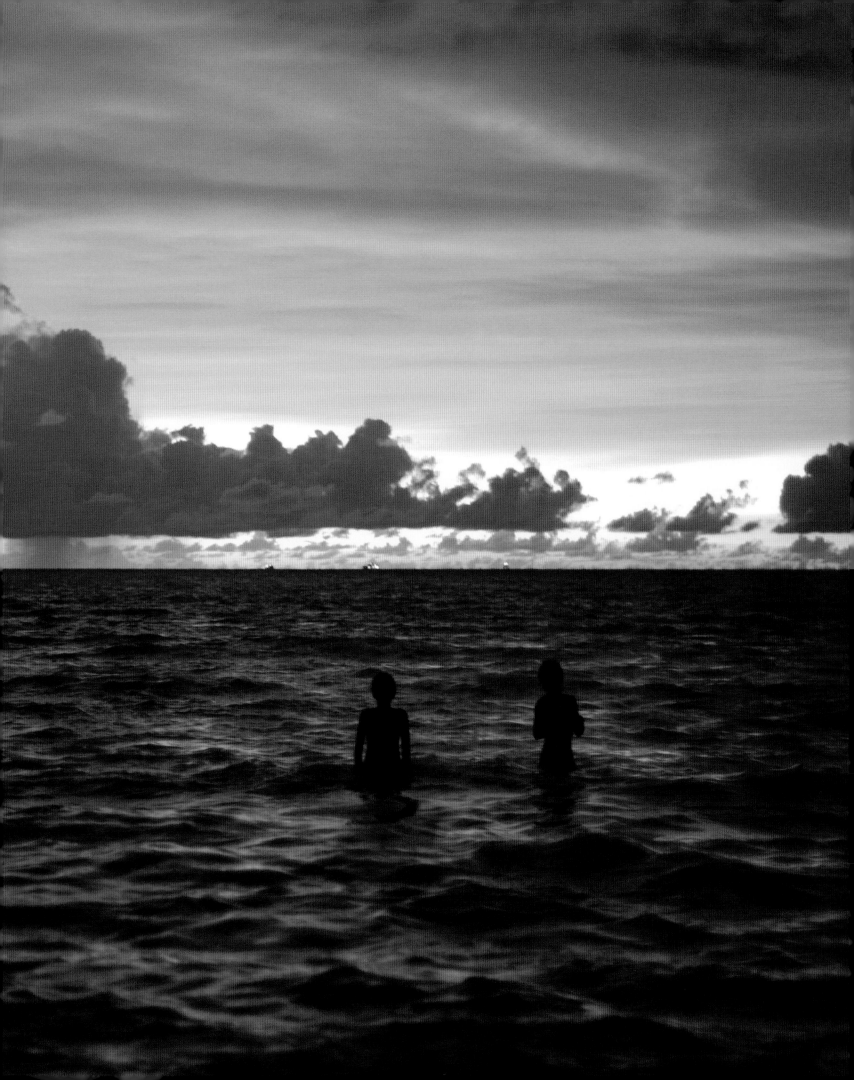

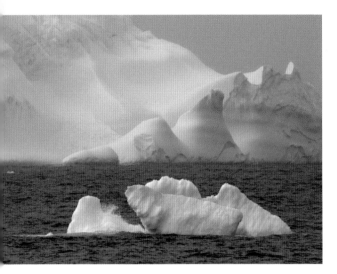

The Polar seas are key to the health of our oceans. Where the cold waters mix with warmer seas, rich upwellings of nutrients generate vital food resources.

The Southern Ocean surrounding Antarctica covers 8 million square miles/20 million square kikometers – nearly twice the size of the United States. Antarctica has as much ice as the Atlantic Ocean has water, and contains 90 per cent of all of the ice on our planet, but major melting of ice sheets and collapses of ice shelves – such as the Larsen B – have been documented in recent years.

[Page 46-47] While the oceans give the planet half the oxygen it needs, seagrass beds, like these surrounding the Capraia Island in the Mediterranean, help oxygenate the oceans and atmosphere as well as providing food and shelter for numerous species ranging from algae to fish to dugongs and manatees.

[Page 48-49] The vast expanse of coral might look spectacular, but the lack of color is a sign that it is dead or dying. Coral bleaching can be a natural occurrence but seems to be happening more frequently, possibly as a result of climate change. The algae that live in the coral and give them their color cannot tolerate warmer temperatures and are forced out of the polyps, leaving them bleached. If the seas do not cool sufficiently for them to return, the coral dies and collapses.

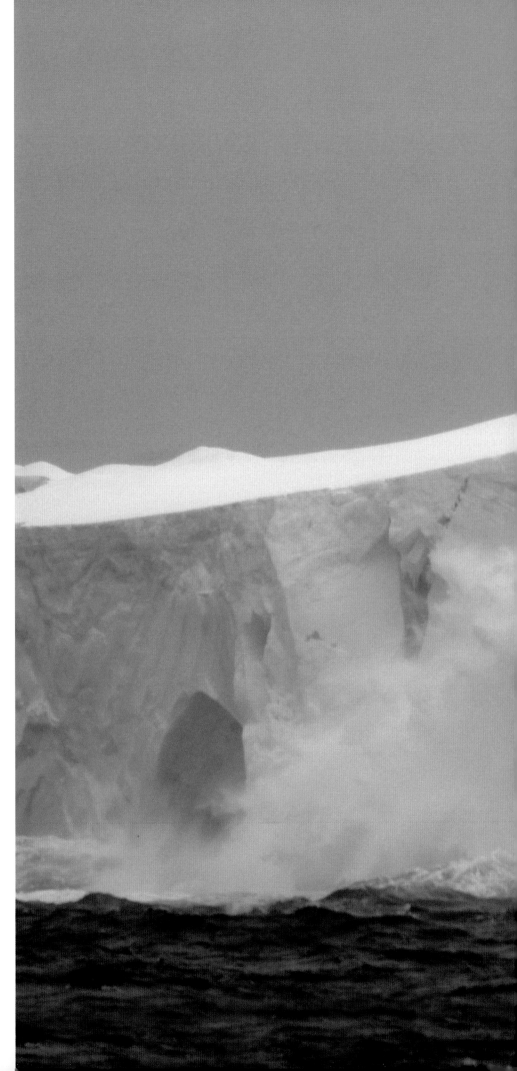

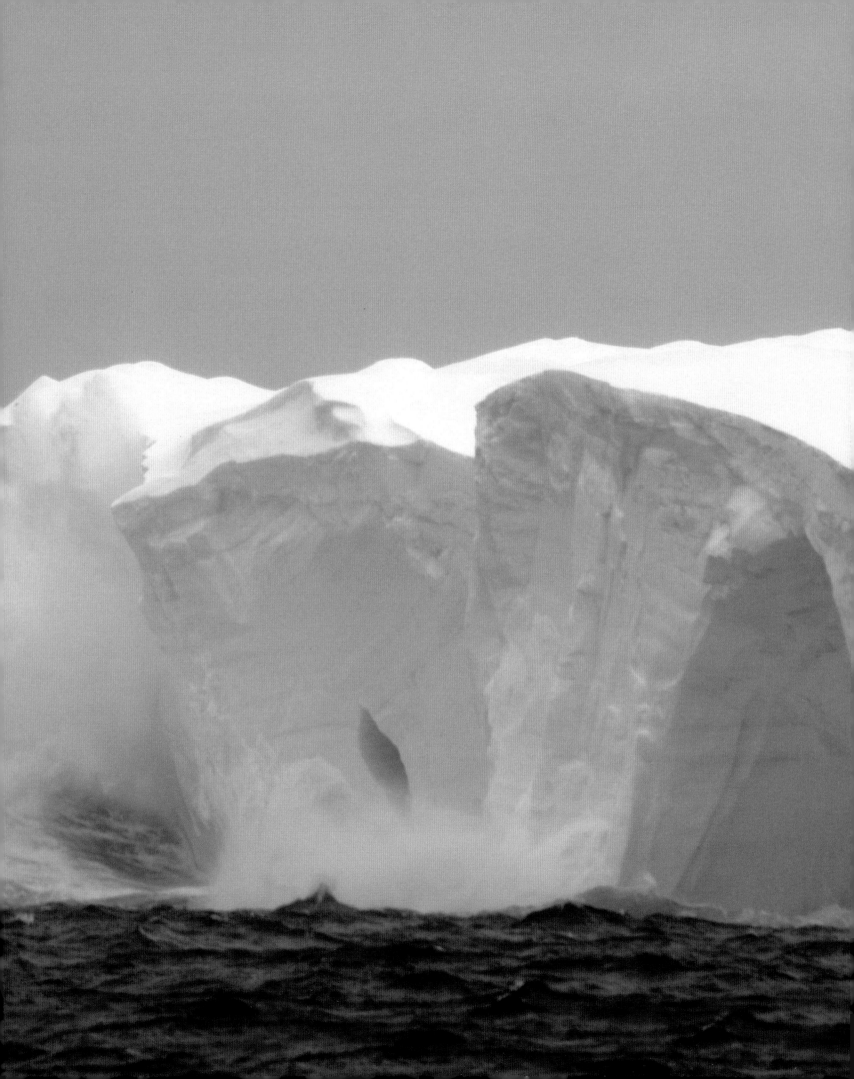

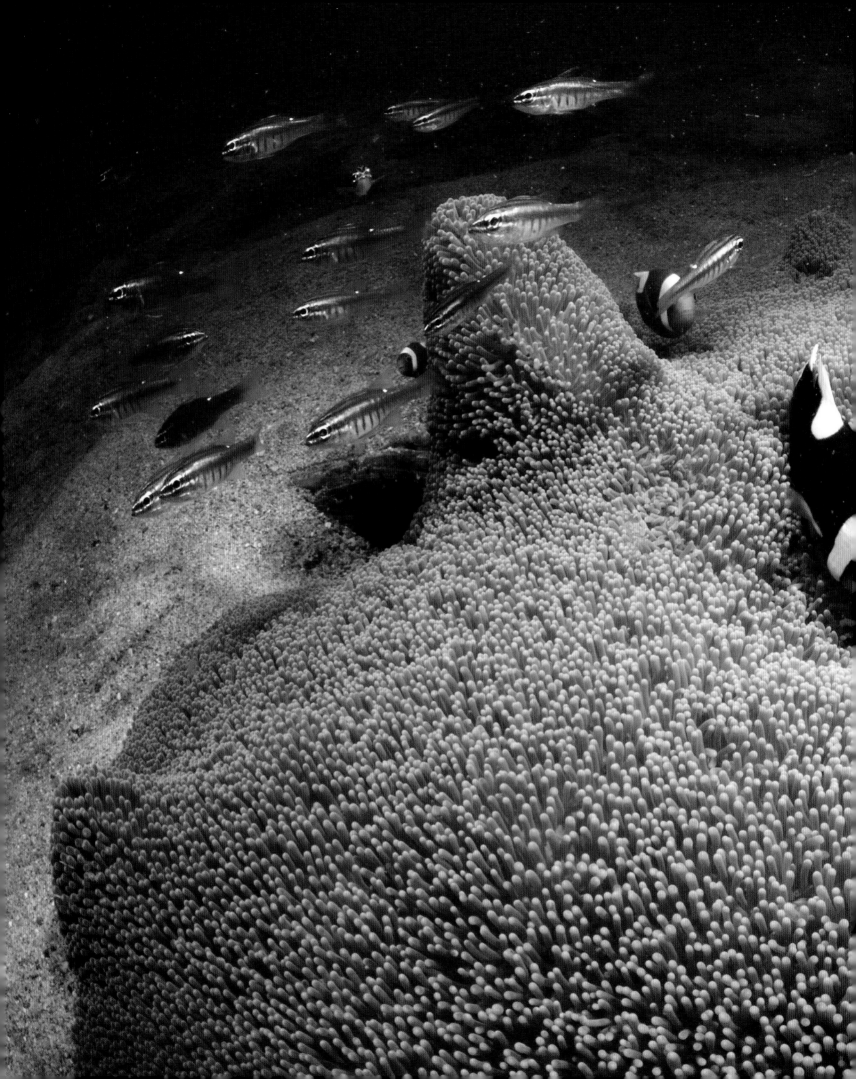

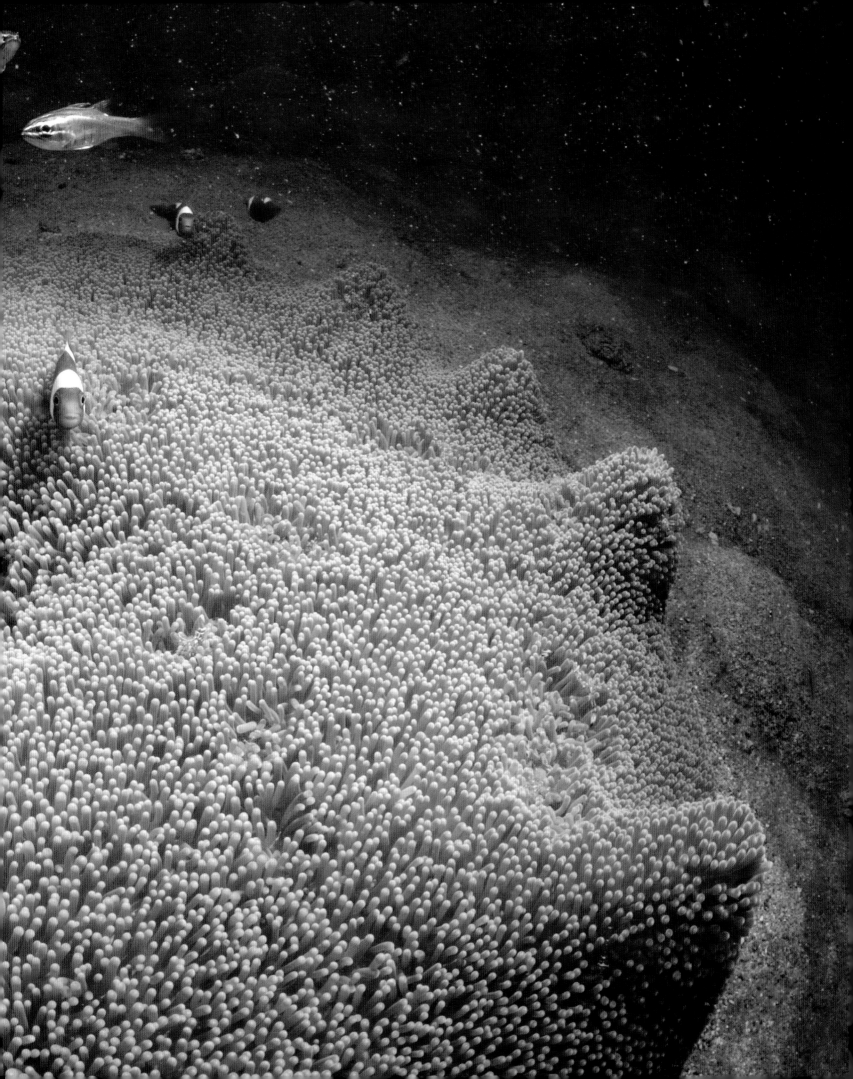

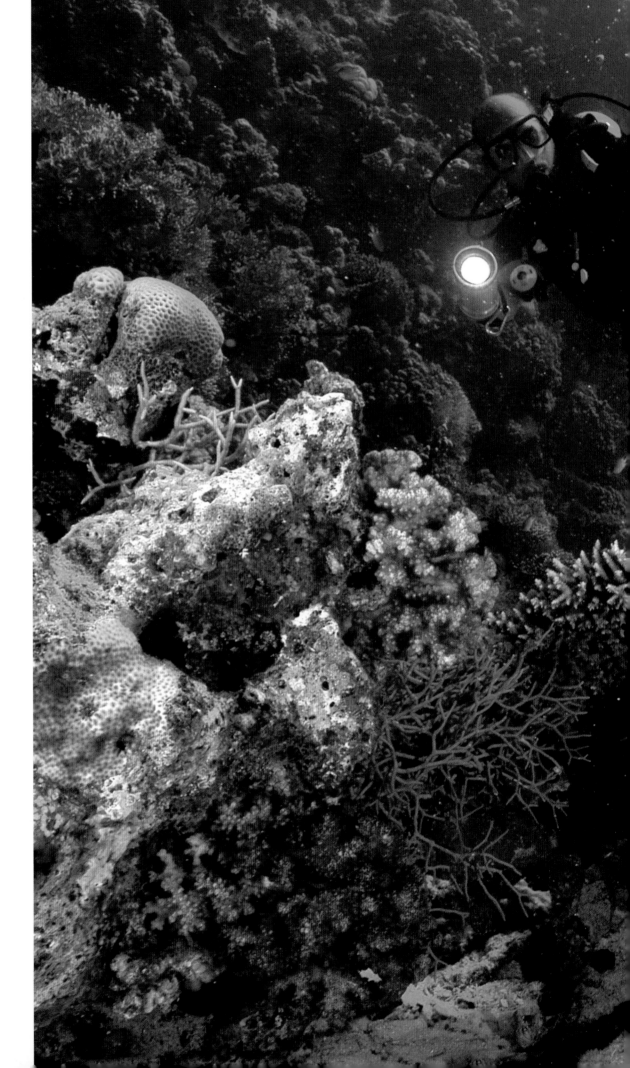

Gotta Abu Ramad reef, Egypt.
Crystal clear waters and unique coral
reefs have made the Red Sea one of
the world's prime diving destinations.
Yet these reefs are threatened by
problems such as overfishing,
pollution and uncontrolled coastal
development.

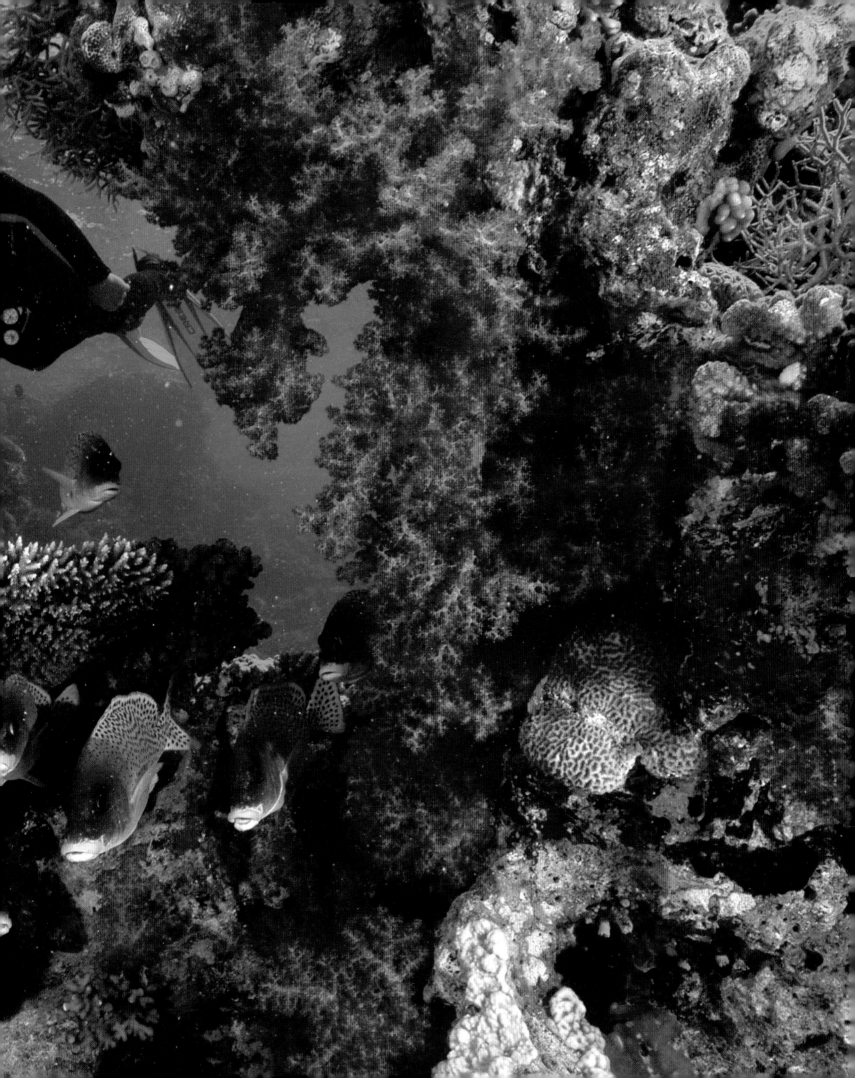

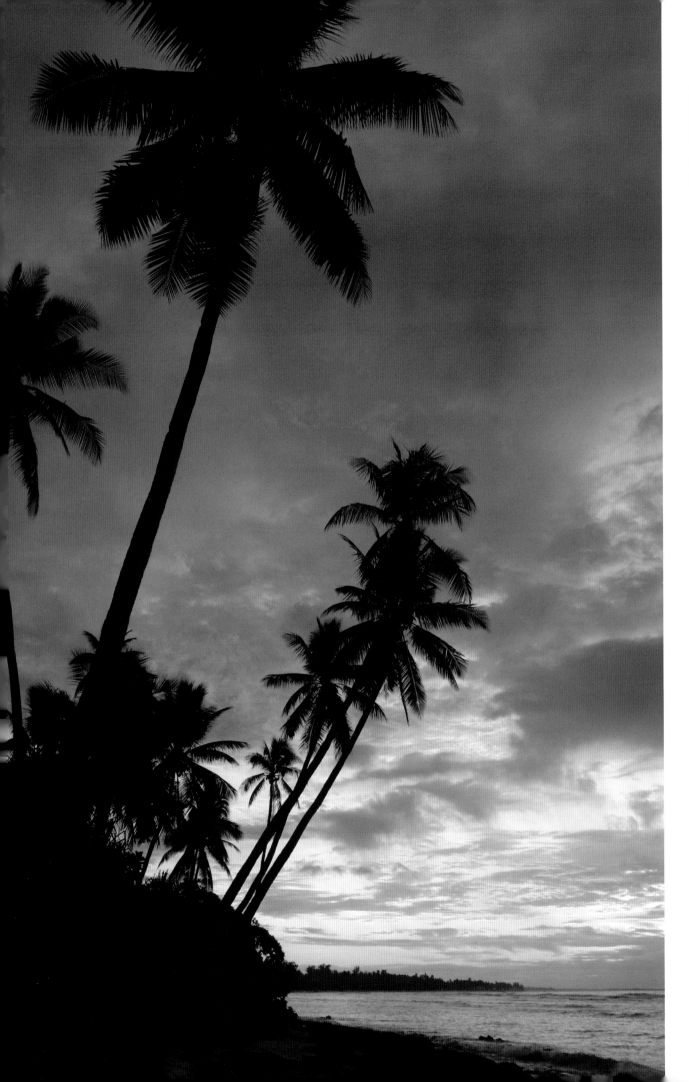

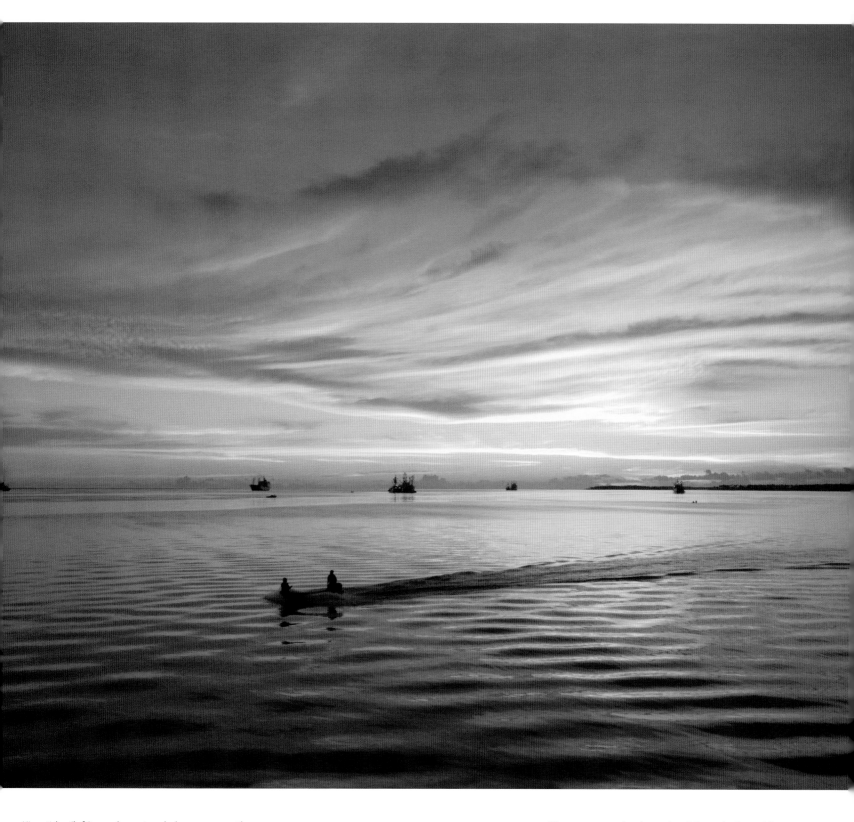

King tides (left) are also natural phenomena – the highest tides of the year that occur everywhere in the world. Rising sea levels due to climate change mean that these tides will become even higher. For small-island nations the combined impacts will put their homes and livelihoods at greater risk.

The oceans can be deceptive. A flat calm beneath a beautiful sunset belies the force of the waves and the power of what is happening below.

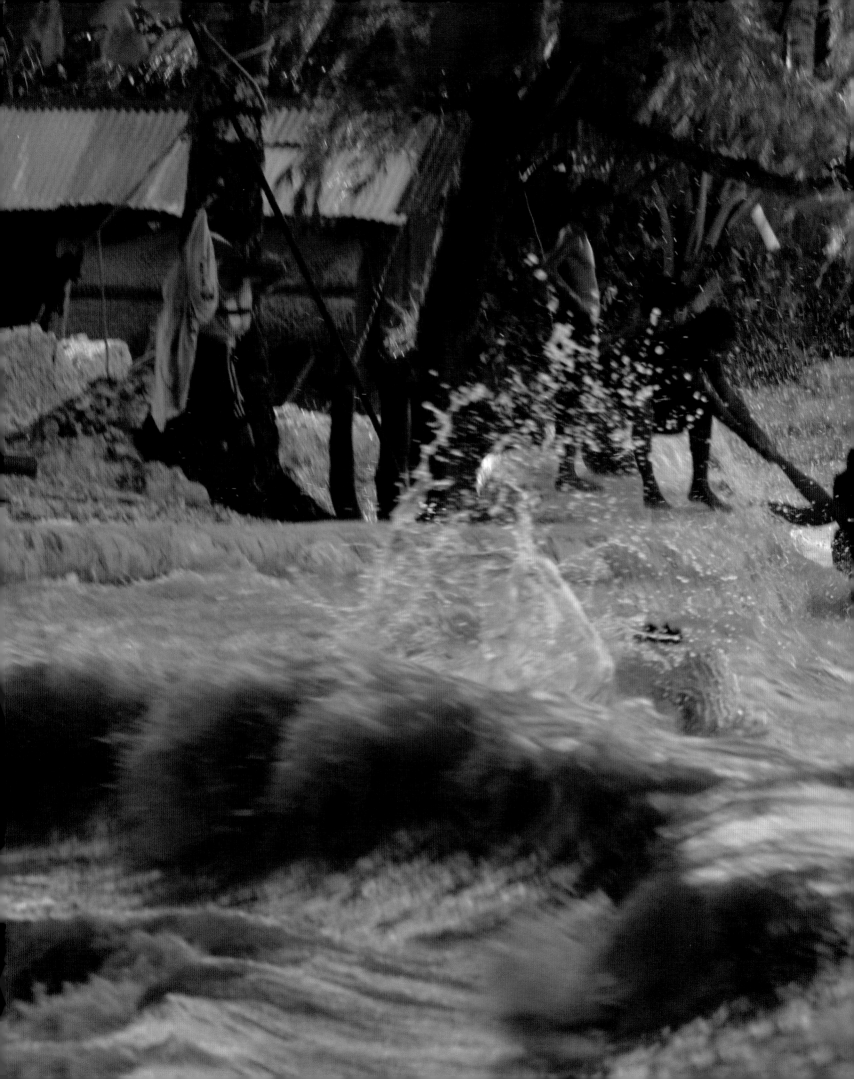

A family living next to the sea in the village of Betio, on the South Pacific island of Kiribati, pull themselves from the high waves of the king tide which came to the fragile atoll in December 2006, peaking at 2.87 meters/9 feet.

A gentle giant, the biggest fish in the ocean is a whale shark. With a mouth that can be up to 2 meters wide (5 feet) and 300 rows of tiny teeth it would dwarf most adversaries, but the whale shark mainly feeds on tiny plankton, algae and krill. Numbers of whale sharks are unknown and they are classed as 'vulnerable'.

CHAPTER 2

PREDATOR OR PREY?

Dating back to the time of dinosaurs, sharks are one of the sea's top predators. They have been portrayed in Hollywood films as horrific killers, but falling coconuts kill 10 times more people each year than sharks do; while bees and snakes are responsible for many more deaths. The risk of being killed by lightning is 30 times greater than that from a shark attack: sharks are responsible for around a dozen deaths a year. People, on the other hand, kill over 100 million sharks annually – accidentally trapping them in nets, or hooking them on long lines, and often killing them only for the precious luxury ingredient for a traditional Chinese soup – their fins.

By contrast, whales usually have a more benign reputation as the gentle giants of the deep. But some whale species are among the most organized of marine hunters. Humpback whales for instance will spiral upwards, releasing columns of bubbles that form an ingenious net around their prey, before engulfing it in their huge mouths. It is ironic, however, that whales are sometimes blamed, usually by those who want to hunt them, for the collapse of fish stocks. While whales do eat fish, both species rubbed along together just fine until the advent of industrial fishing and commercial whaling in the late 19th century. It was only then that numbers of both fish and whales started to crash. Even 20 years after the global moratorium on whaling some populations have not recovered. Three-quarters of all fish stocks are in trouble because of overfishing.

Up to 2 meters/6 feet long, weighing as much as 700 kilograms/1,500 pounds, tuna are classed as one of the most efficient predatory fish – a real high-octane, killing, eating machine. Able to regulate their body temperature to enhance their speed when needed, they eat anything from other fish to squid and even crabs. The Yellow Fin tuna can even smell out its prey, following oil traces in the water. But the very thing that makes them so dominant under water – their muscular, powerful flesh – is also what makes them so highly prized on land, for the meat is rich and tasty. As a result many tuna species are on the brink of collapse in the goldrush to land the highly prized flesh.

One of the most deadly of sea creatures actually has no teeth, no bones and 24 eyes, displays no unprompted aggressive behavior and lives in mainly warm tropical waters. A chance encounter with a box jellyfish is usually fatal in a matter of seconds. It's claimed that venom from just one tentacle is enough to kill 60 people. But the greatest ocean predator is not marine, but human. Very little ocean life escapes our increasingly sophisticated nets and lines. In every ocean, the predators have become the prey.

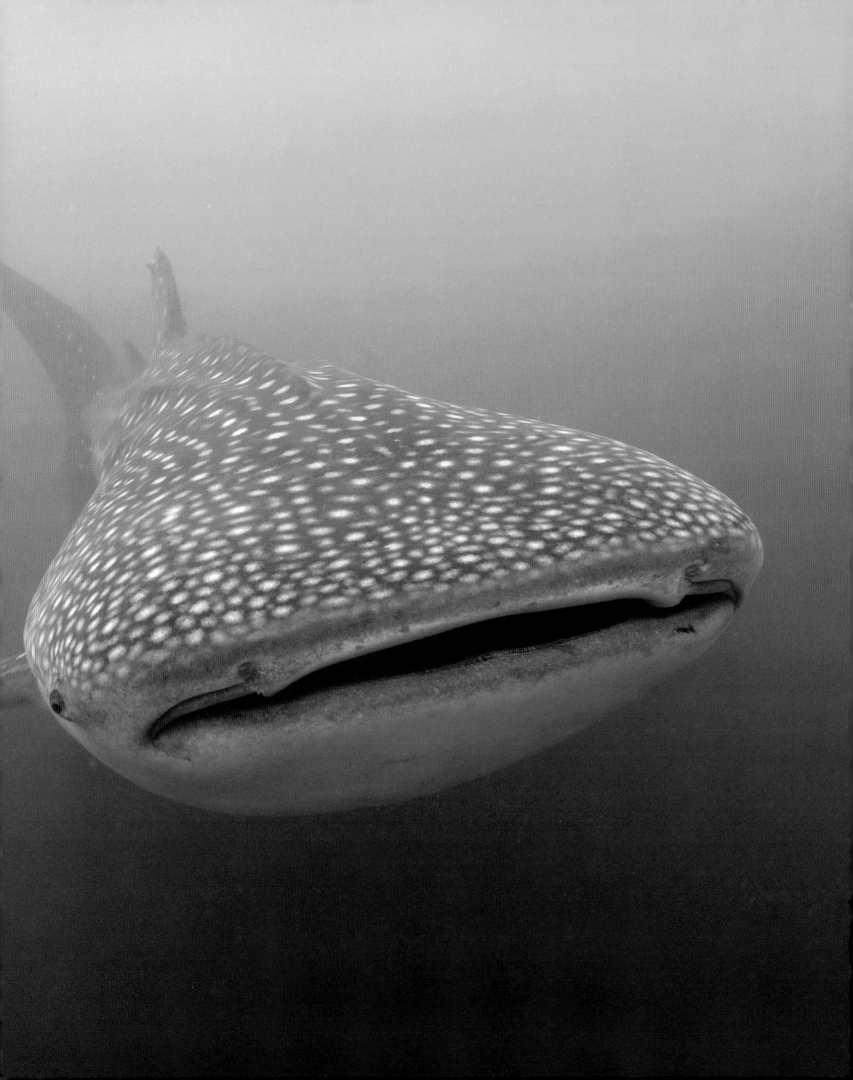

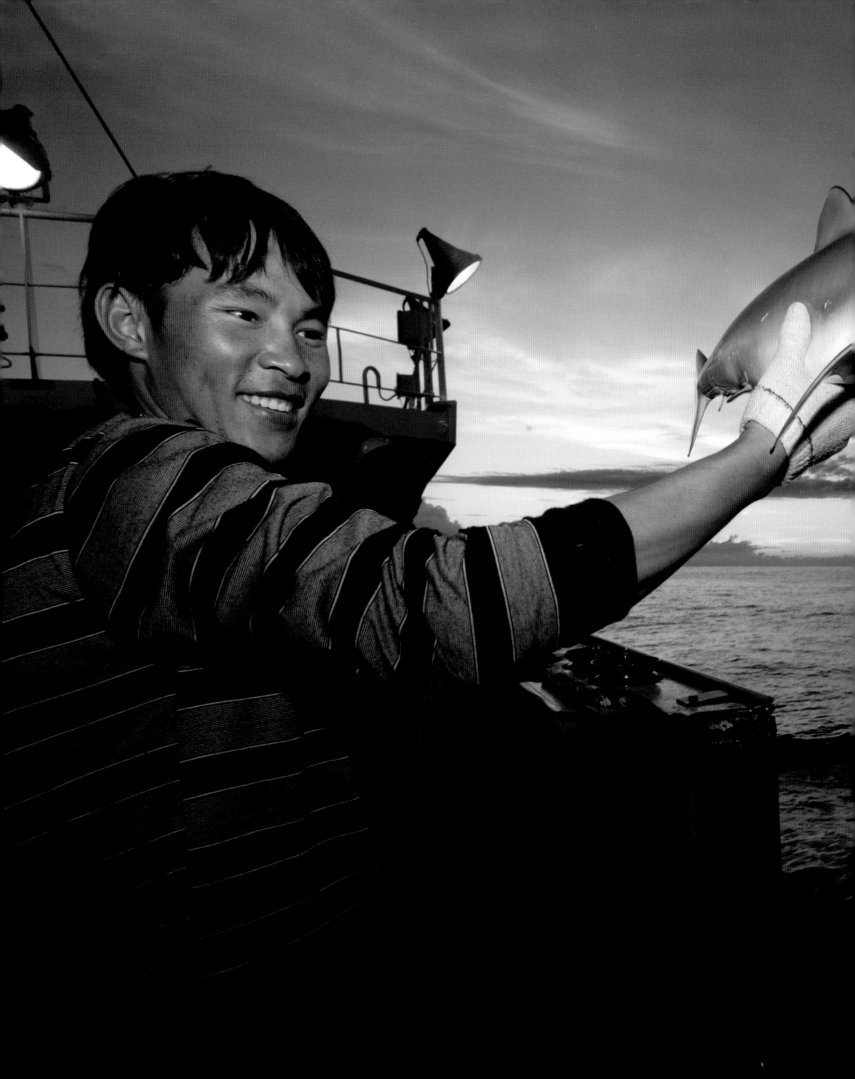

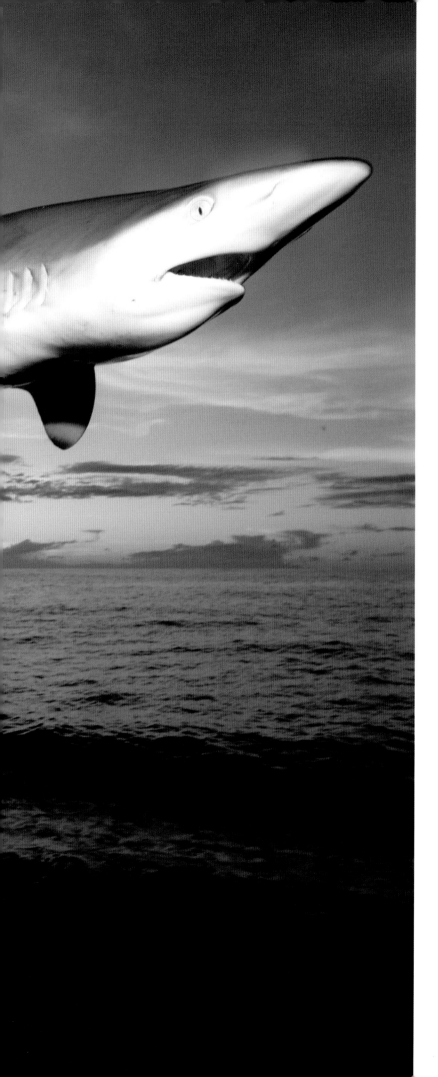

The fact that there were cameras on this fishing vessel probably saved this shark from being finned. This is one of the few thrown overboard unscathed. Ships, with fishing lines up to 100 kilometers/60 miles long and baited with thousands of hooks, will often catch sharks by accident. For many fishers the chance to take their fins is a welcome boost to their income.

Shark fin soup is considered a delicacy in parts of Asia and commands a high price in restaurants. Getting the ingredients is less palatable. Sharks are finned while still alive and then thrown back overboard to drown. Hammerhead shark fins and heads are shipped from as far away as Mexico to feed the Chinese market for soup.

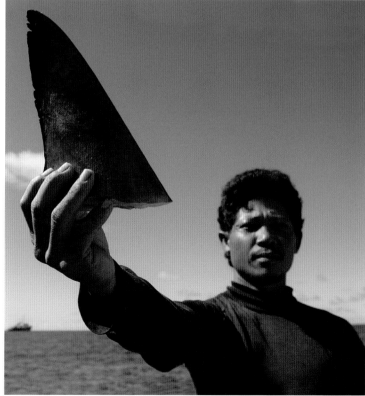

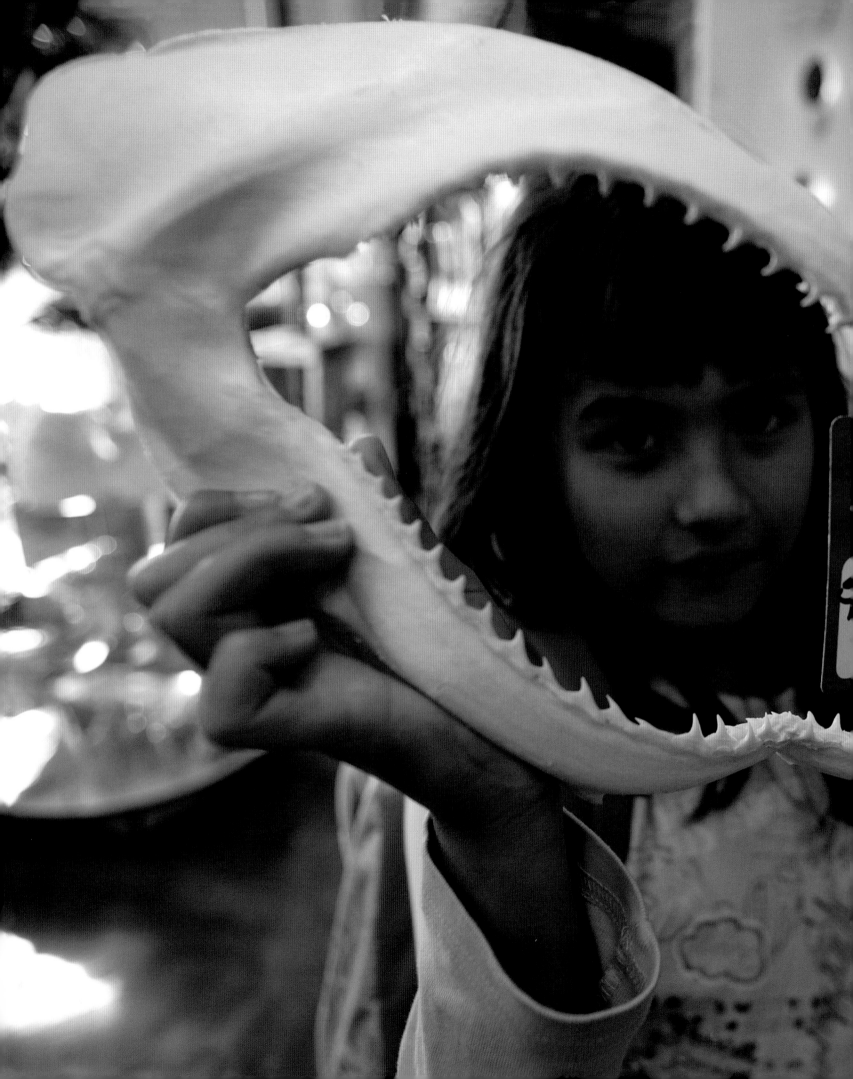

It is not only the fins that make sharks profitable prey for humans. Tourists will willingly pay for teeth and jaws as souvenirs.

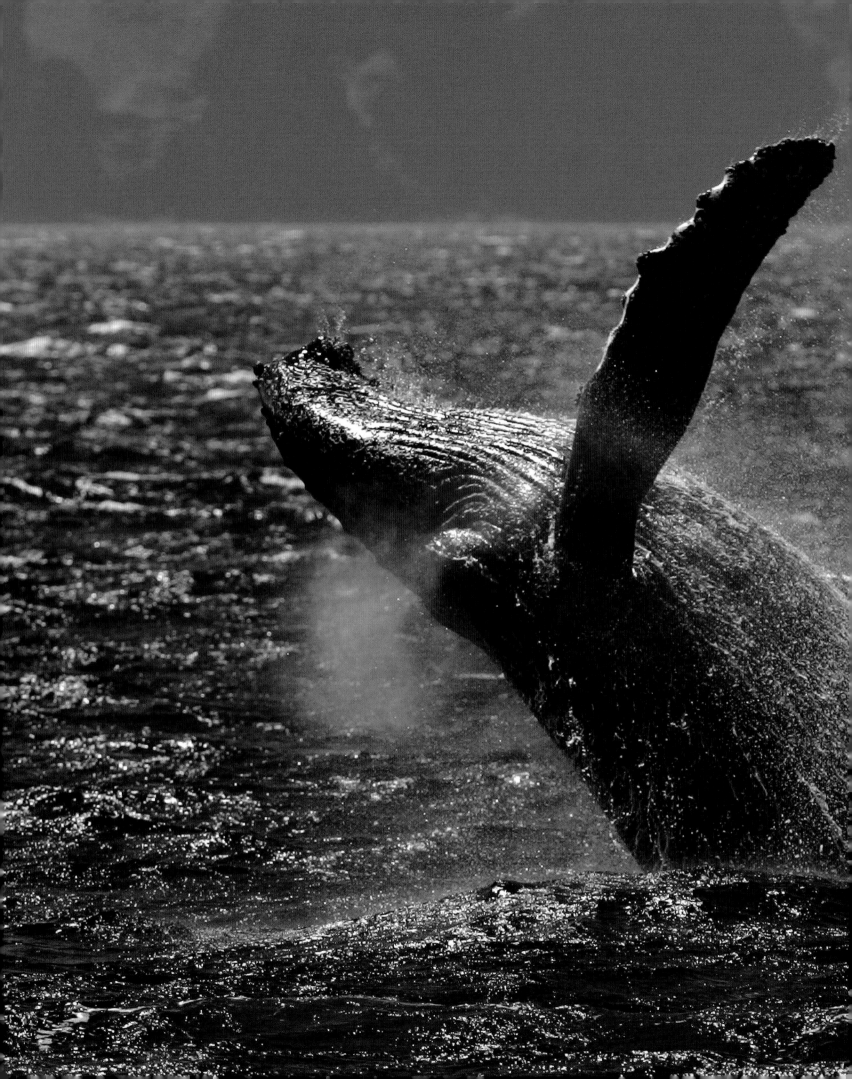

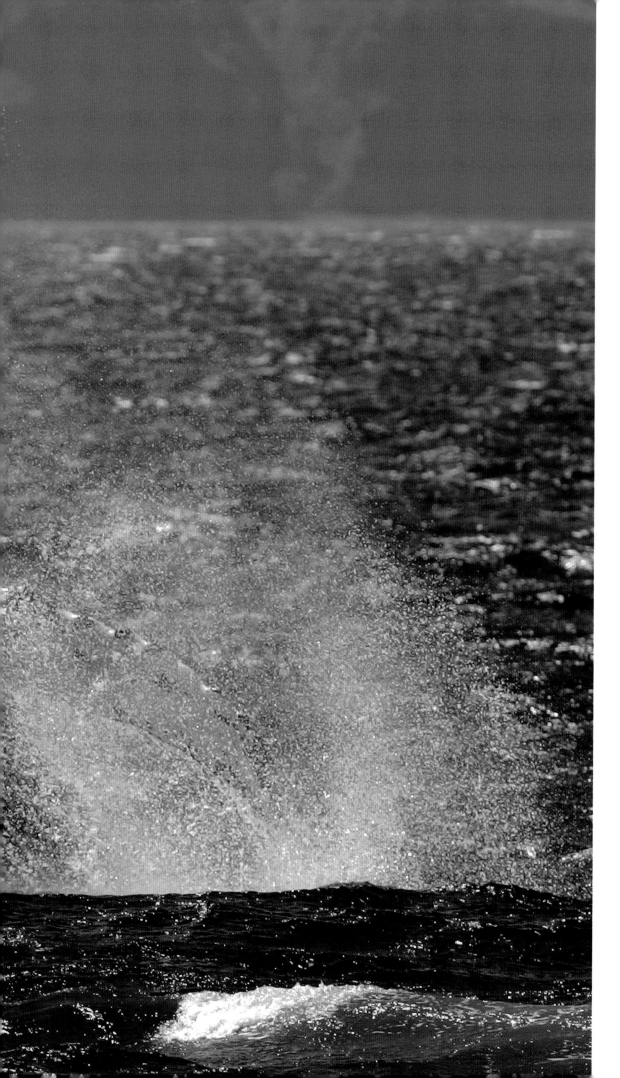

The humpback whale is an endangered species but the Japanese whaling fleet will still continue to target them in the Southern Ocean.

A harpooner's view of the Southern
Ocean whaling grounds. The
harpoons carry explosive tips, but it
can still take more than 30 minutes for
a whale to die.

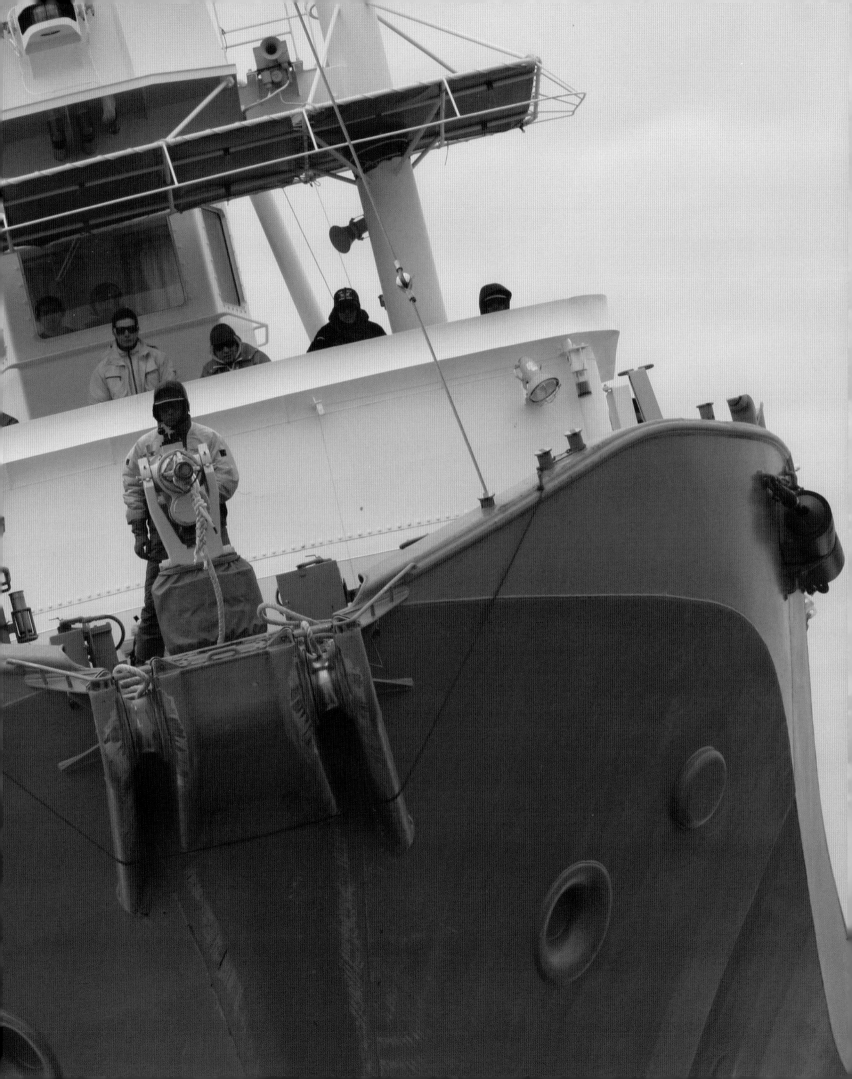

Whales are, for many, the icons of the oceans. Some species are highly social and the 'songs' of others can be heard over vast distances. They reproduce slowly and invest a huge amount in rearing their young. Japan, Iceland and Norway continue to hunt whales, despite an international ban. Iceland resumed commercial whaling in October 2006, after years of defying the international ban under the guise of scientific research. All of the 'scientific' research done by the Japanese and Icelandic governments could be as effectively achieved with non-lethal methods.

More than two thirds of the whales killed in the Southern Ocean Whale Sanctuary in the 2005/2006 whaling season were pregnant or nursing mothers.

Whales will frequently be drowned after they are harpooned – dragged head down through the water until they die.

[page 68-69] The whales are then lashed to the side of the catcher ships until they can be transferred to the factory ship to be cut up, boxed and frozen before being taken back to Japan. The majority of Japanese do not support whaling in the Southern Ocean.

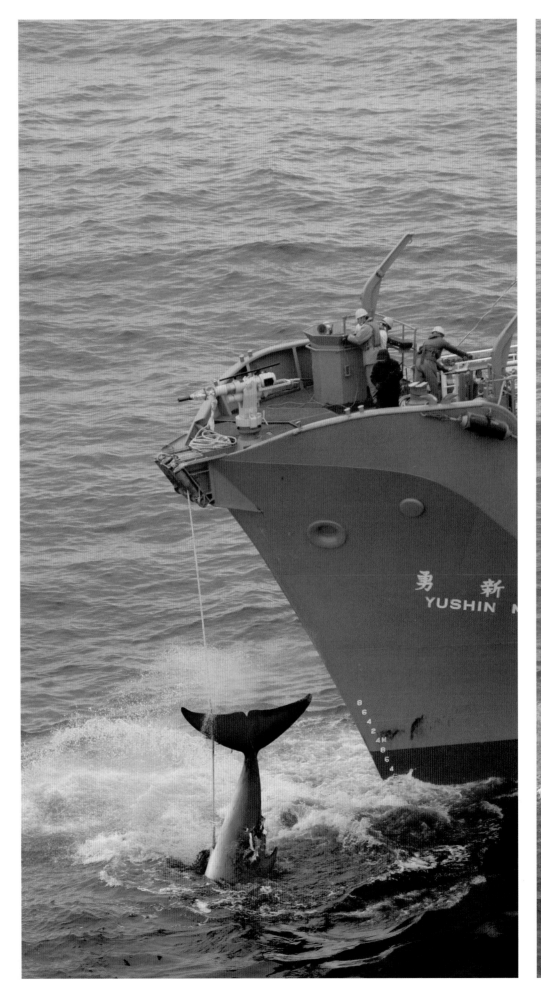

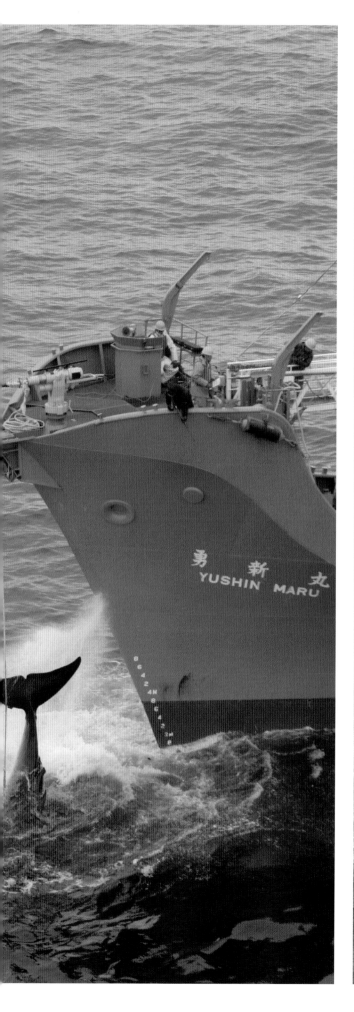
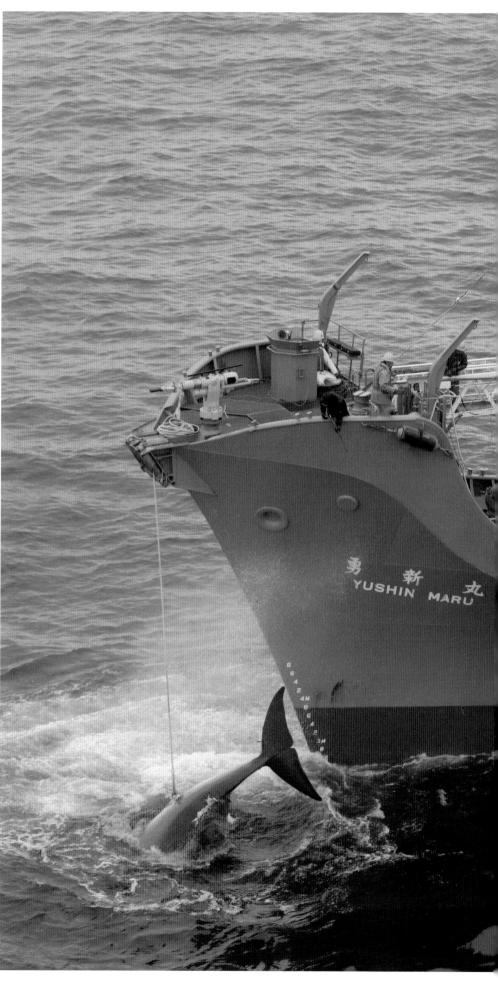

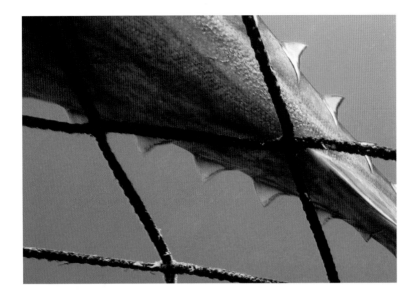

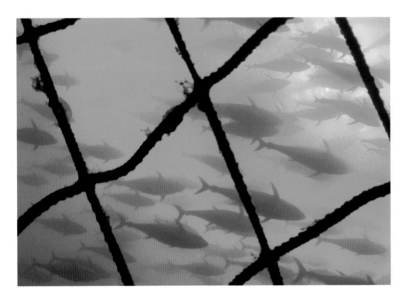

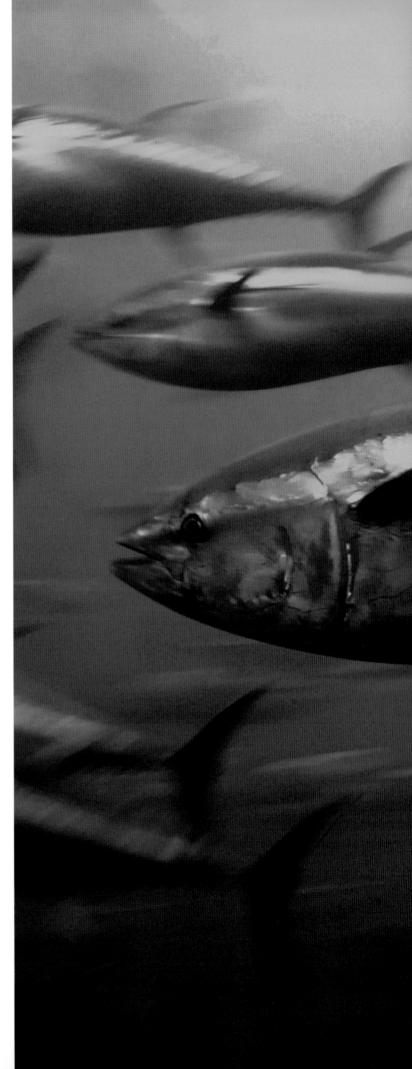

Tuna can swim faster than a horse can gallop and faster than any other fish. They undertake huge migrations each season. In 2001, a single bluefin tuna was sold for 20.2 million yen (around $174,000) in the Tokyo fish market.

In the last 50 years, 90 per cent of all the big predatory fish like tuna and swordfish have been fished out.

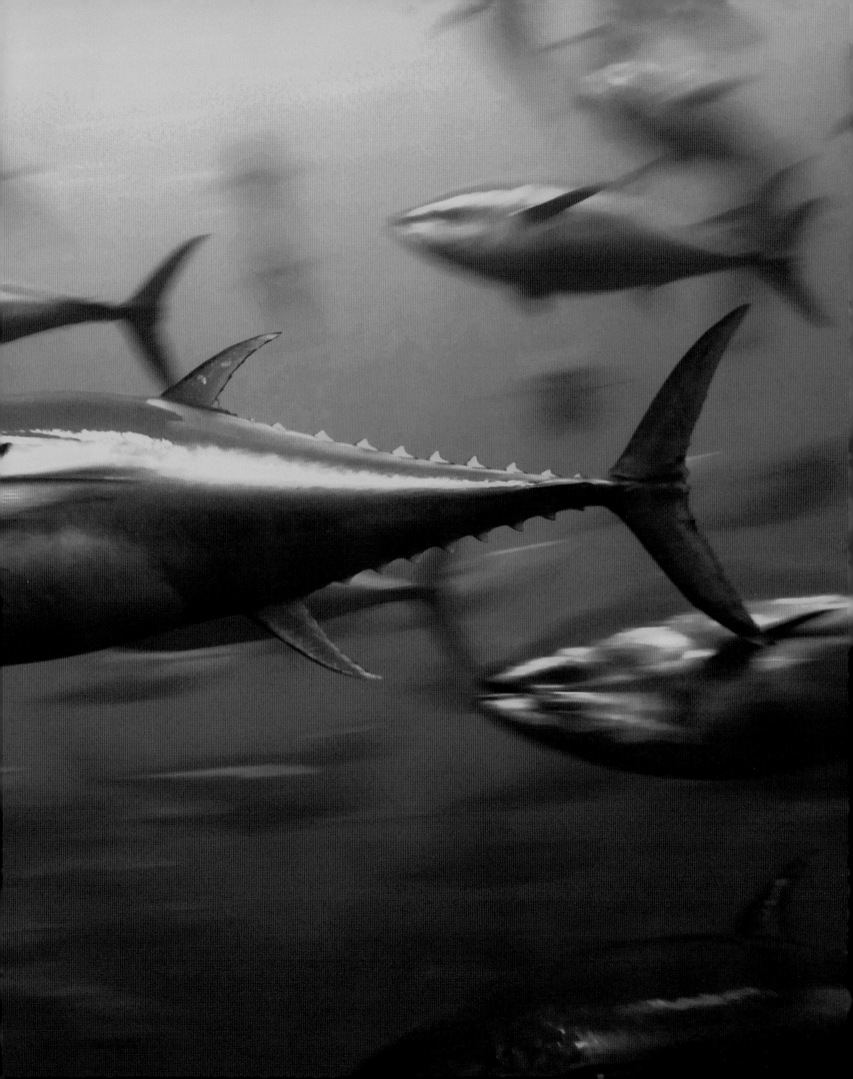

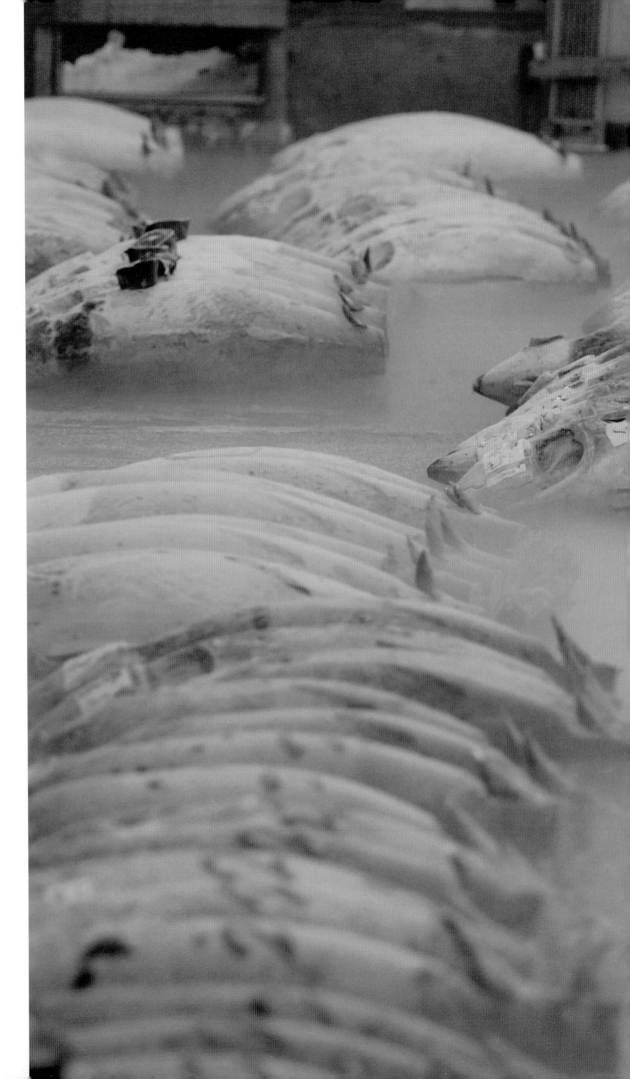

Frozen tuna being inspected prior to auction at the Tsukiji wholesale fish market, the biggest fish market in the world, in Tokyo, Japan. Japan is the world's largest consumer of tuna.

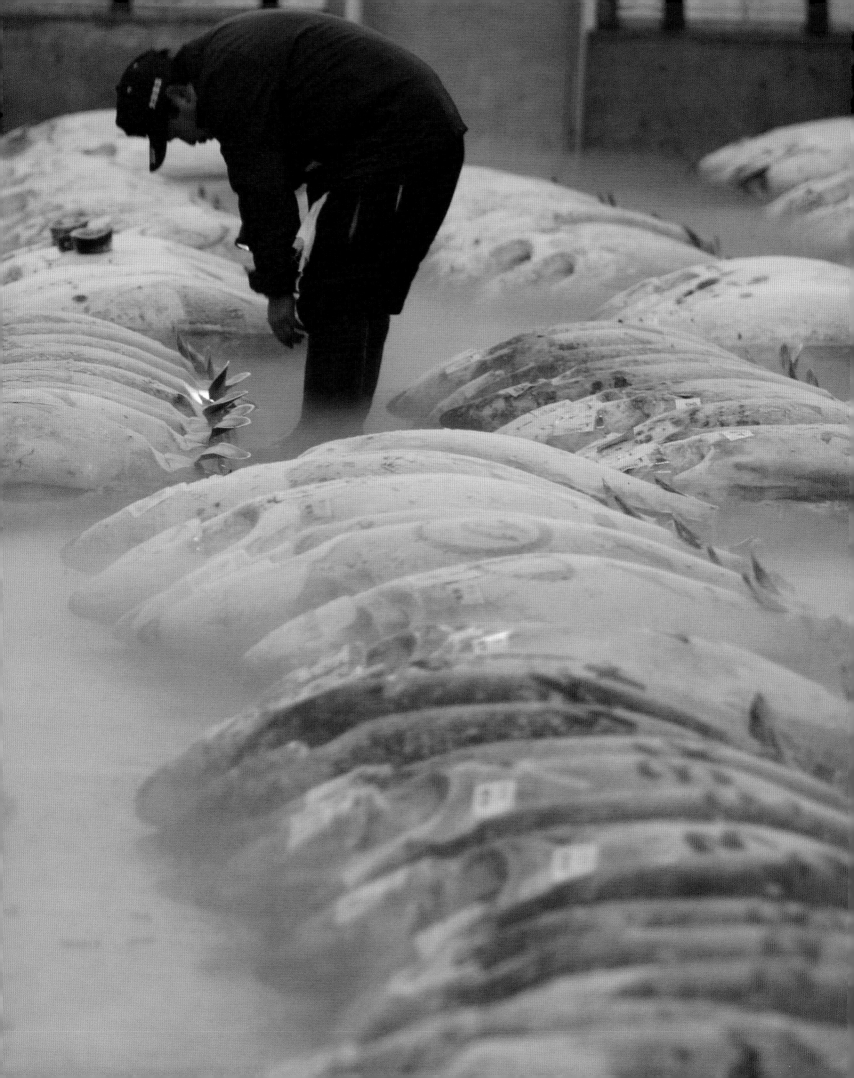

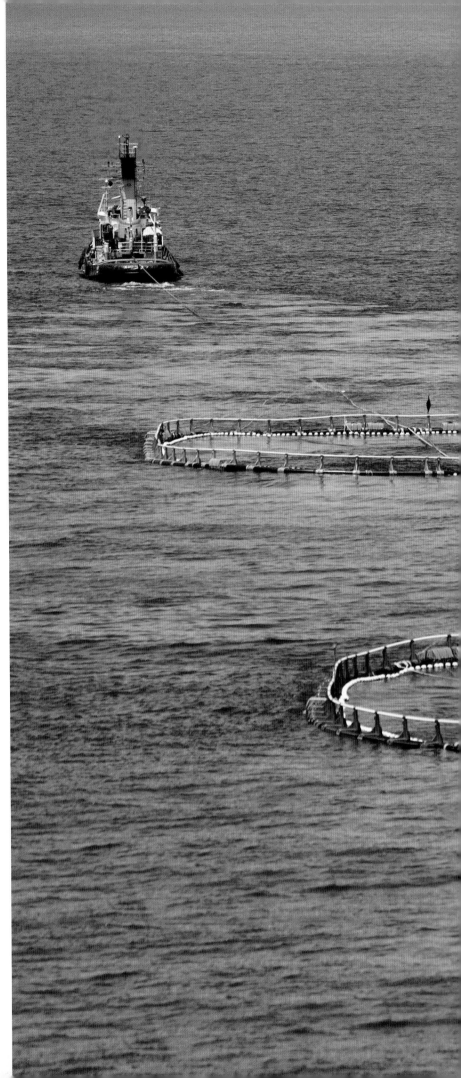

From top class sushi to classic tuna sandwiches and right down to cat food, the global appetite for tuna seems insatiable. Tuna ranching – catching fish in the wild, caging them and then fattening them for sale – is now a growing industry. But there is a downside: ranching takes juvenile fish out of the wild stock, adding to the near collapse of some populations in the wild.

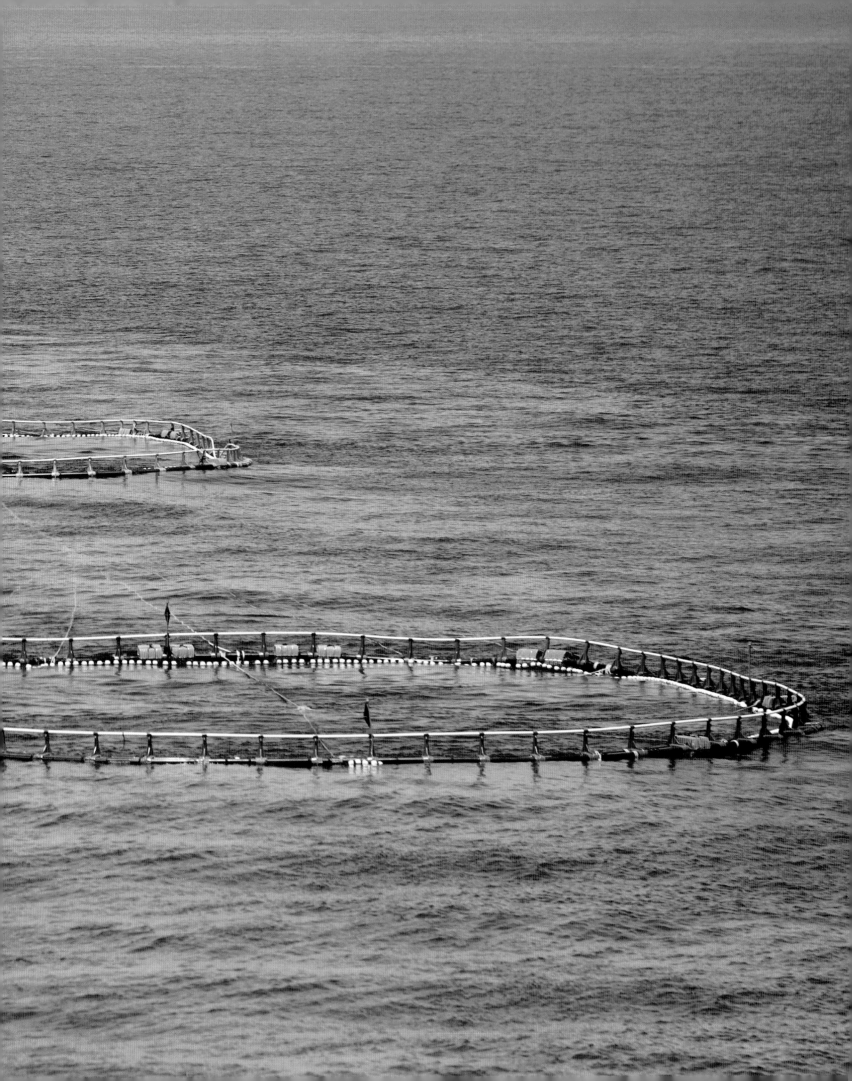

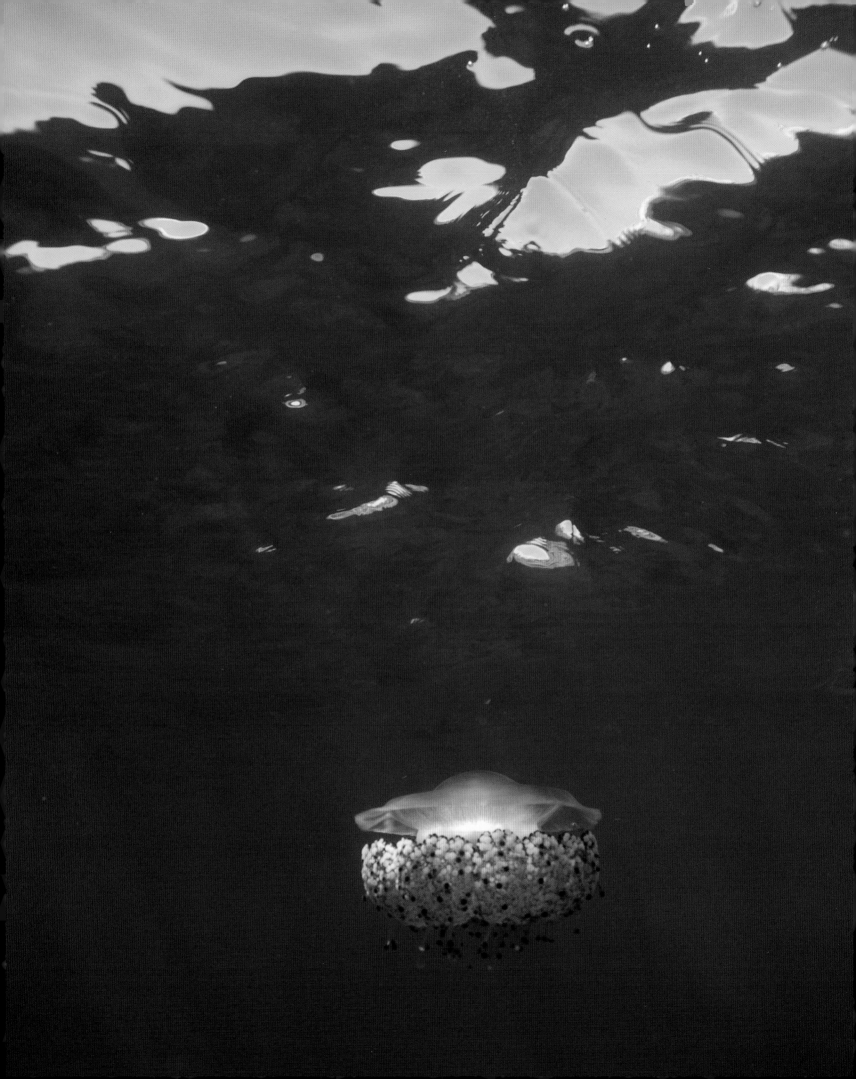

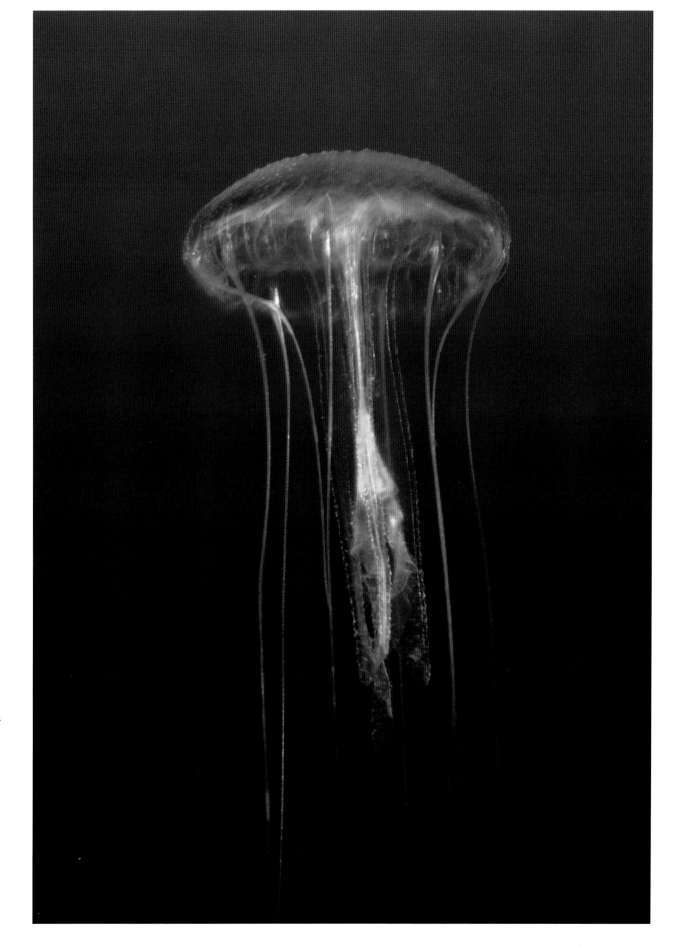

Not all jellyfish sting. The mauve stinger jellyfish (right) seen here in the Azores sparks flashes of light at night if it is disturbed. While the box jellyfish may be the deadliest marine creature, others species such as this one in the Mediterranean (left) are completely harmless and can even provide shelter for juvenile fish.

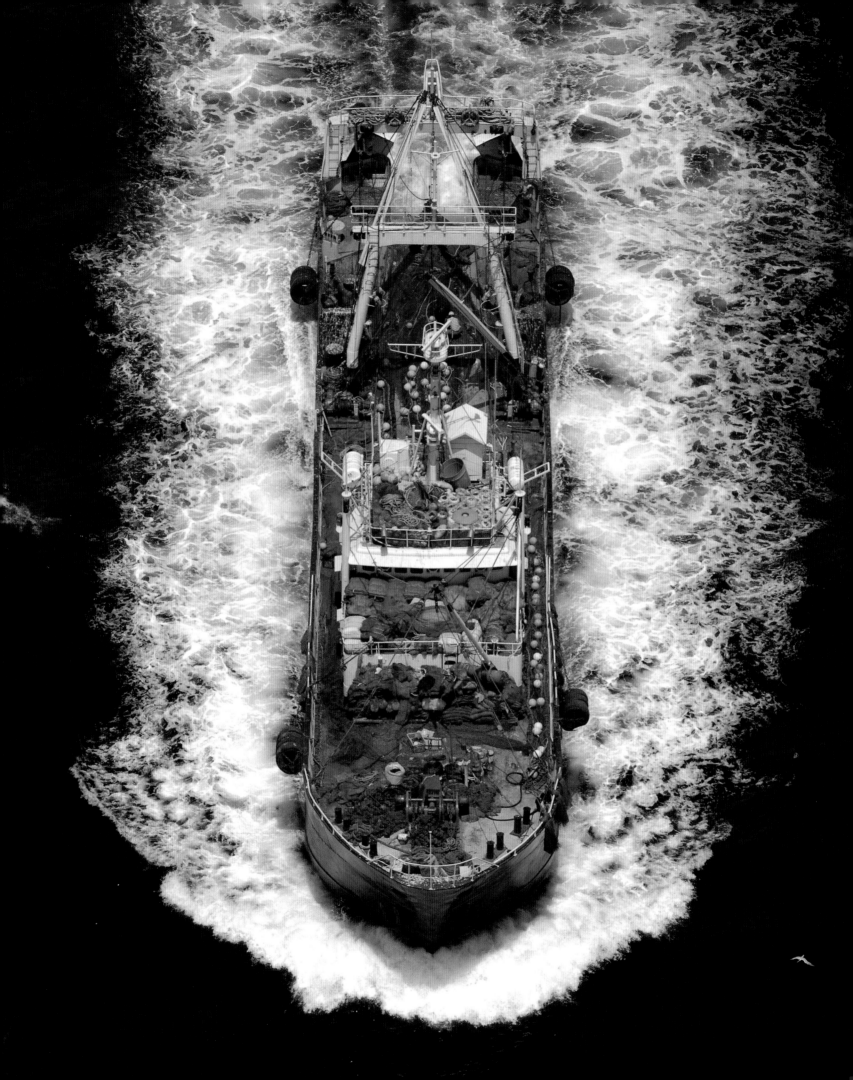

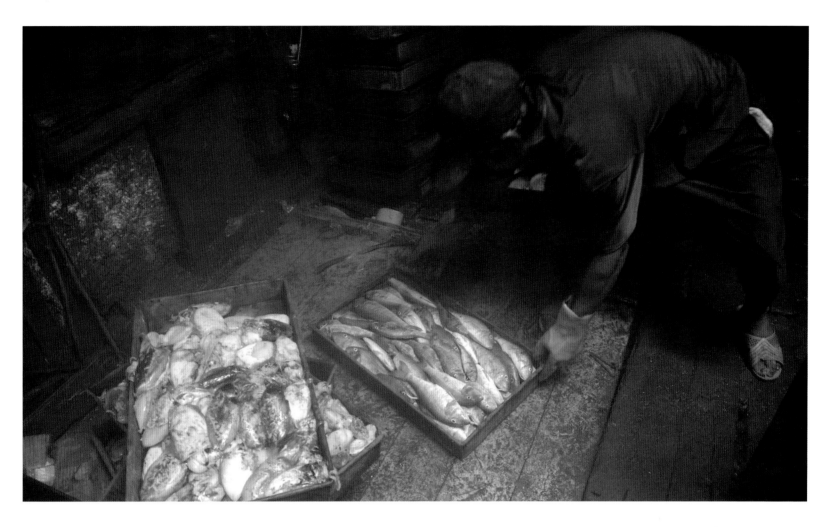

Some fishermen are selective about what they want to catch, but others go for maximum yield. This trawler (left) has all available deck space covered in green nets, ready to trawl. By-catch – what comes up in the net that isn't needed or wanted, including sharks, dolphins, turtles, crabs and other fish – can account for as much as 70 per cent of a single haul. Dead or dying, it is shovelled back over the side. Only a few shallow trays of fish (above) make it into the freezer below, the rest – classed as useless, has been thrown overboard.

The problem is compounded when smaller meshed nets (right) are illegally hidden inside regulation mesh nets in order to maximize the catch.

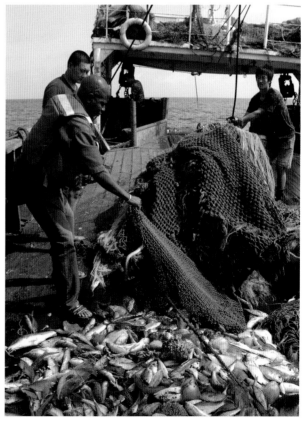

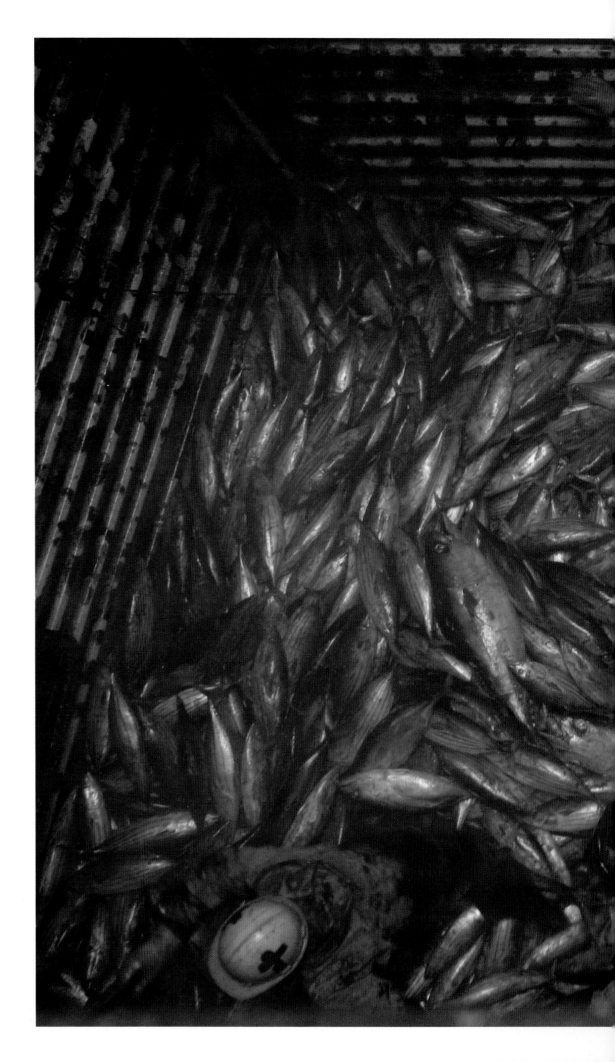

The global appetite for fish is fuelling concerns that commercial fish stocks will collapse in the next 50 years. Currently the United Nations estimates that three-quarters of all fish stocks are in trouble from overfishing.

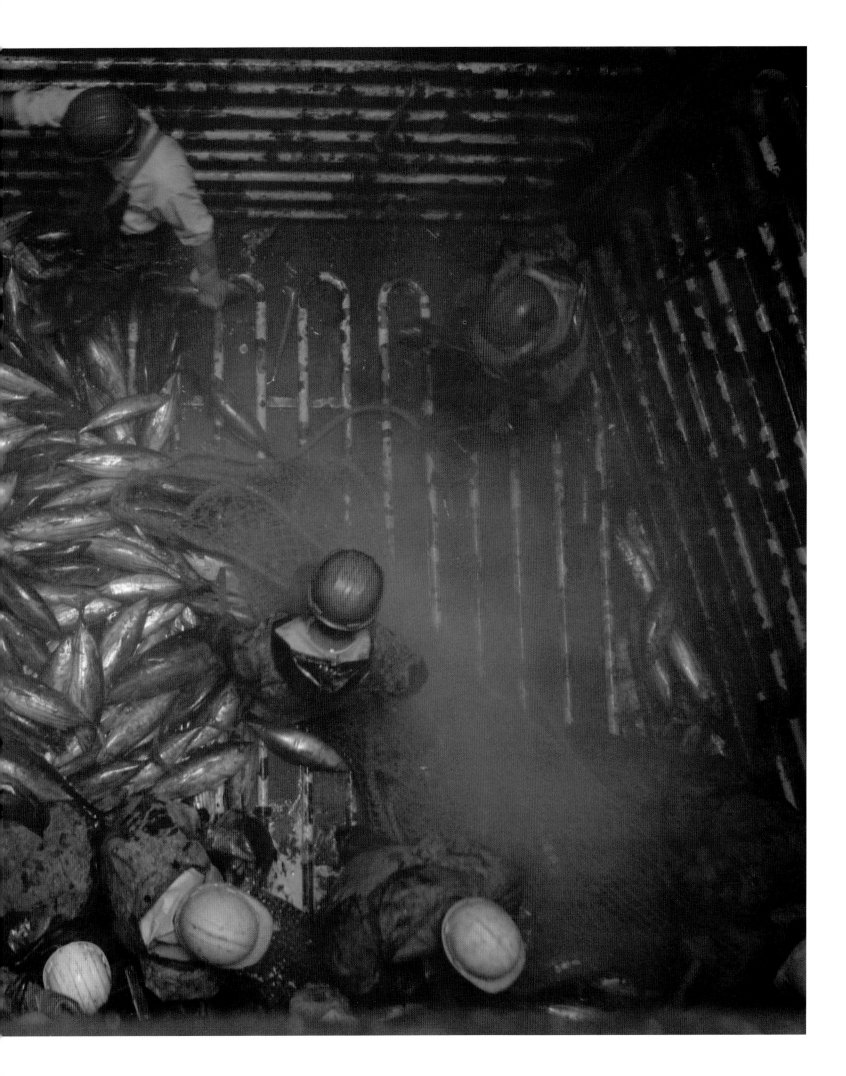

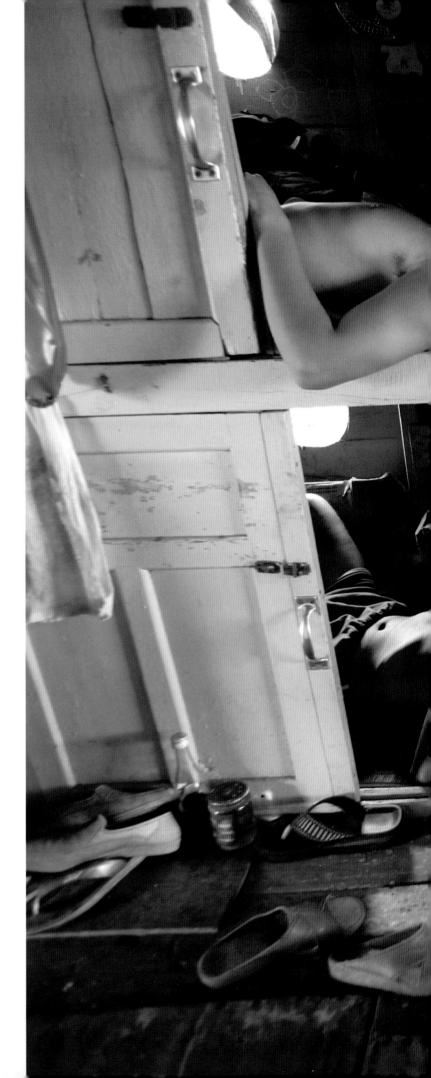

CHAPTER 3

PEOPLE AND THE OCEANS

Half the world's population lives on or near the coast. For over a billion people, fish is the main source of protein, as many people also earn their living from the seas. Oceans provide jobs, food and simple pleasure, they have inspired poets and artists, set the challenge for some of the world's greatest explorations and achievements, provided a natural buffer between warring nations and given others common ground. The Pacific Ocean – the 'peaceful sea' – was so named by the 15th-century Portuguese explorer Magellan. With thousands of islands and dozens of nations dotted across this, biggest of all the oceans, the islanders have a saying that the waters are not what divide us, they are what join us.

With only a third of the planet available to discover on foot, it is not surprising that we felt the need to explore and conquer the oceans at an early stage. Documented evidence of one early voyage dates from around 7250 BC, and was made between the Greek mainland and the island of Melos. Since the first boats pushed off from the shore our oceans have become the economic arteries of the planet, carrying 80 per cent of all the world's trade.

The oceans, though vast, are not limitless; they are plentiful but not inexhaustible. And while we all rely on them, most of us have no real idea what is happening beyond our beaches.

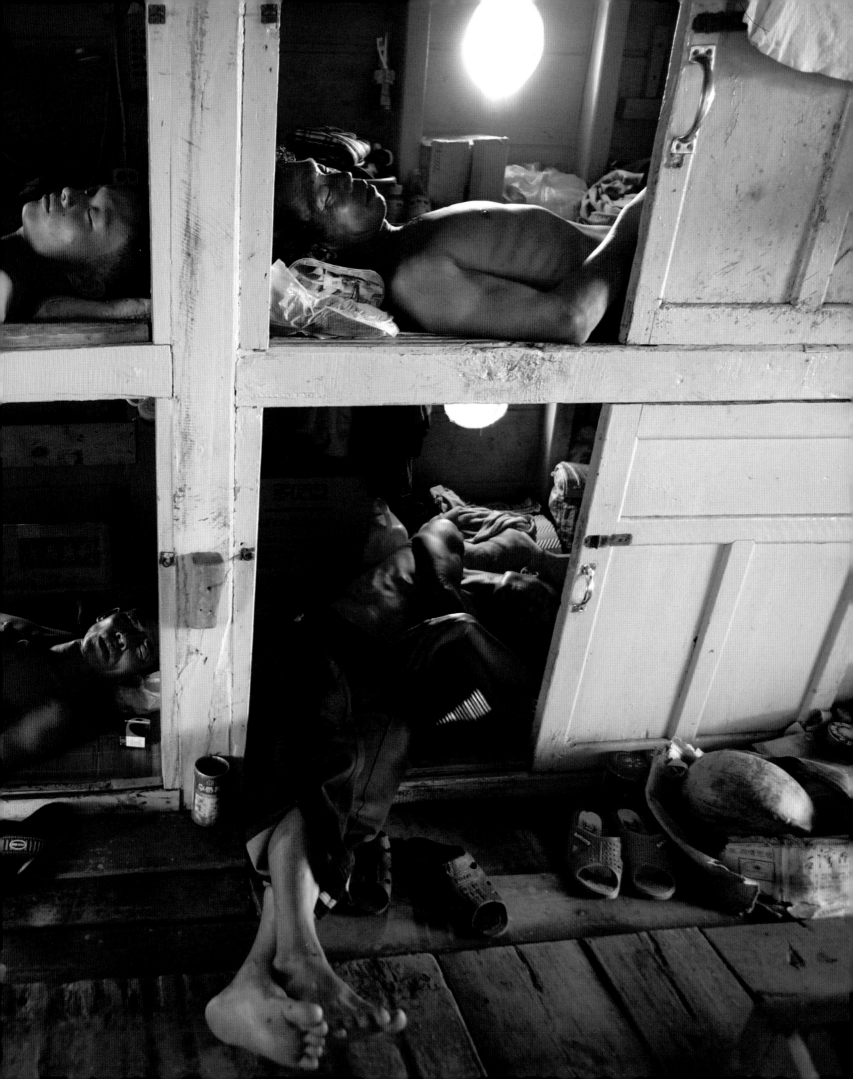

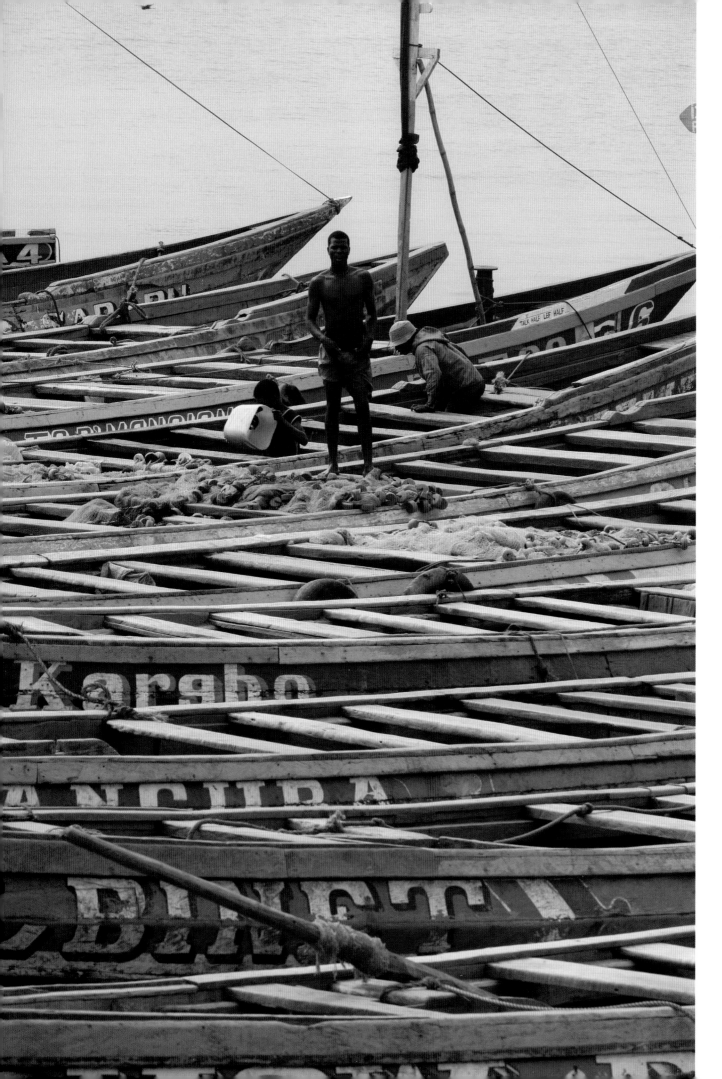

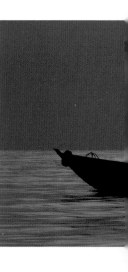

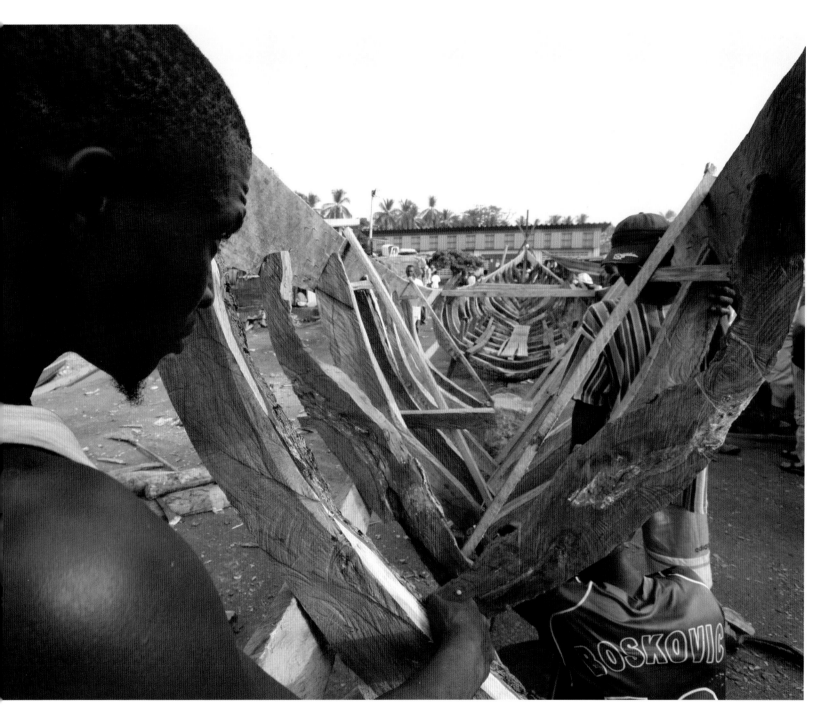

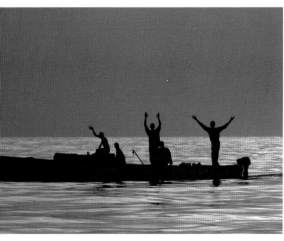

All but 10 per cent of fishers work in small-scale operations. These Guinean pirogues – canoes – are only a few meters long and use hand-cast nets. Competing with industrial vessels is impossible and sometimes even life-threatening. Industrial ships, which account for only one per cent of the global fleet, but catch 60 per cent of all the fish, often move close to shore and have run down the pirogues.

In many communities fishing is a family affair, with traditions and even boats handed down through the generations. For small-scale operations, like this family in the Baltic, fishing is no longer a long-term career option as fish stocks fall and competition grows from vastly bigger vessels.

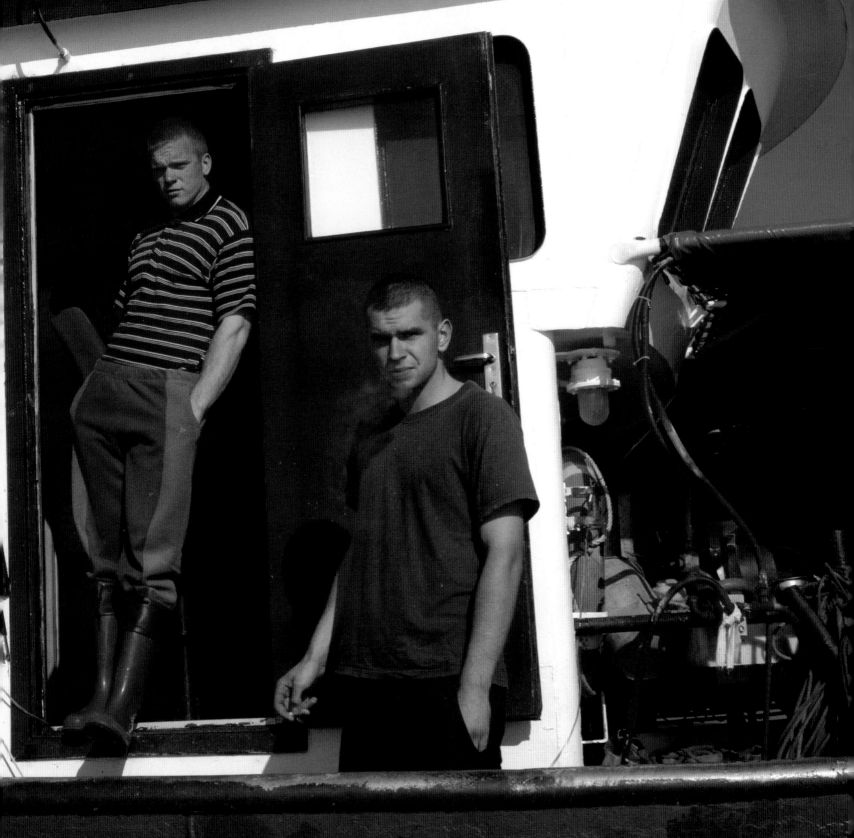

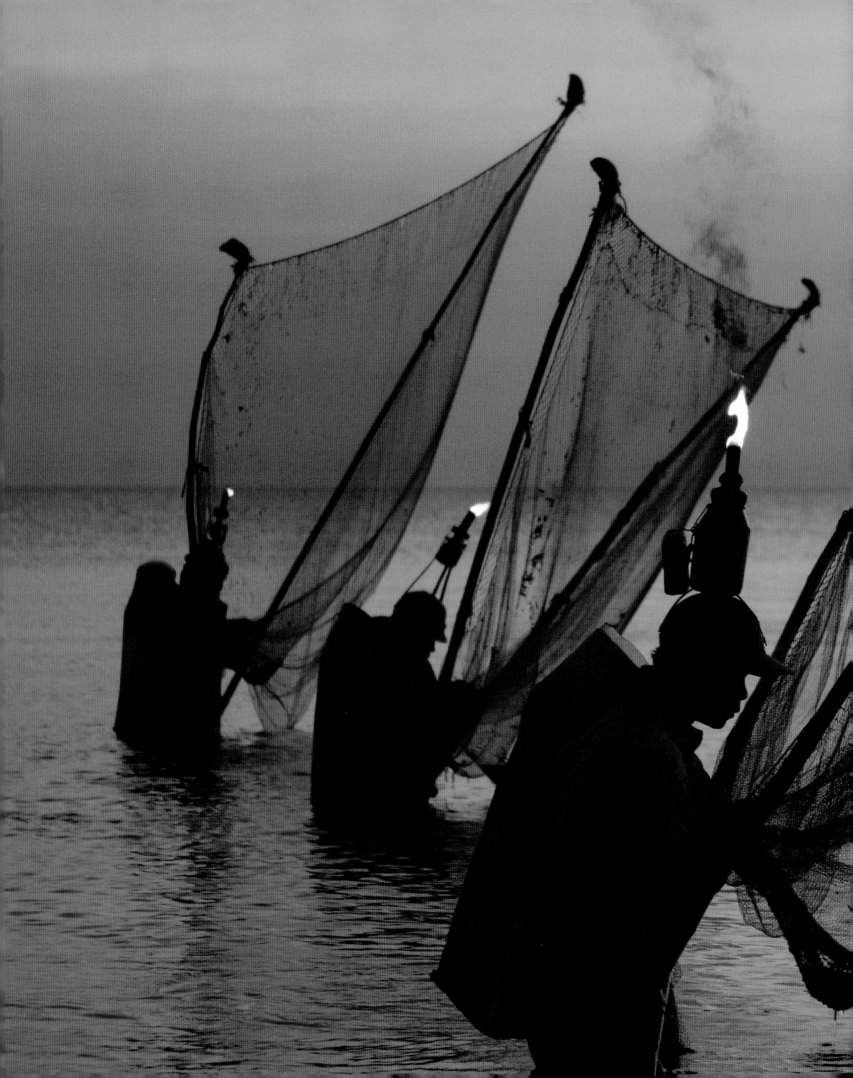

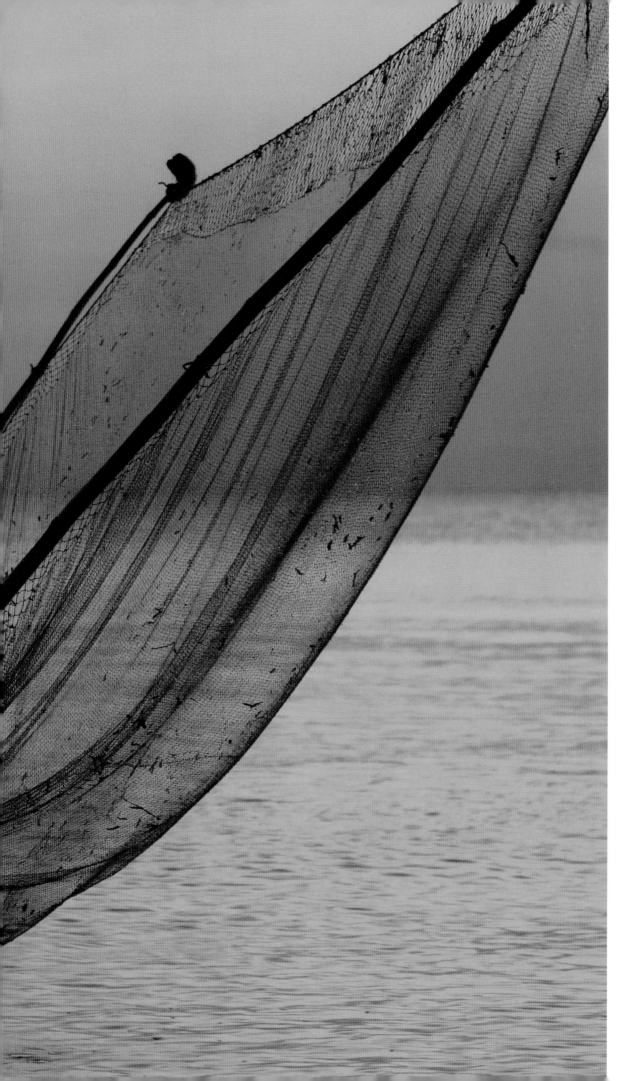

Local fishermen using 'sudsud' nets to catch shrimps in Donsol, Philippines.

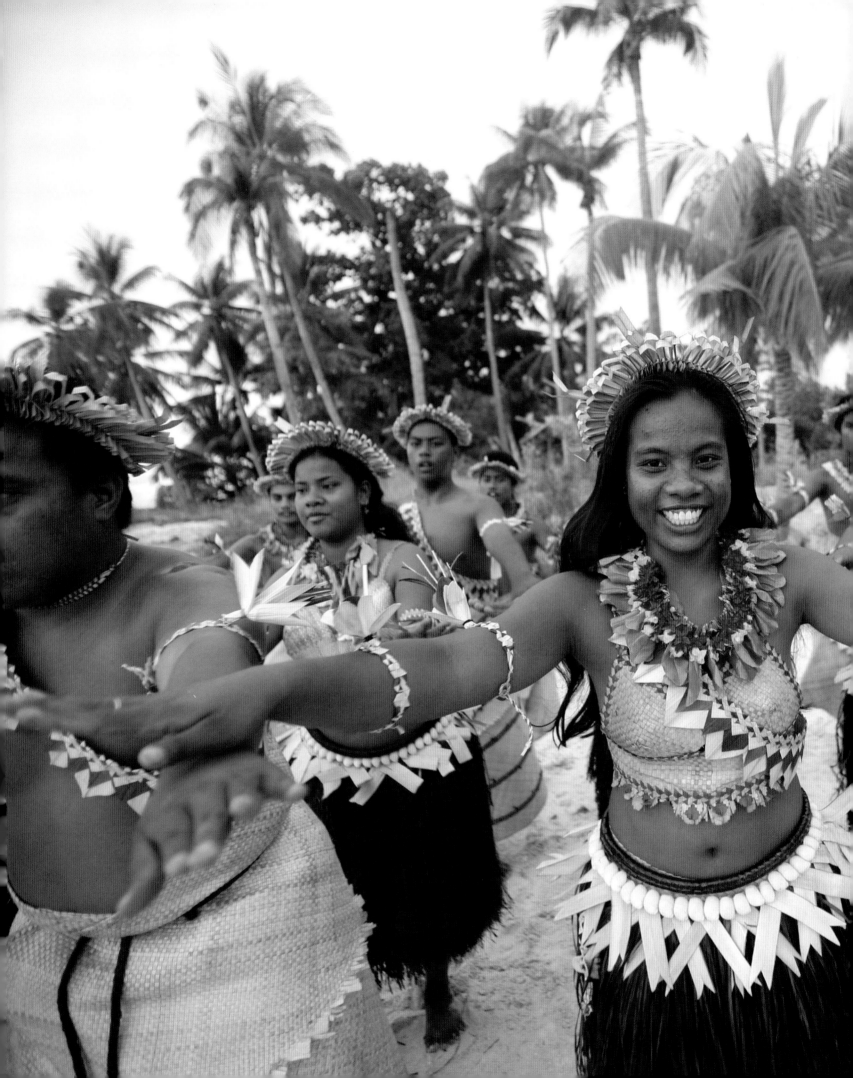

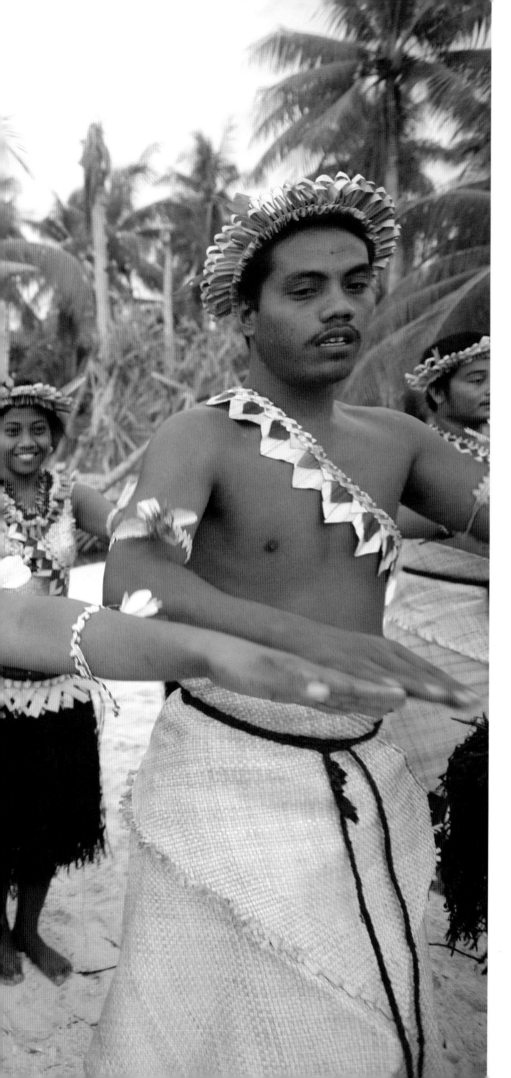

Pacific island dances (left) celebrate the oceans, while in the Philippines local people (below) make a colorful display out of their demonstration to protect the whale shark. Across the world the seas are praised in dance, song and poetry, as a source of food, money and pure pleasure (overleaf).

A young woman climbs between two fishing boats in harbor in Kiribati (right).

'A girl in every port' is an age-old sailors' cliché and it was believed that revisiting the charms of the Pacific Island women was one of the reasons that later led to the infamous mutiny on the British Navy Ship, the Bounty. But history continues to repeat itself in the Pacific Islands. 'Korakorea' girls – who spend time with fishermen – are as young as 14 years old and are sometimes the sole breadwinner in the family. HIV rates are increasing in the Pacific and it is feared that the foreign fleet sex trade is making the problem worse.

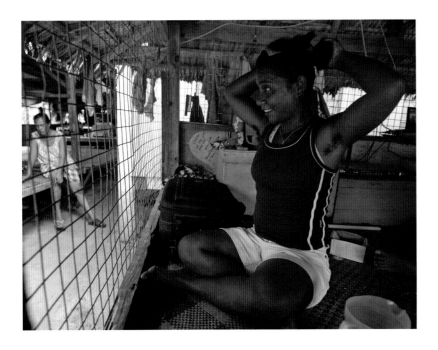

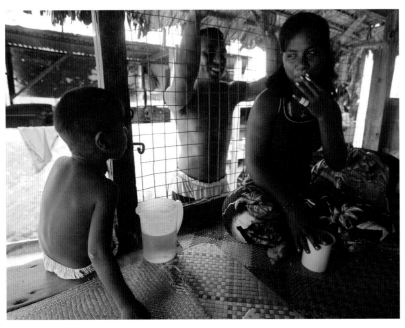

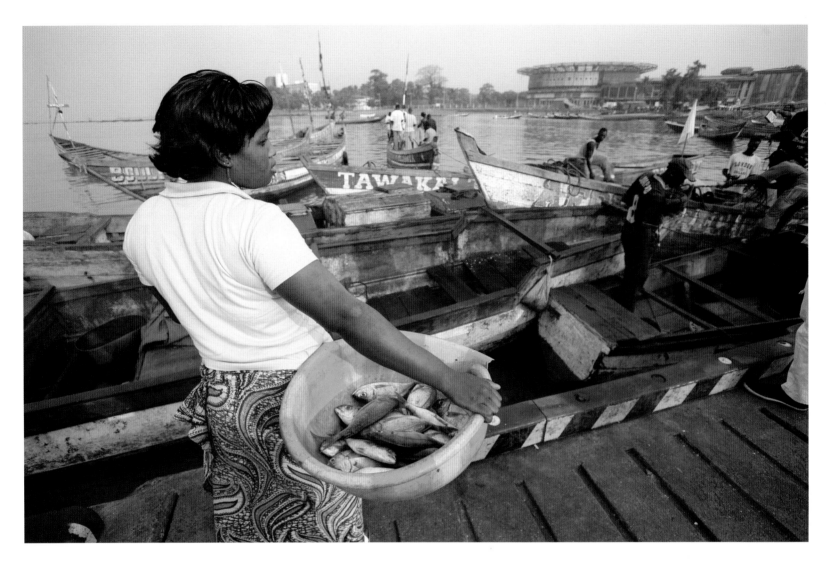

For many coastal communities, the rest of the family also relies on the sea for food and income. Wives and daughters of fishermen in Guinea, West Africa, await the daily haul (above). The fish will be sold fresh or smoked (pp 98-99), but competition with industrial fishing vessels means less fish and less money. West Africa is the only region in the world where fish consumption is falling.

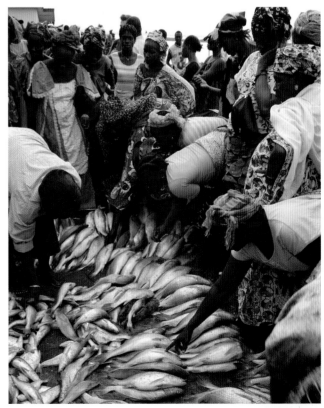

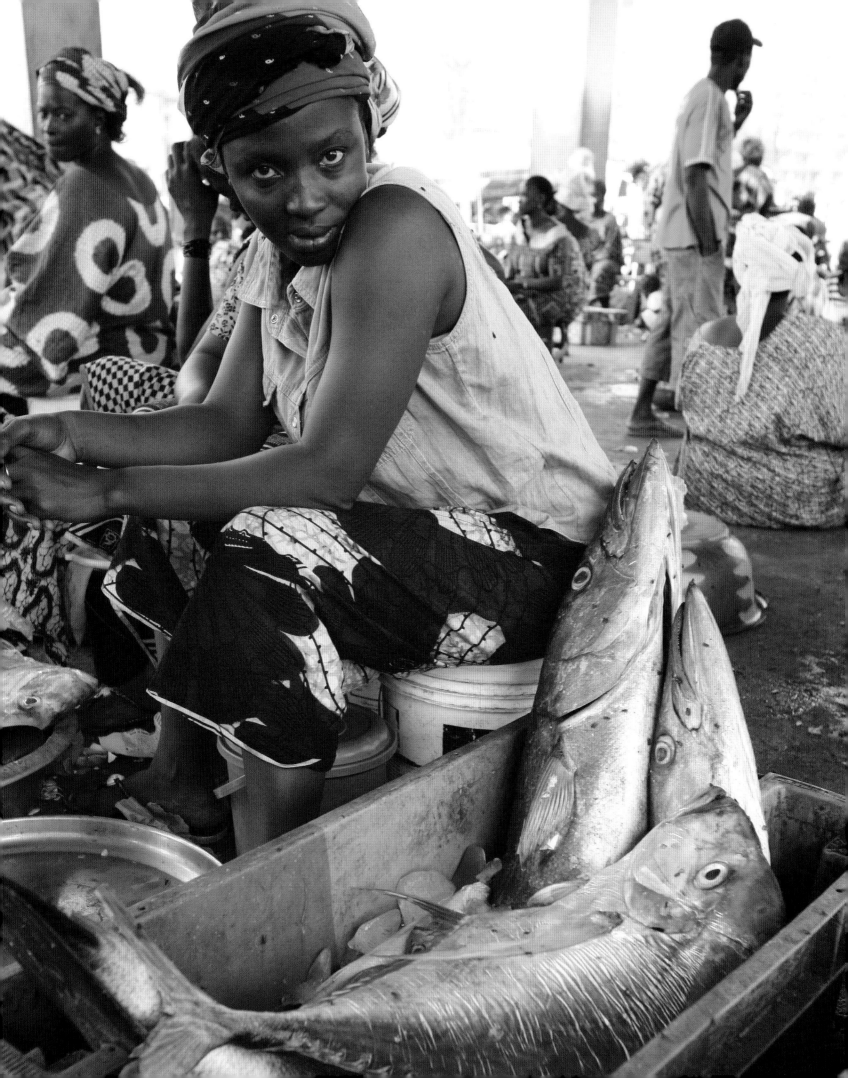

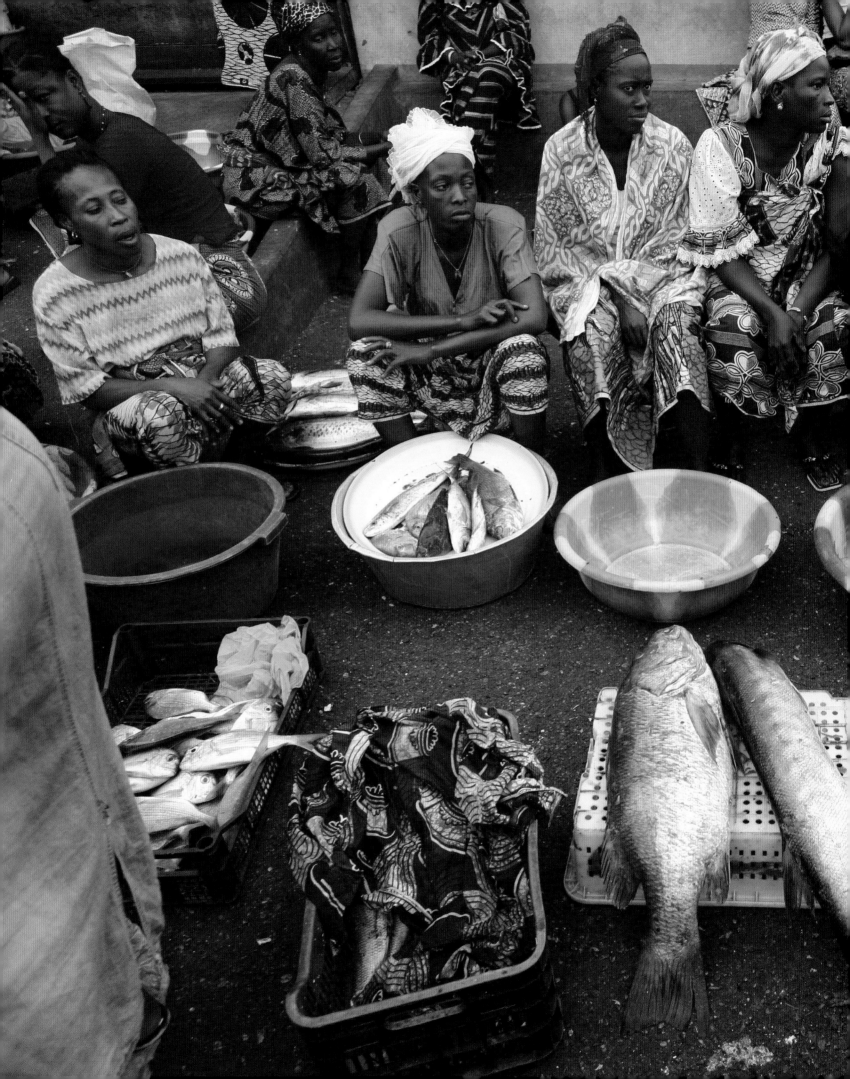

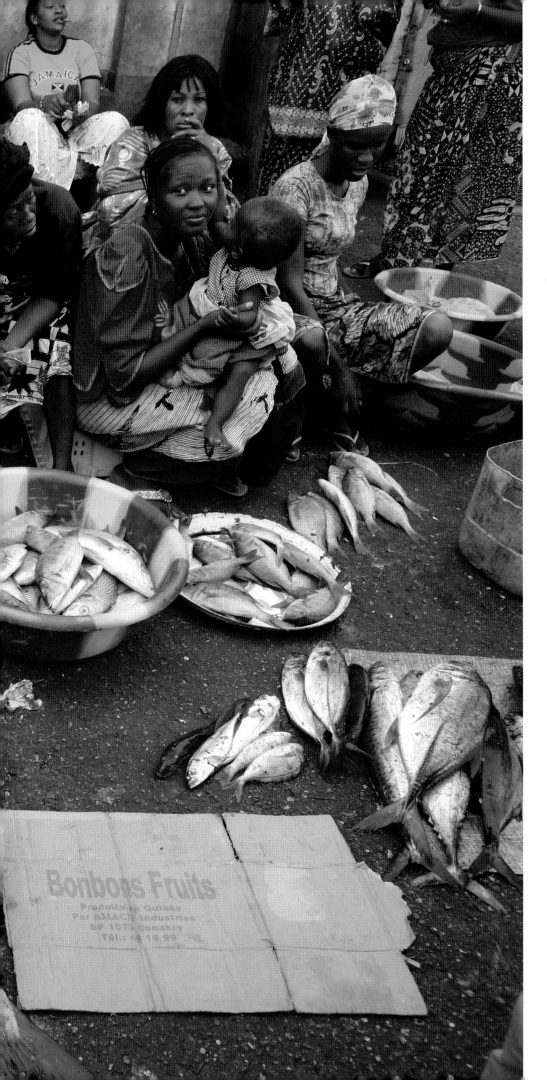

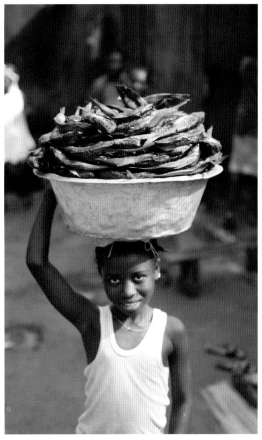

Fish market, Boublinet harbor, Conakry, Guinea.

[page 100-101] *Many fishing fleets stay at sea for years, re-supplying with food, fuel and crews at sea. But these rusting vessels – dubbed 'zombie ships' and found off West Africa – are permanently moored over a hundred miles off shore. Working almost like dormitories for the operating fishing fleet, some crew are left stranded and unpaid for months on end. They have no functioning engines or radio and are only left supplies of food occasionally. The vessels are collapsing with rust and at least one rotting hulk sank in a storm, drowning 14 men. Lying beyond the horizon and out of sight of land, conditions on board are rarely scrutinized. These floating hostels would be shut down if they were operating on land.*

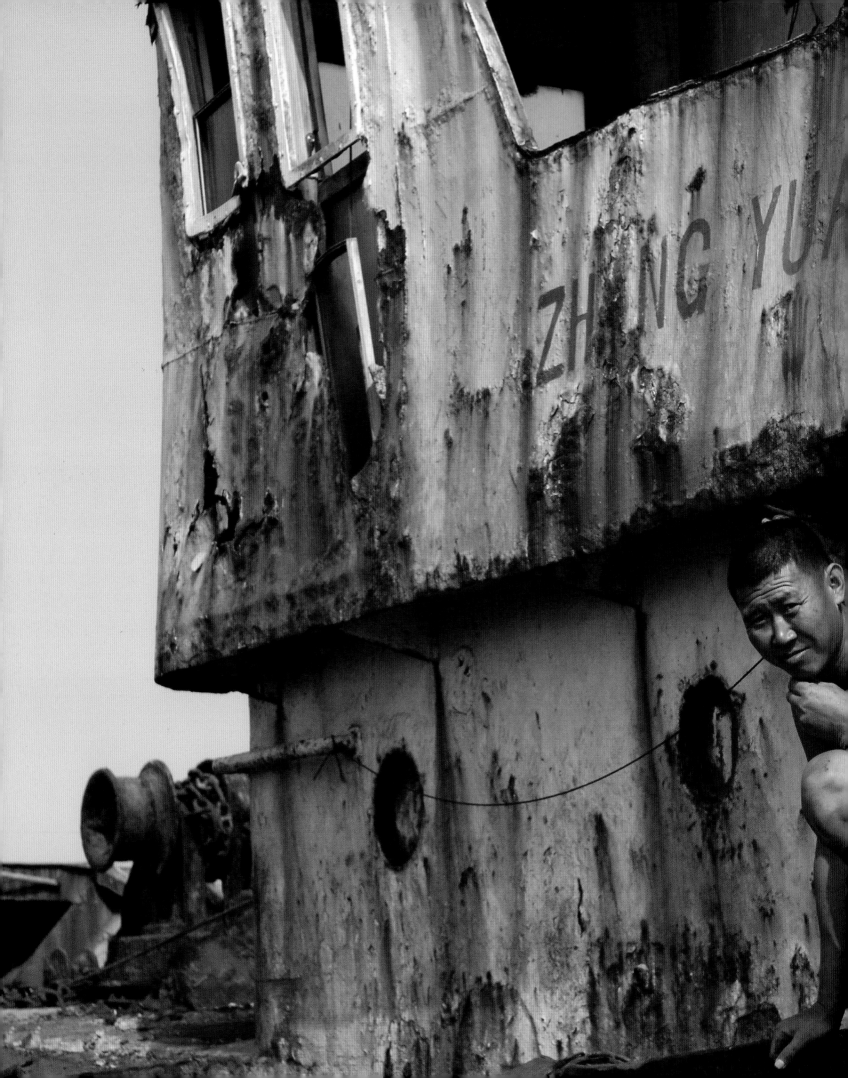

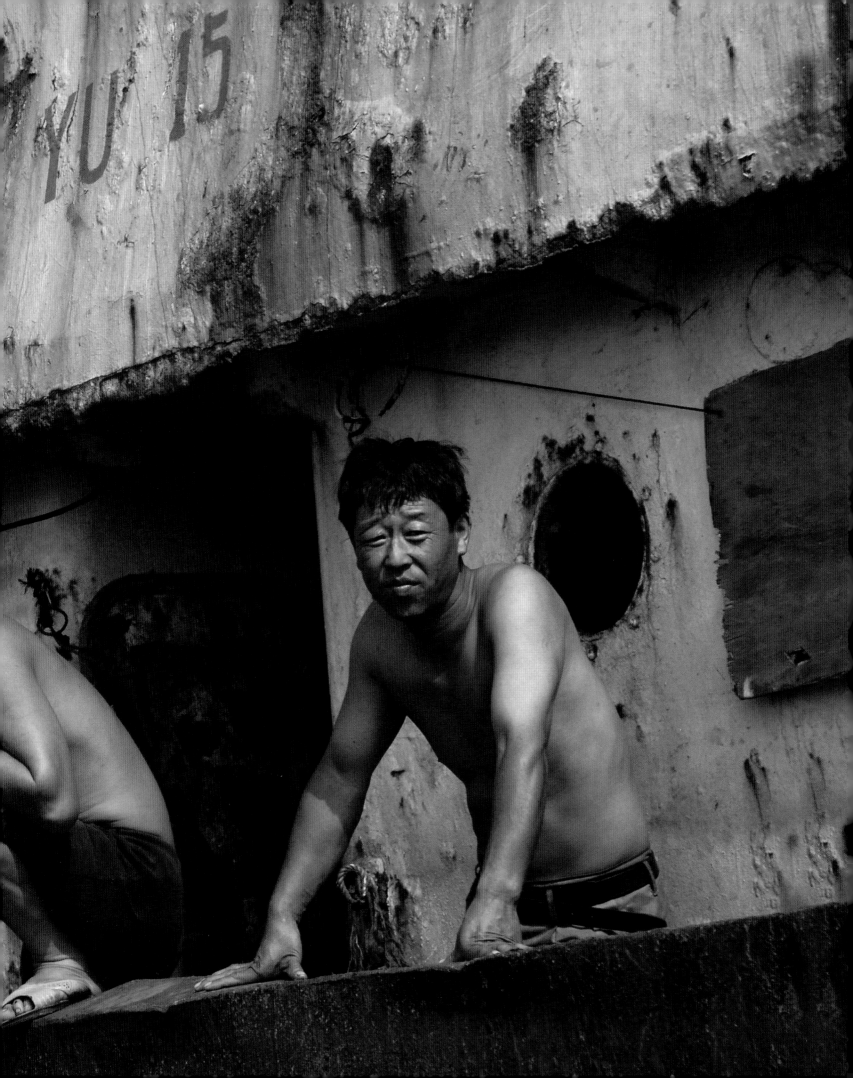

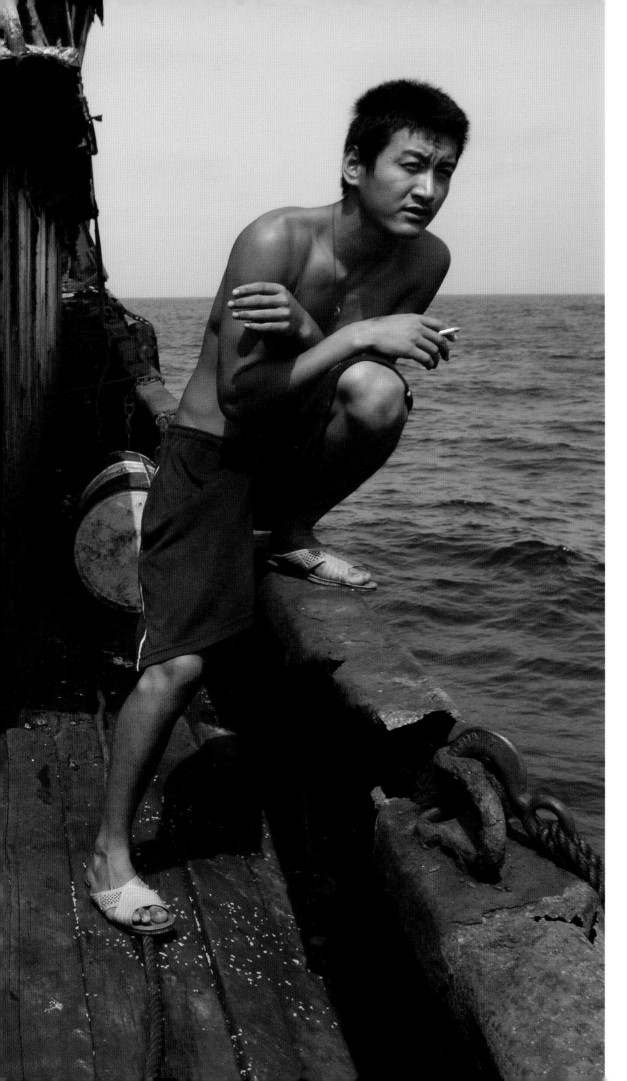

Workers are only paid when they are fishing, but some have been marooned for months on ships that have no working engines. Their contracts mean they won't see home for two years.

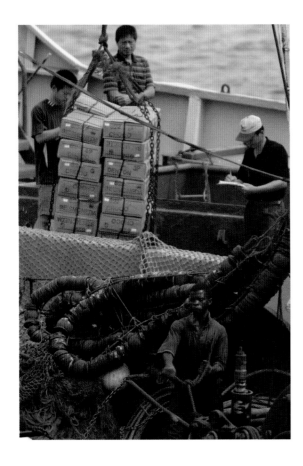

Pirates are not only in the Caribbean! Pirate fishing vessels, those that break, bend or just ignore the rules, steal up to $9 billion worth of fish from the oceans and legitimate fishers every year – as much as 20 per cent of the total global catch. Ship names are hidden and the catch is off-loaded onto freezer ships far out to sea, away from the scrutiny of inspectors. Most of us eat stolen fish at one time or another. Ironically, local crews (right and above) are often hired to work on the foreign boats that are stealing fish from their communities.

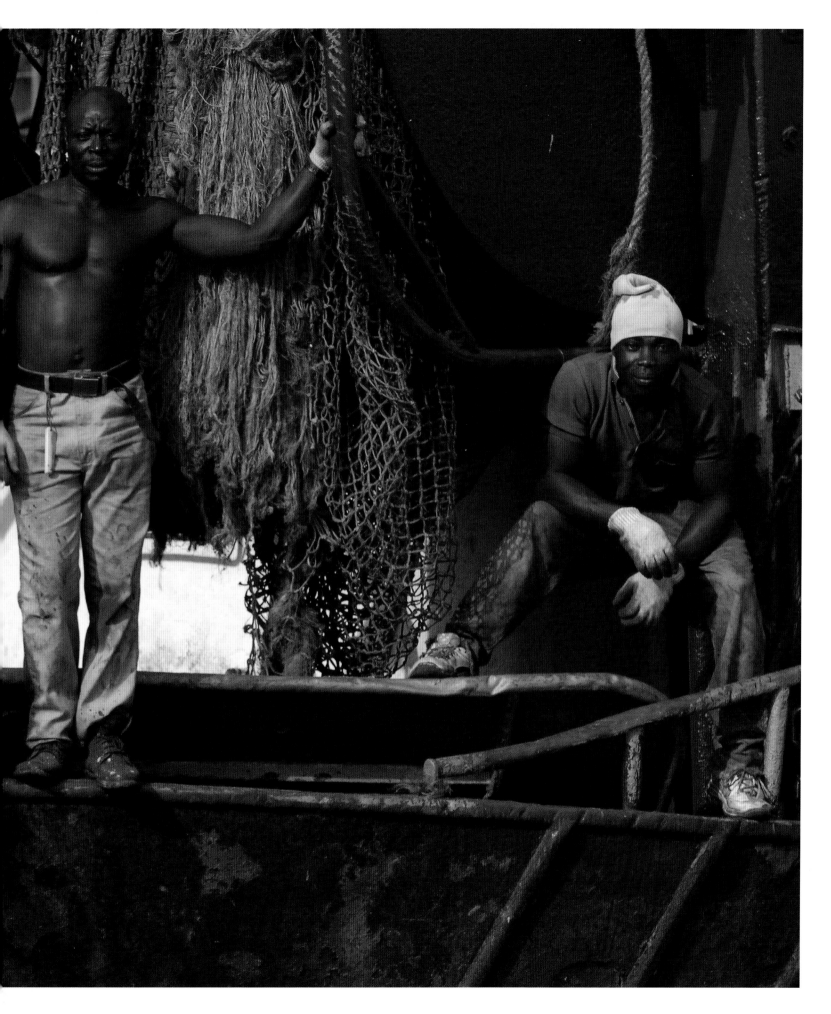

We dump three times more rubbish into our oceans than the amount of fish we take out, graphically illustrated here in Manila Bay where a local boatman has to swim through some of the thousands of tonnes of rubbish discarded each day.

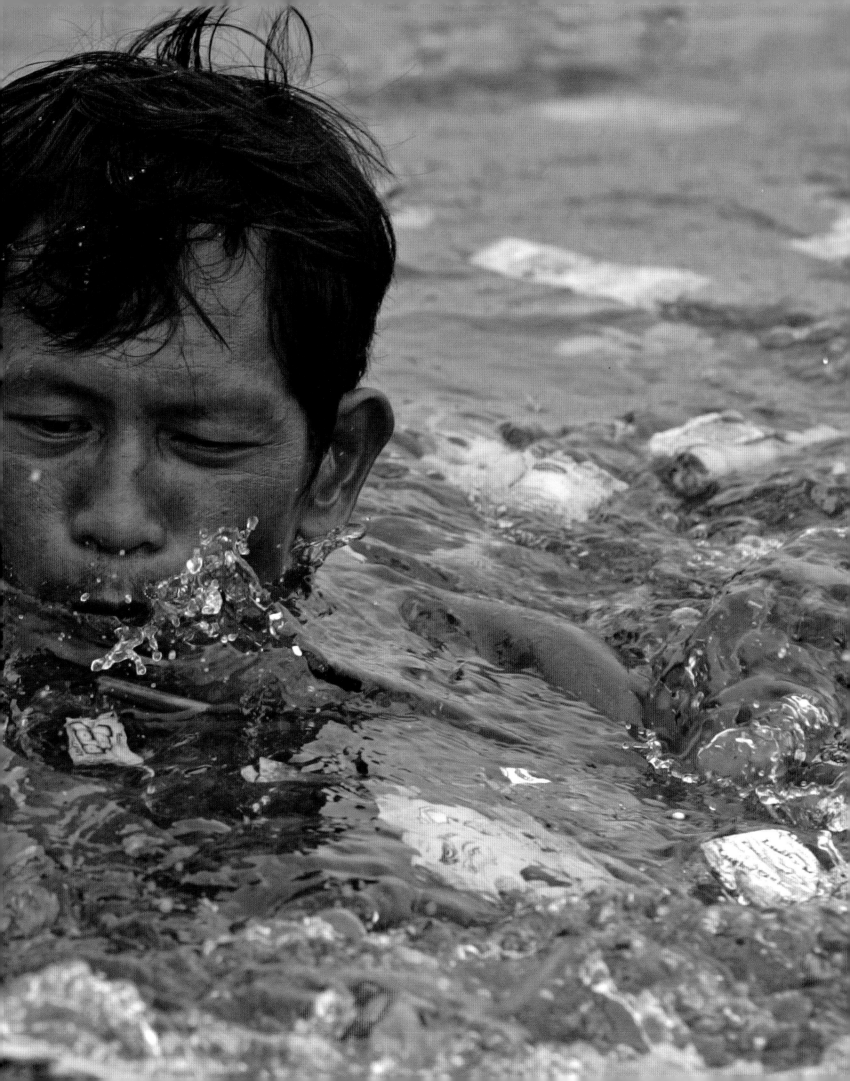

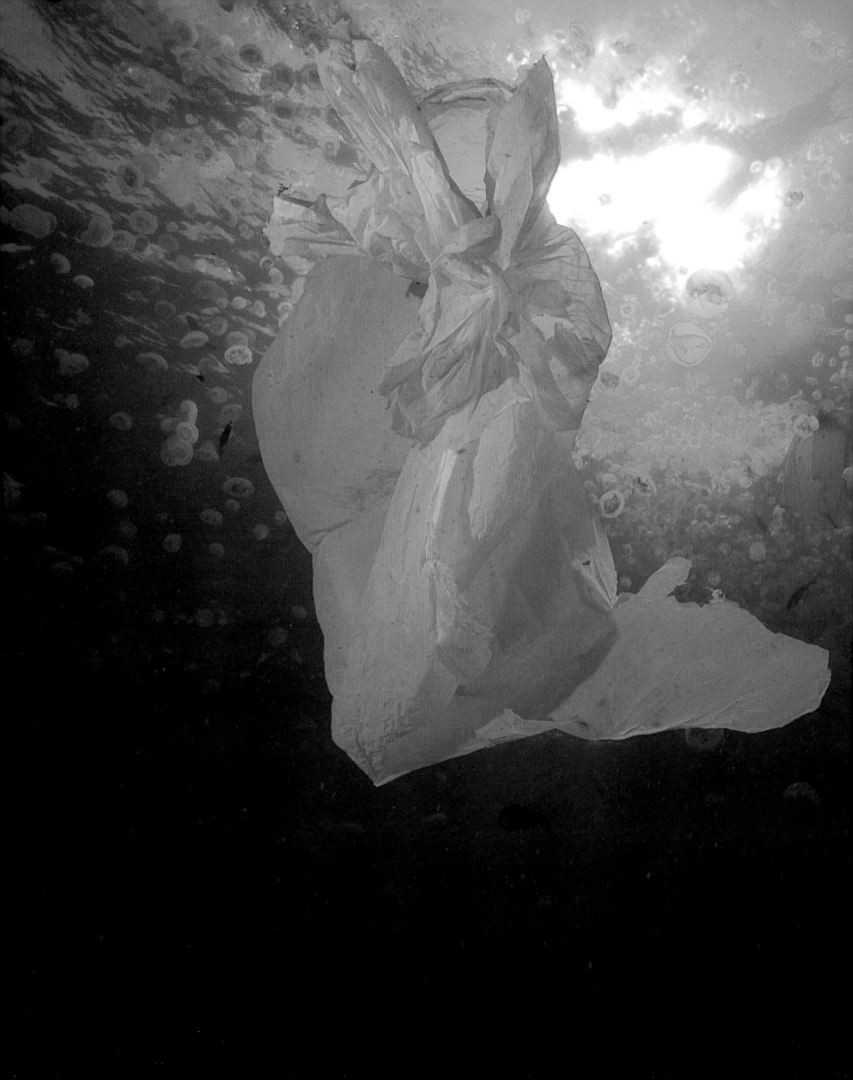

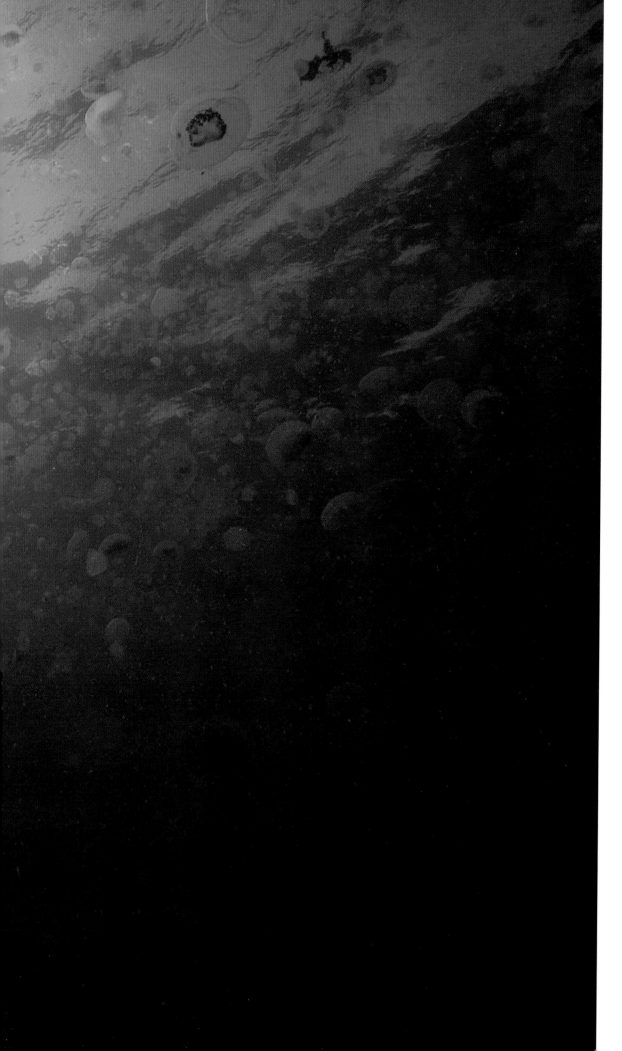

The oceans aren't just fish and water.
Easily mistaken for a jellyfish or
other tasty morsel, this plastic bag
is just one of the millions of pieces of
garbage left floating in the ocean,
snaring and choking animals such
as turtles, albatross and sea lions
that fatally misjudge its shimmering
appeal. In the Pacific a 'trash vortex'
collects plastic from around the
world in an endless cycle.

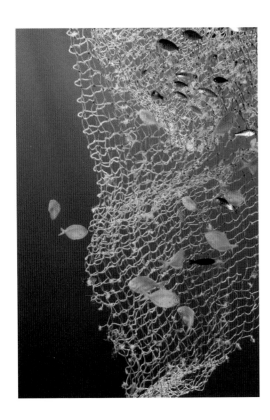

Rubbish that has found its way from Japan floats alongside discarded 'ghost' nets (above), trapping the sea life that had successfully dodged the fishermen's haul. Millions of tonnes of garbage and particularly plastic, pollute the seas, with adverse effects for the people who rely upon them.

[page 112-113] The glazed-over eye of a swordfish tells the deadly story of illegal driftnets. These hang like walls of death and are left floating in the water to indiscriminately entangle anything that passes by. Whales, dolphins, turtles and countless fish become wrapped in the nylon, drowning before they can break free.

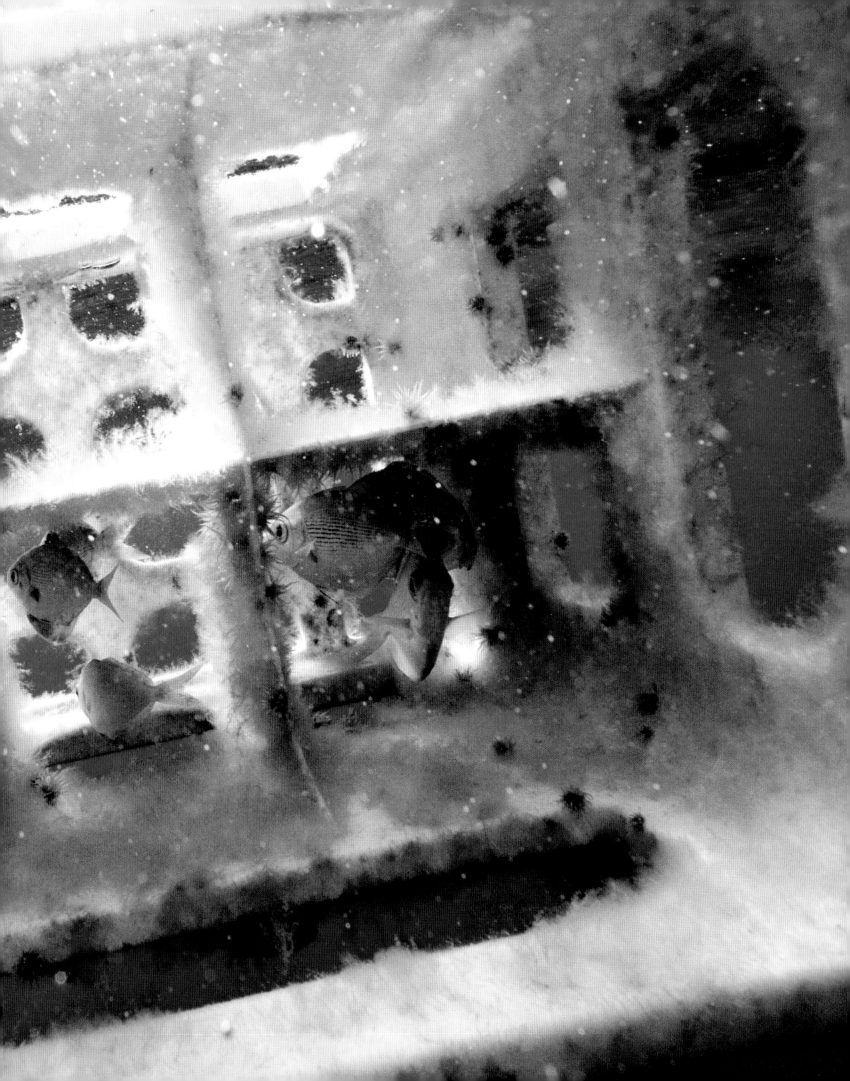

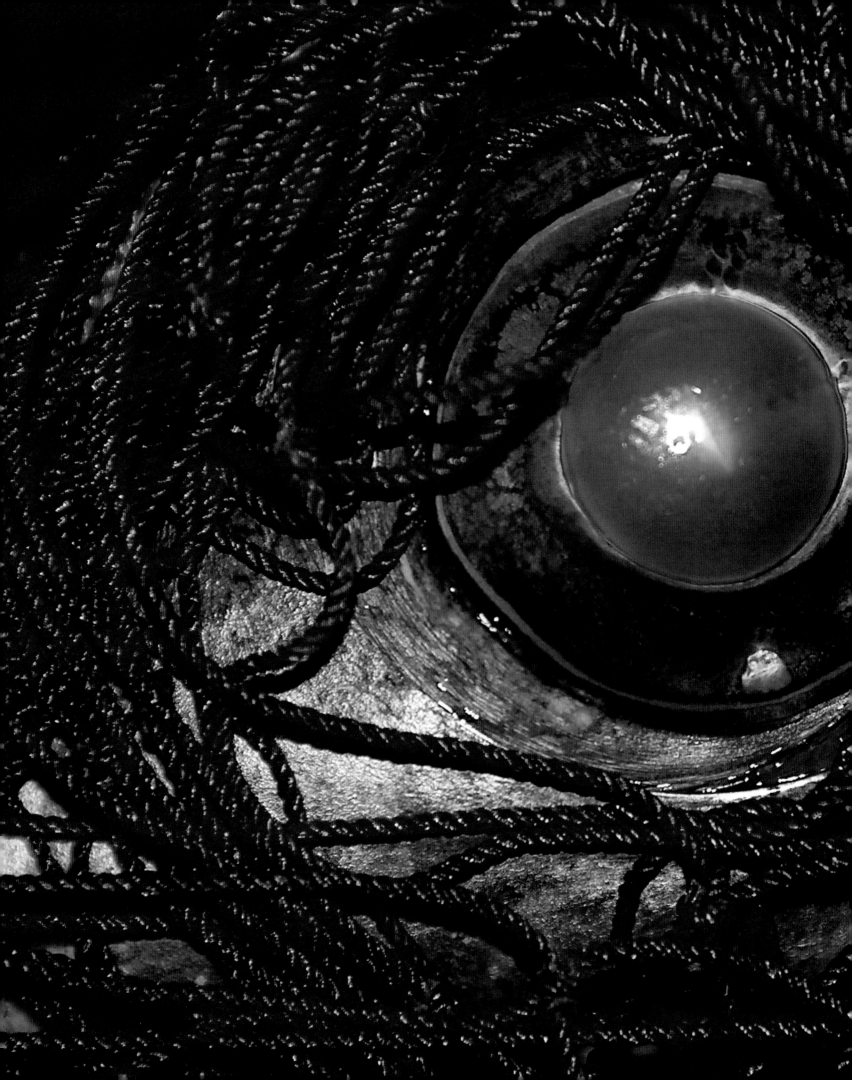

Catastrophic oil spills always guarantee that our environmental footprint on the oceans makes headlines. In the Philippines in 2006, its worst-ever oil spill was declared a national disaster. Shellfish beds, mangroves and entire communities were devastated.

What is rarely reported is that more oil reaches the oceans each year from land based sources than from dramatic shipping accidents. Leaking vehicles in cities, together with other indirect sources put more oil into the seas annually than the 11 million gallons spilled in 1989 in Prince William Sound by the Exxon Valdez.

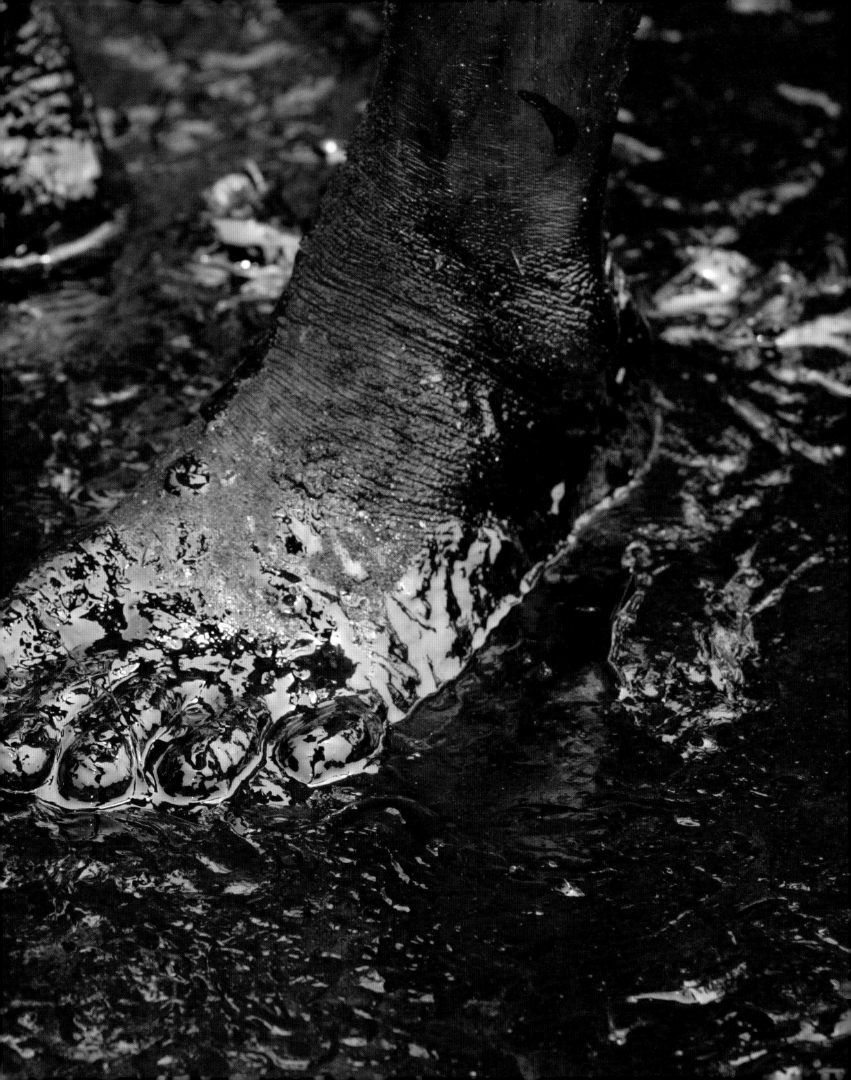

Light filtering down through the water illuminates a school of dolphins in the Red Sea. Most species live in shallower waters of the world's oceans, but have also been recorded diving to over 300 meters/about 1,000 feet down.

CHAPTER 4
SECRETS OF THE DEEP

More people have orbited in space than have descended into the deep ocean. Globally, only a small fraction of the oceans has been explored at all and each new foray brings new discoveries and new species. It is not surprising that our knowledge is so limited when the average depth of the ocean is more than five times greater than the average height of the land above sea level. Just getting down there involves stretching human ingenuity and technology to the limit.

Some of the things we do know about the oceans seem to make nonsense of all we have learned about natural sciences in our terrestrial habitat. For instance, the speed of sound in water is nearly five times faster than the speed of sound in air. While almost all life on Earth needs light to grow and thrive, whole communities of strange deep-sea species can survive entirely on chemicals dissolved in the hot, mineral-rich waters released from the seabed at hydrothermal vents.

The oceans have revealed strange creatures bursting with color, sponges that look as hard as rock and corals so delicate they bend in every current, fish with special lightbulbs to draw in their prey and creatures with spectacular neon displays. We have explored less than one per cent so far and each expedition has the potential to bring further finds. The multi-million dollar Census of Marine Life program is making new discoveries every year and has also documented a huge range of species such as furry lobsters – shrimp thought to have become extinct 50 million years ago – and a school of fish the size of Manhattan.

Seamounts are one of the biggest secrets of the deep. These are underwater mountains with peaks rising over 1000 metres/3000 feet from the seabed. There are as many as 100,000 scattered across the oceans, the majority in the deep sea. Yet only 200 seamounts have been studied in any detail so far. Some of these reveal what seem to be unique collections of species in isolated and fragile ecosystems, which once damaged, may never be replaced. In the modern age of discovery, the deep oceans can rightly claim to be one of the last frontiers of exploration.

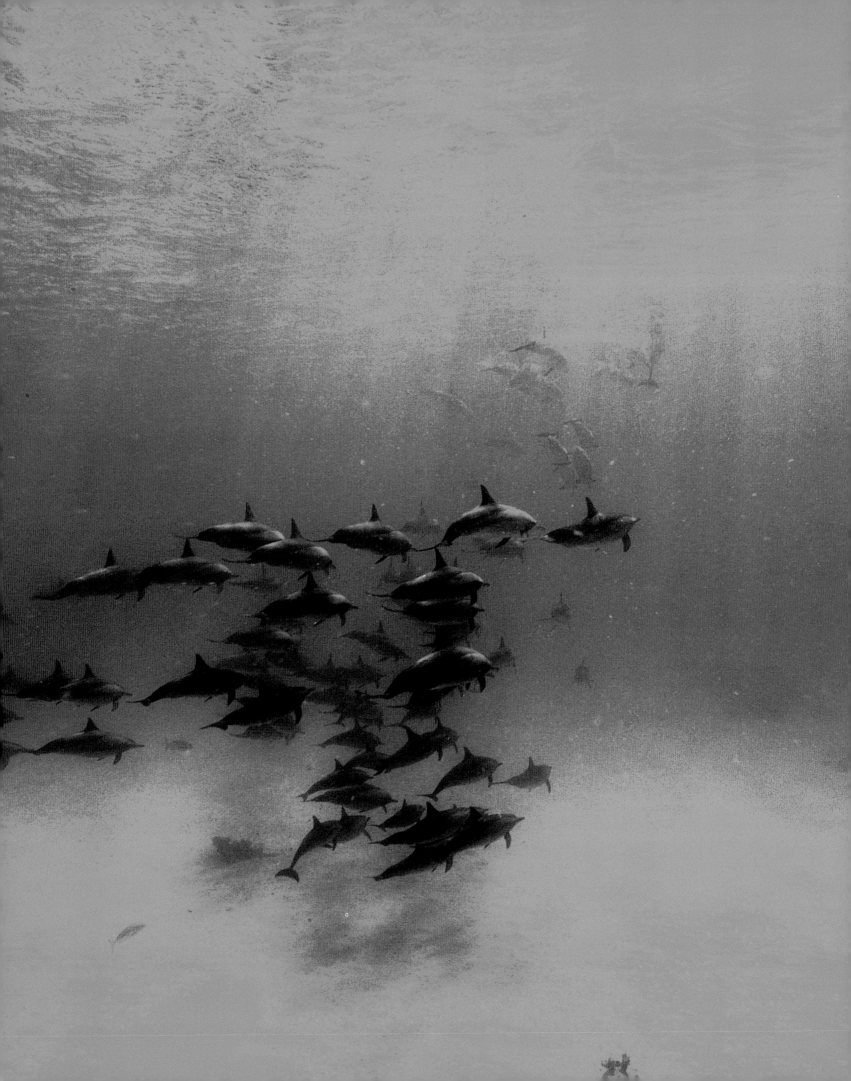

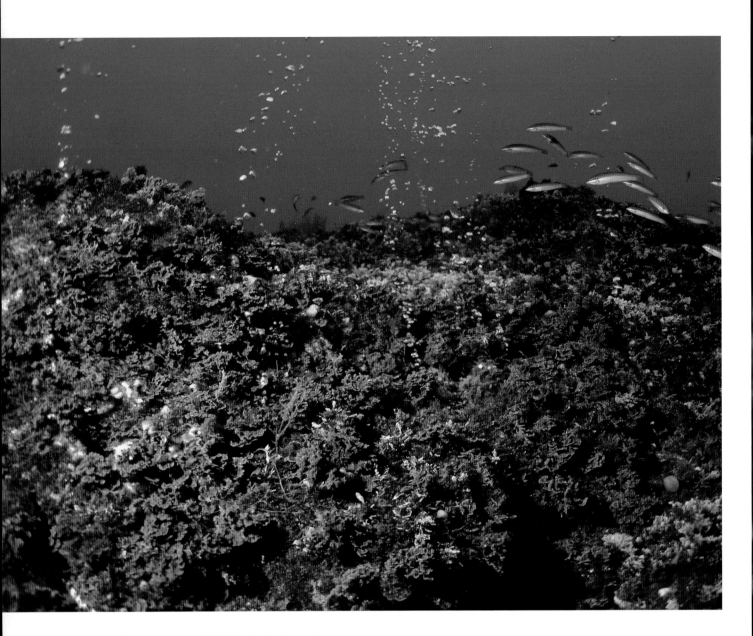

The rich soup of nutrients around bubbling hydrothermal
vents (above) attracts a range of marine life, including
tubeworms (right). Hydrothermal vents are found thousands
of meters below the ocean surface.

[page 120-121] Almost flower or feather-like in appearance, tube worms are not only
beautiful but are one of the fastest growing of all marine species. Tube worms thrive close
to hydrothermal vents – mini underwater volcanoes. Gripping the side of the vent, their
tentacles sway in the warm currents, reaching out to grab passing microscopic food and
quickly retract at the first sign of danger.

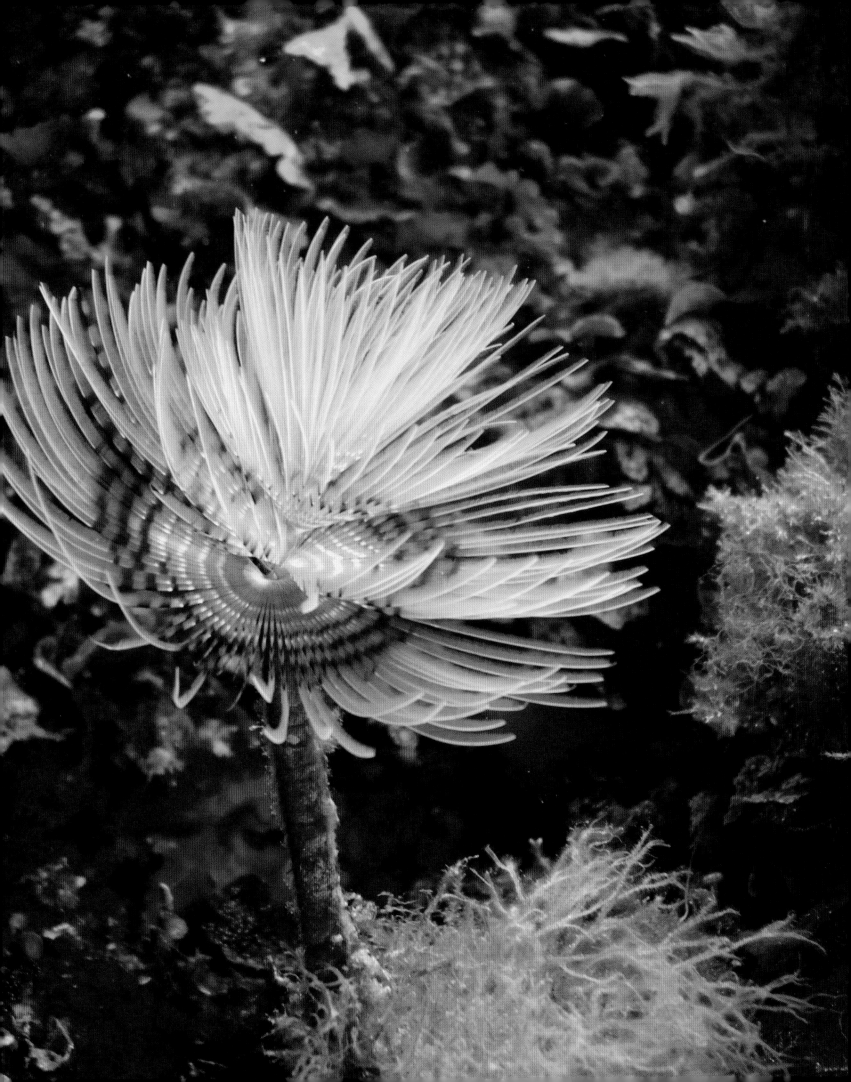

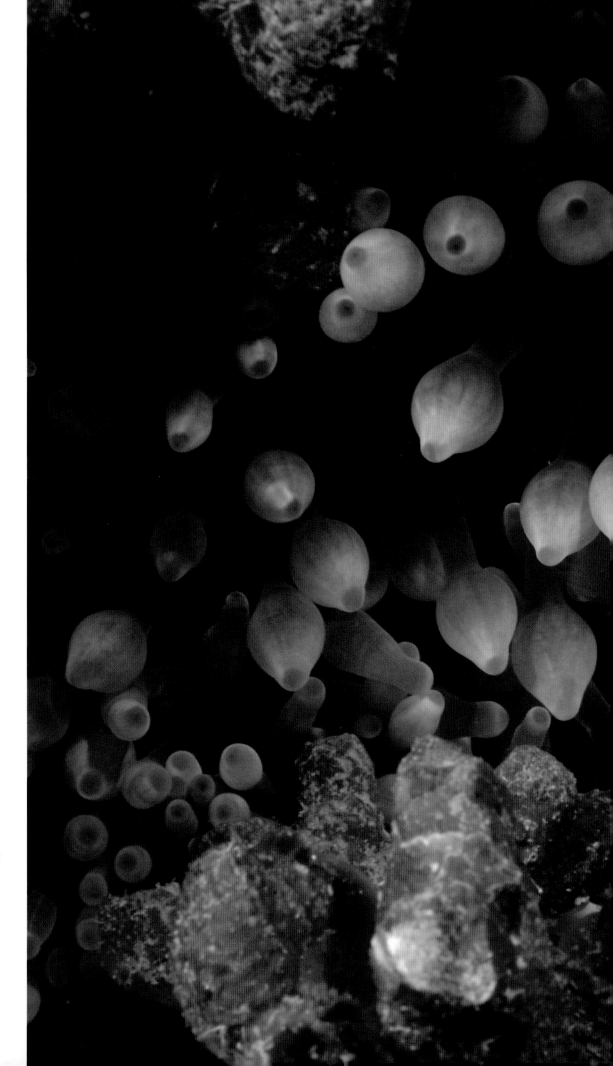

Clown fish are immune to the stings of the sea anemone, which are fatal to other fish. In return for protection from predators, the clown fish offers a cleaning service to the poisonous anemone, seen here in the Apo Island Marine Reserve in the Philippines.

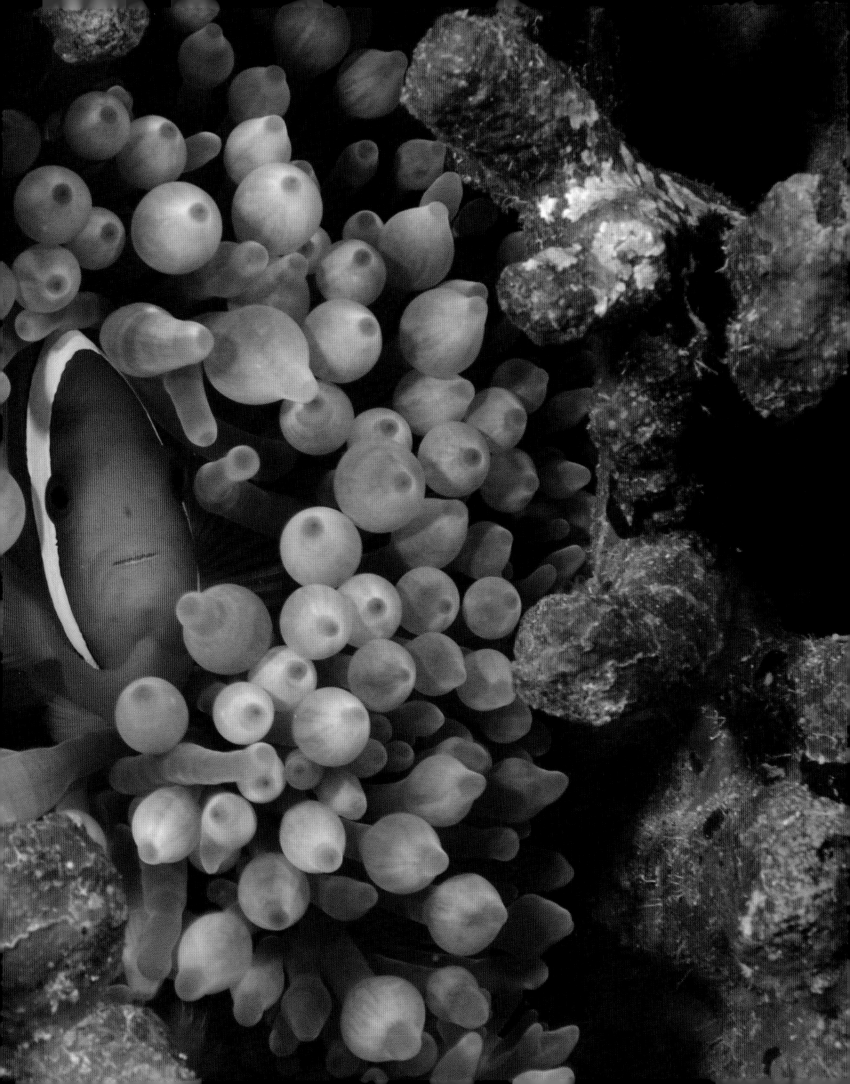

Coral (left) is so close in chemistry to human bone that it is used for bone grafts. Taking all kinds of shapes and sizes, they can be incredibly slow-growing and extremely sensitive to disruption.

These deep-water corals (below) , far beyond the reach of sunlight, are growing at depths of 240 meters/800 feet around the Azores and have never before been documented. Special remote cameras were needed to search and photograph the ocean floor.

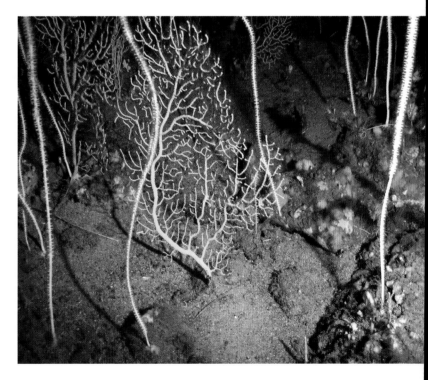

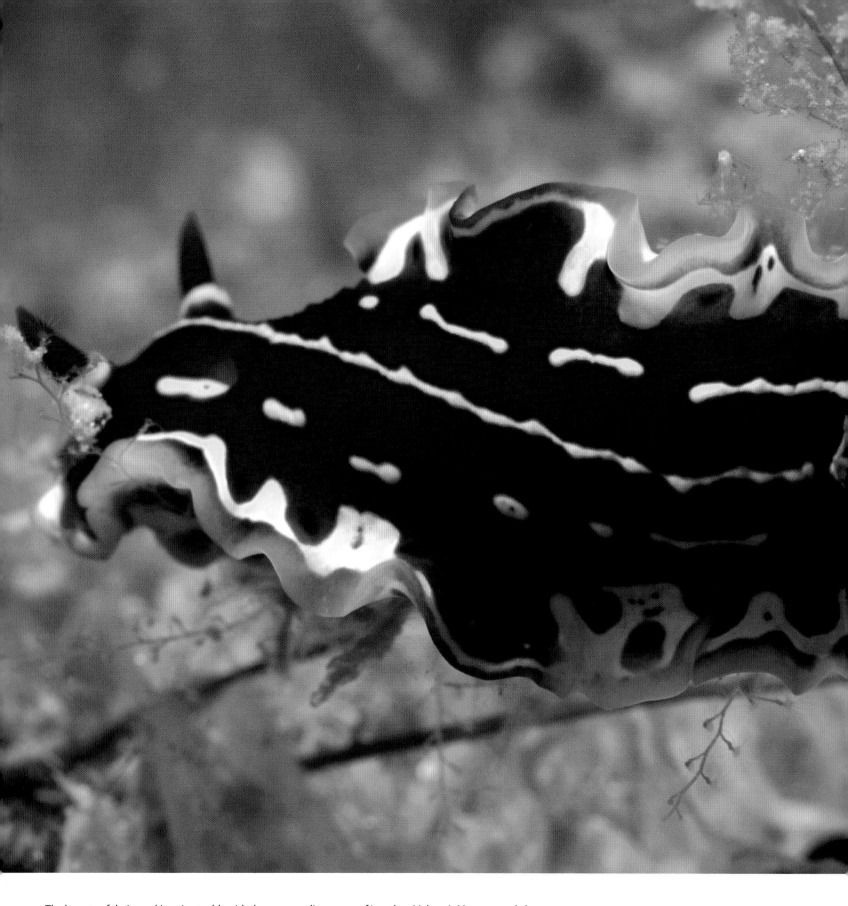

The beauty of their markings is at odds with the unappealing name of 'sea slugs' (above). More properly known as 'nudibranch', their feeding habits are also rather unappealing. Carniverous feeders, they will eat sponges, hydroids, barnacles and even each other. With no hard-shelled protection they avoid predators by camouflaging themselves or by exuding poisonous chemicals when they come under attack.

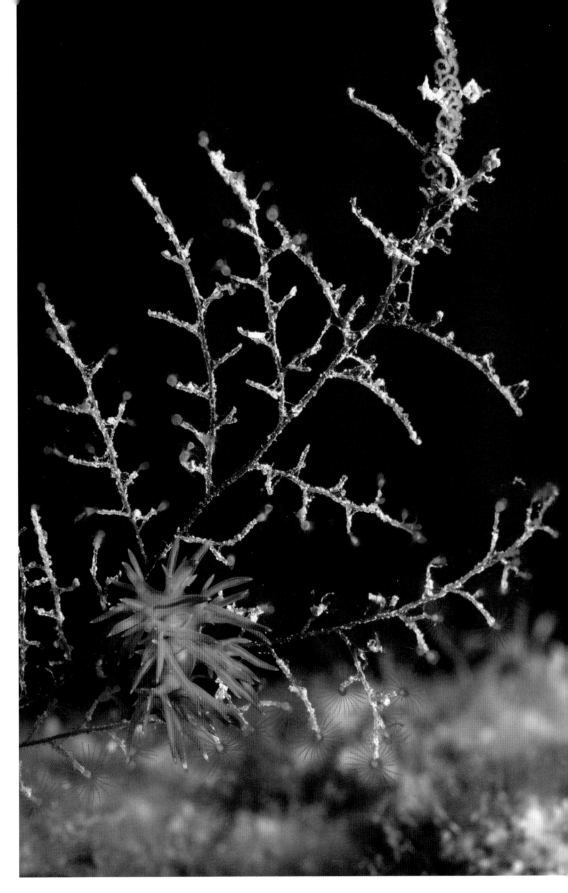

They are found in every ocean and come in a range of shapes and sizes.
This lilac colored sea slug (above) has already eaten its way through
much of its host hydroid and left a purple chain of eggs at the top.

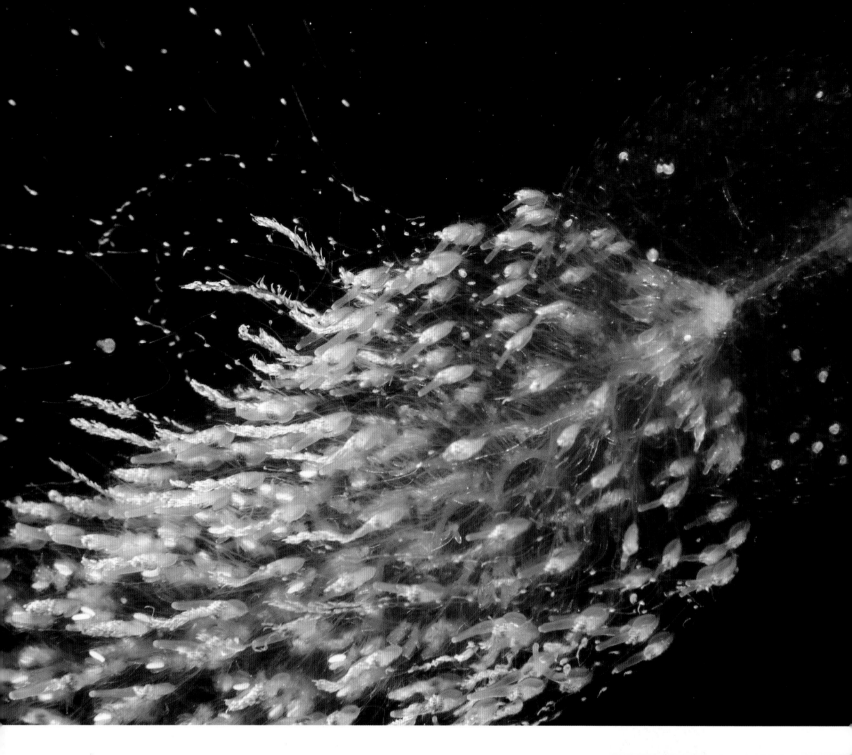

Luminous salps are free floating, often in vast colonies in the deep water of the Azores. They feed themselves by sucking in plankton and power themselves by pumping the excess water through their bodies.

Salps are the only animals to produce cellulose – otherwise uniquely produced by plants – and have been found to contain chemical compounds that may prove to be a key to some cancer treatments.

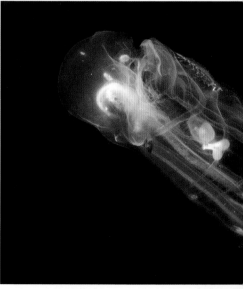

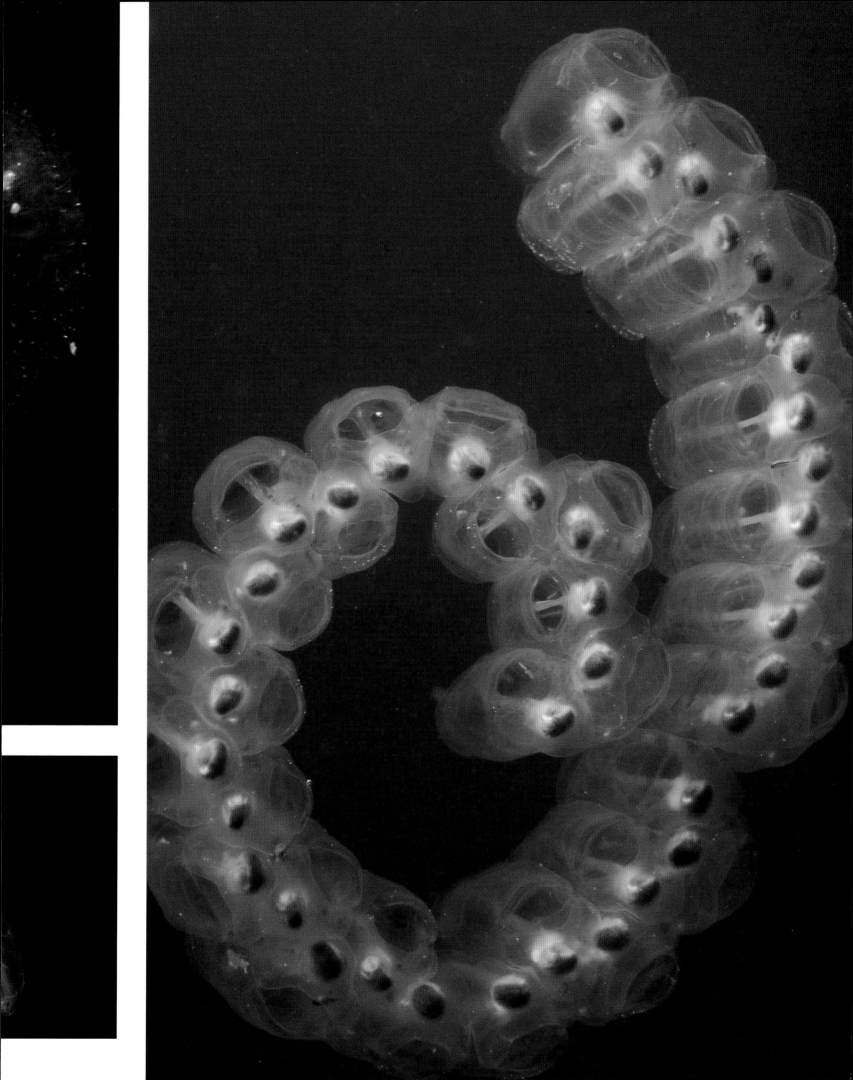

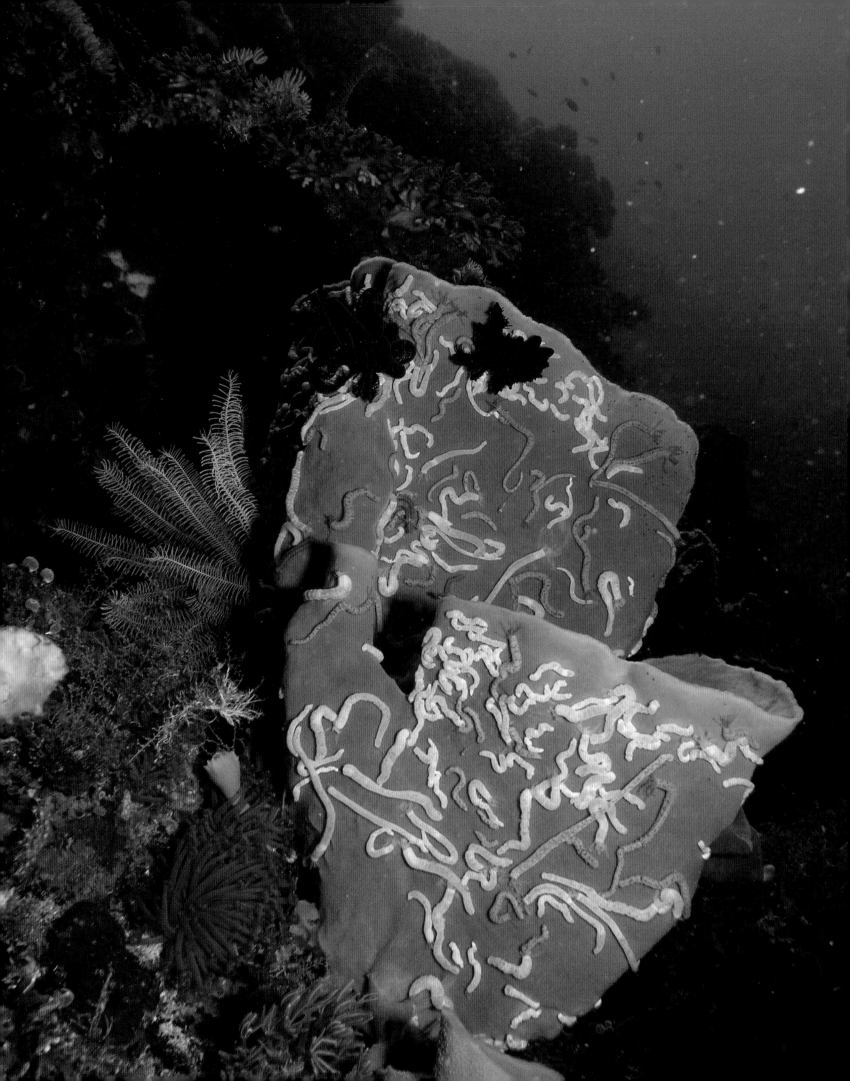

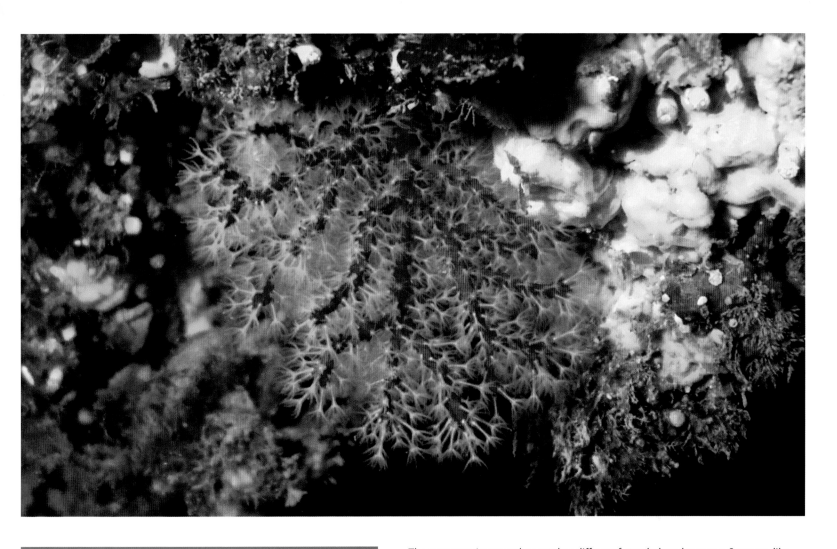

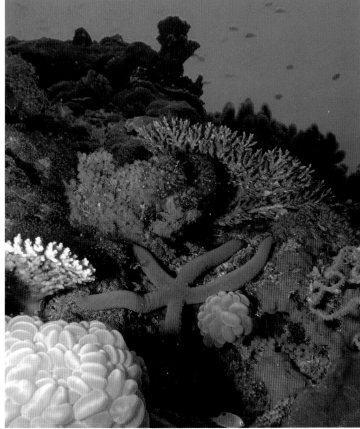

The same species can take countless different forms below the waves. Sponges, like corals, come in an almost endless variety of shape, color and size. Sponges are in fact extremely primitive, with no muscles, nerves or internal organs. They live in both shallow waters and in the deepest ocean and are filter feeders – sucking in water and filtering out the nutrients.

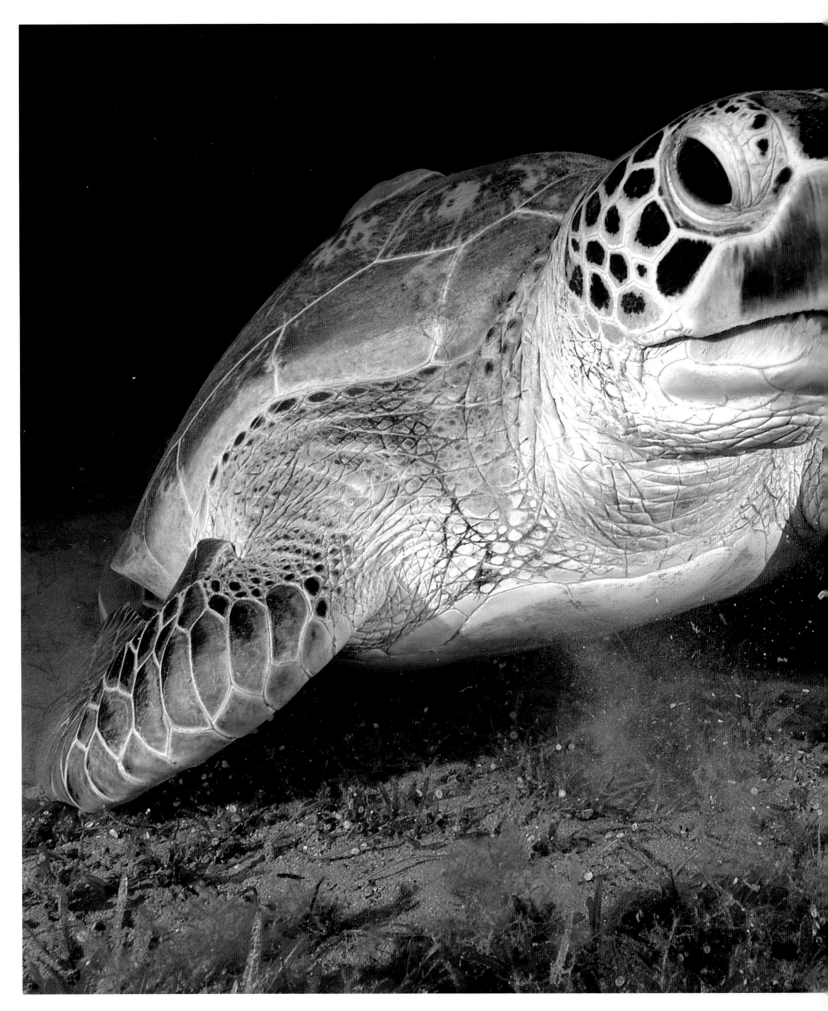

Sea turtles can hold their breath for several hours. Leatherback turtles can dive to depths of 1,000 meters (over half a mile), though shallower depths are the norm for smaller sea turtles such as this hawksbill in the Red Sea.

'Cleaner' fish known as remora hitch a ride with the turtles by means of a suction cup on the top of their heads. In return they nibble parasites from the turtles' bodies.

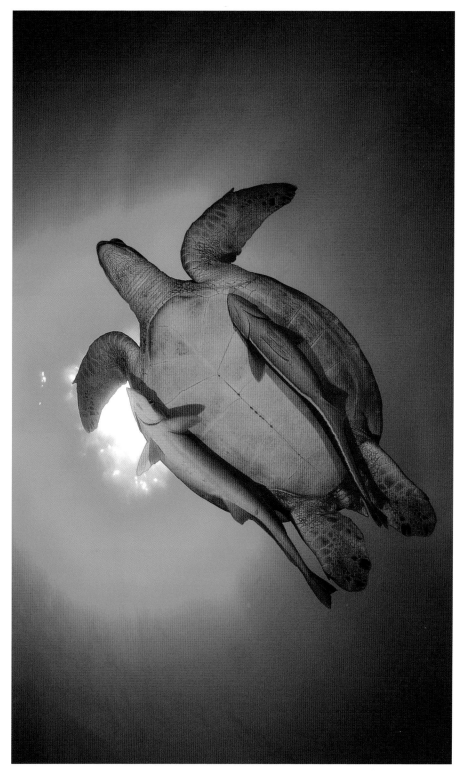

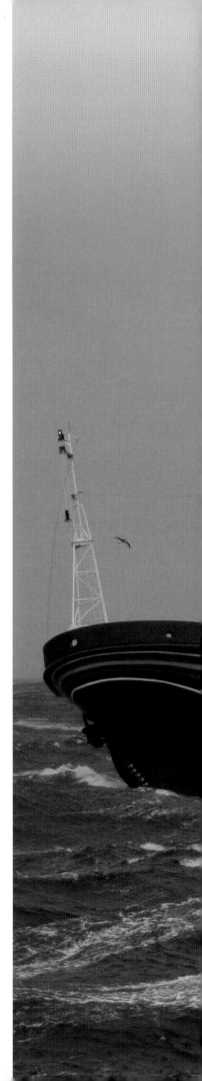

The Esperanza *ploughing through one of the many storms that rage through the Southern Ocean. Sometimes the oceans don't show much sign that they appreciate the help being offered.*

CHAPTER 5

DEFENDING OUR OCEANS

The oceans give life to our planet and to us. In return we are suffocating them; trawling up too many fish, stealing food from hungry mouths, recklessly killing countless creatures including whales, turtles, sea birds and corals. Human-induced climate change warms the oceans and changes their circulation patterns, undermining their capacity to support life. The waste gases from power generation acidify the oceans and chemical pollution spreads throughout their waters. Even so, they are resilient: full of beauty and wonder. The current onslaught can be reversed. Greenpeace has a simple message: defend our oceans.

A grey-headed albatross can circle the globe in 46 days, bluefin tuna can cross oceans in a matter of months and great whales can travel from the pole to the equator in just one season; it took Greenpeace a little longer! Over 16 months the Defending Our Oceans campaign, on board the *Esperanza*, sailed the oceans. At times she teamed up with her sister ships, *Arctic Sunrise* and *Rainbow Warrior*, to highlight the rare beauty of the seas and challenge the all-too-frequent threats they are facing.

With a multinational crew and state-of-the-art technology, the ship was well equipped. But it was not always plain sailing. We dodged hurricanes and volcanic eruptions, as well as earthquakes, devastating oil spills, and even a war. We stopped at more than 30 ports and covered thousands of miles. Many people visited the ship and well over a million people visited the ship's website. The expedition gave a unique insight into the perilous state of our oceans: slaughter of whales in the Southern Ocean Whale Sanctuary, devastating pollution, the social and environmental threats of pirate fishing, the reality of overfishing and the wreckage caused by habitat destruction. This unique journey has brought the story of our oceans back to the land.

The expedition is over, but the work continues. A global network of properly enforced marine reserves covering 40 per cent of the world's oceans is key to protecting the oceans. It is estimated that it would cost $12 billion each year to give that kind of protection. At first glance this seems like a lot. But Americans spend an estimated $20 billion each year just on ice cream, while Europeans spend $11 billion. Globally we hand over $18 billion worldwide for face creams and $15 billion for perfumes. Hold your breath. Which would you rather have?

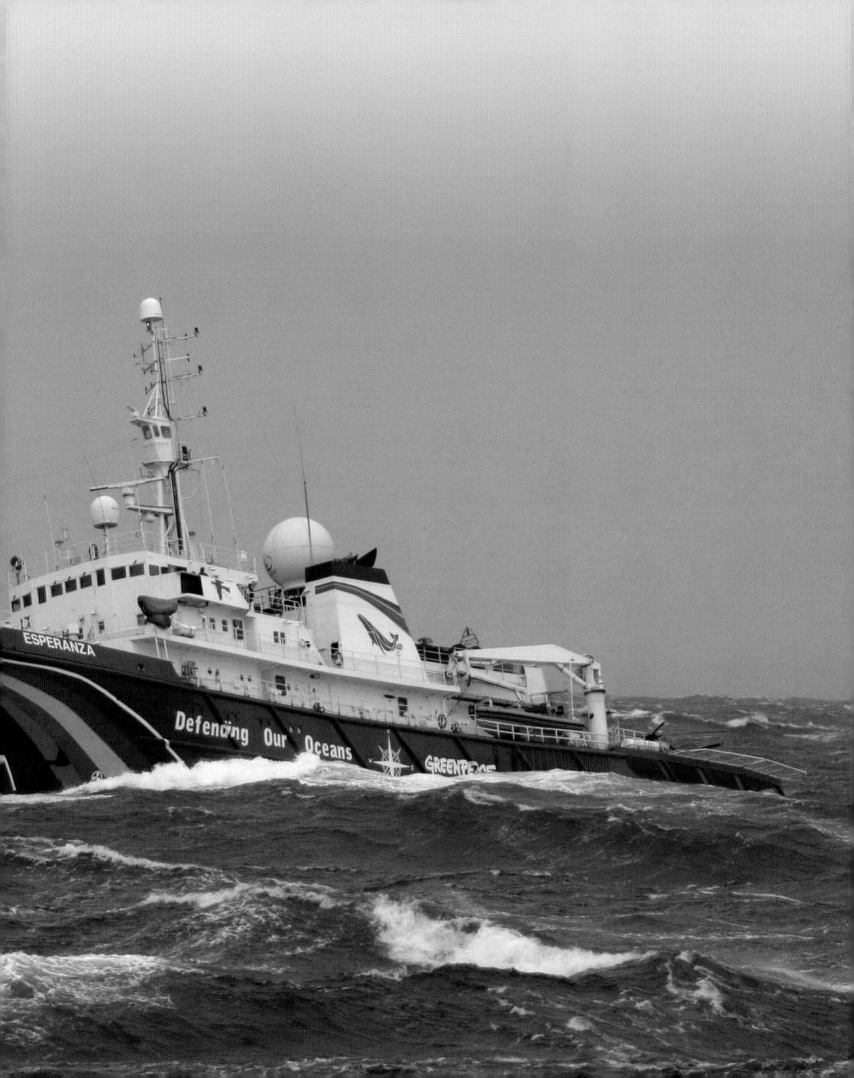

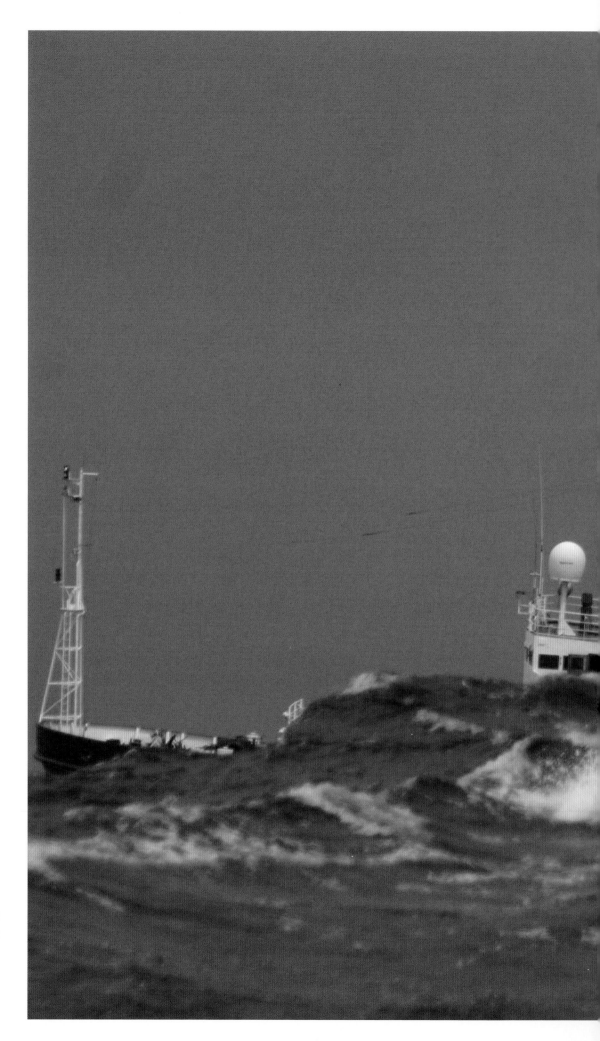

With the strongest winds and engulfing waves, the weather in the Southern Ocean is the harshest on the planet. Sailing in these conditions took the skills of all the dedicated crew who spent 73 days in the Southern Ocean Whale Sanctuary.

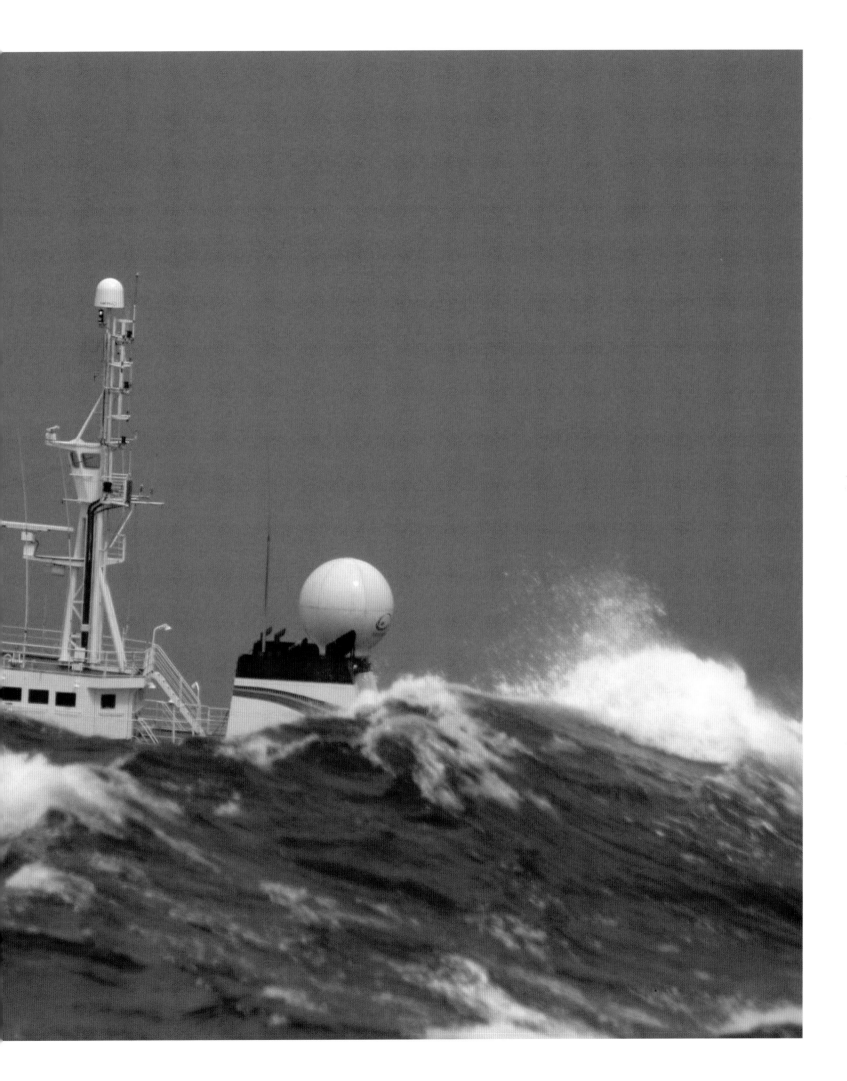

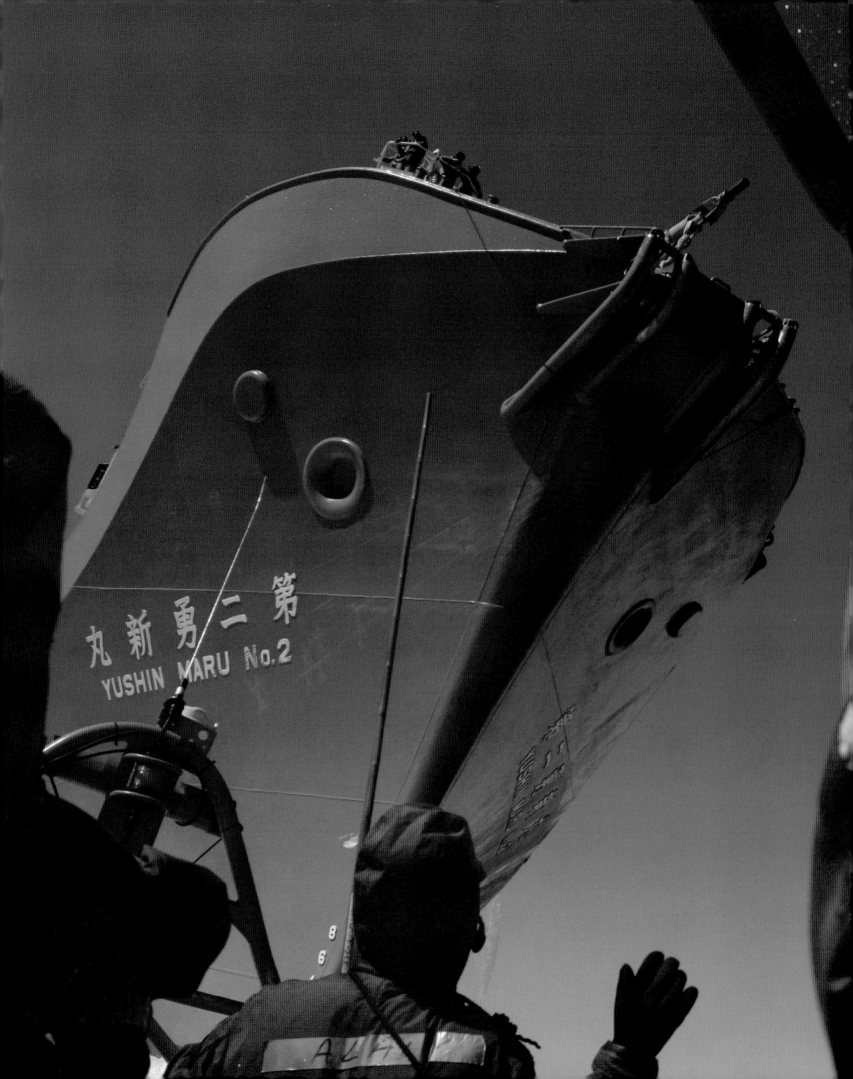

The symbol of Greenpeace – the rainbow (below) – arches over activists putting themselves between the Japanese government whaling ships and the whales in the Sanctuary, stopping dozens of whales from being killed. Two-thirds of Japanese people are also opposed to whaling on the high seas.

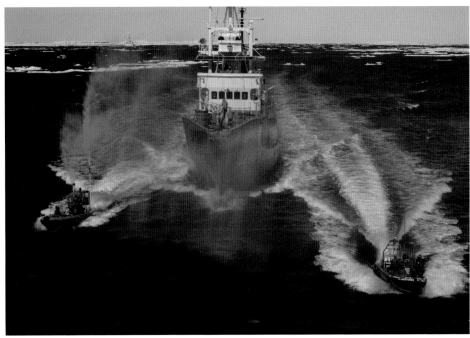

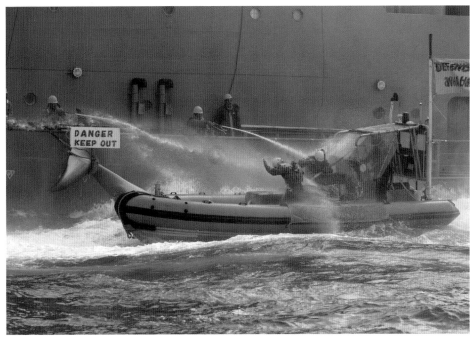

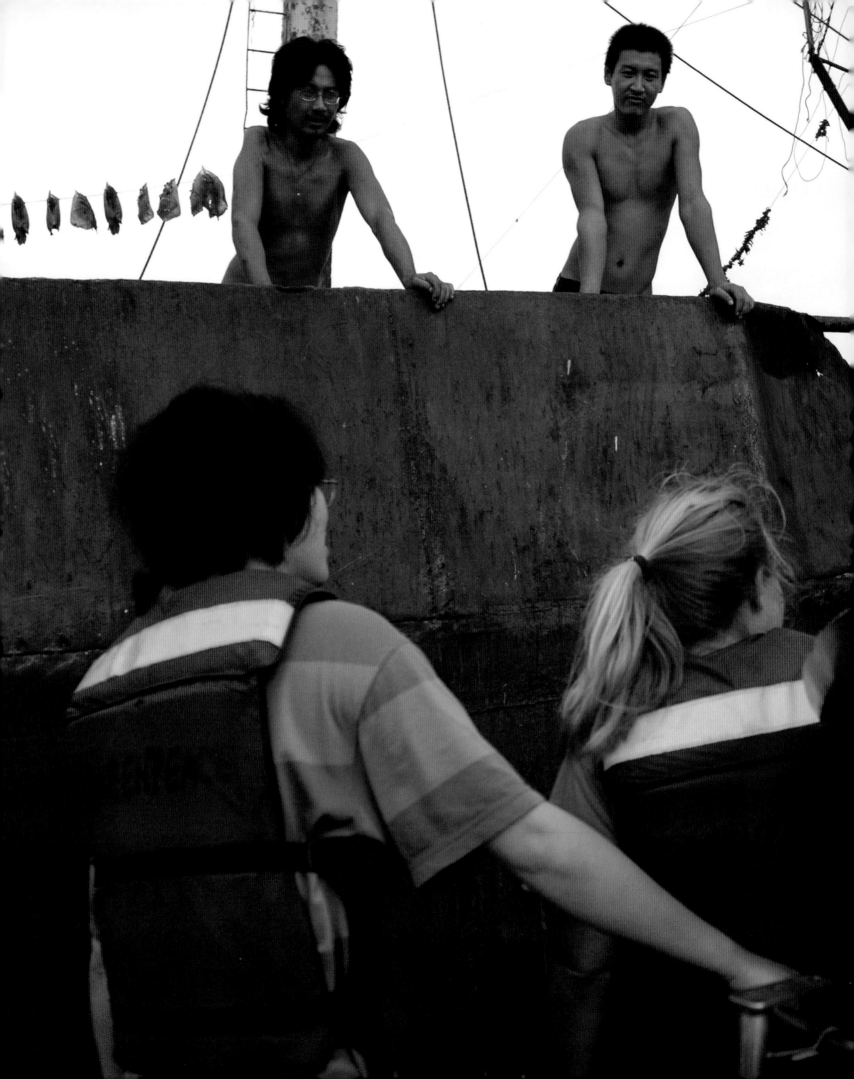

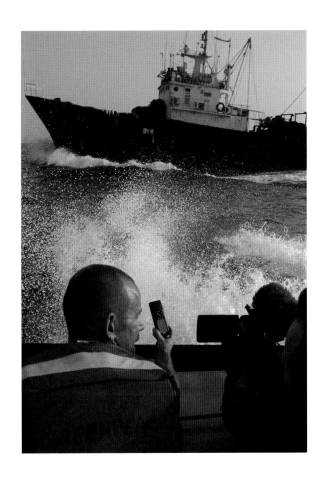

In the warmer waters off West Africa, exposing pirate fishing vessels stealing food from local communities sometimes needs fast action in Greenpeace inflatables. The pirate ships often try to hide their names and call signs. Plotting their routes with GPS recordings helps track illegal ships, like this one from Korea (right).

Bearing witness to environmental crimes is at the core of Greenpeace work (below). This vessel, now daubed with 'Stolen fish', was fined US$400,000 after its illegal activities were exposed during the expedition.

Campaigners did not expect to find abandoned fishermen marooned on wrecked fishing boats 70 kilometers/40 miles from shore off the Guinean coast (left). Basic food supplies were given to the men, some of whom had been at anchor for seven months waiting to be taken back to shore and home to China.

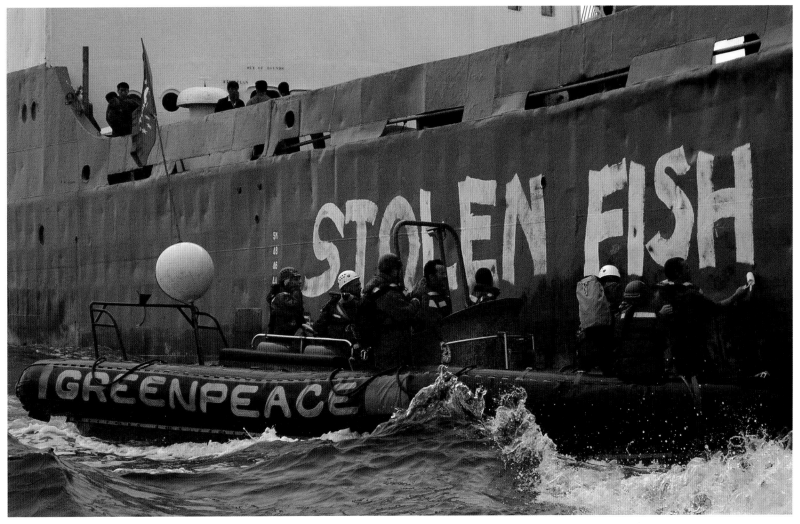

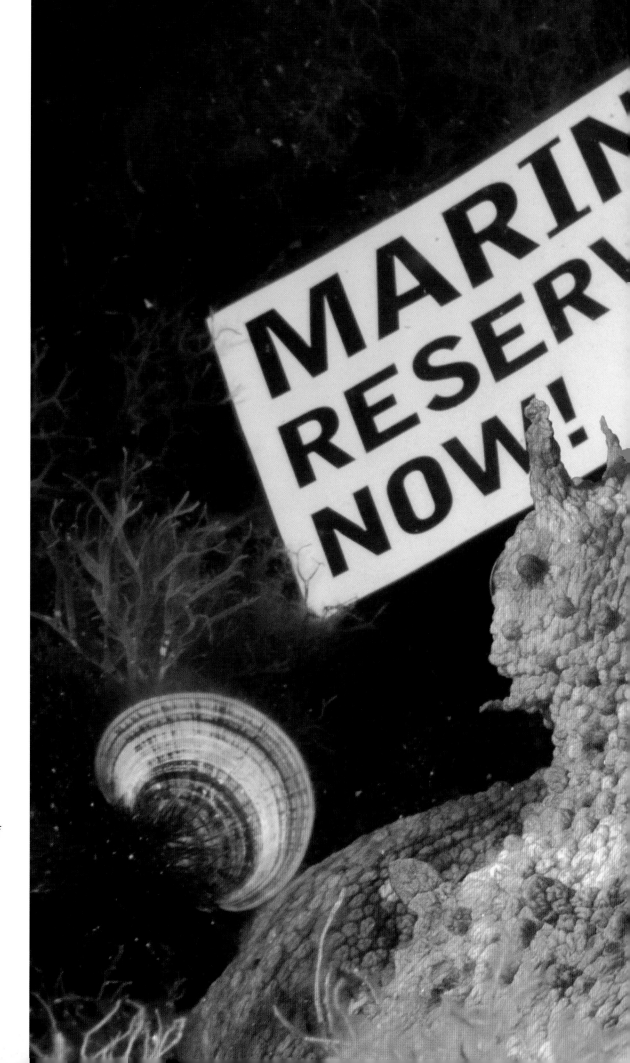

The Defending Our Oceans campaign also showed the beauty of the deep. This playful octopus didn't want to share the limelight with our mini banner – flipping it over three times until cameraman Gavin Newman handed it back upside down and waited for the octopus to turn it the right way up. Snap!

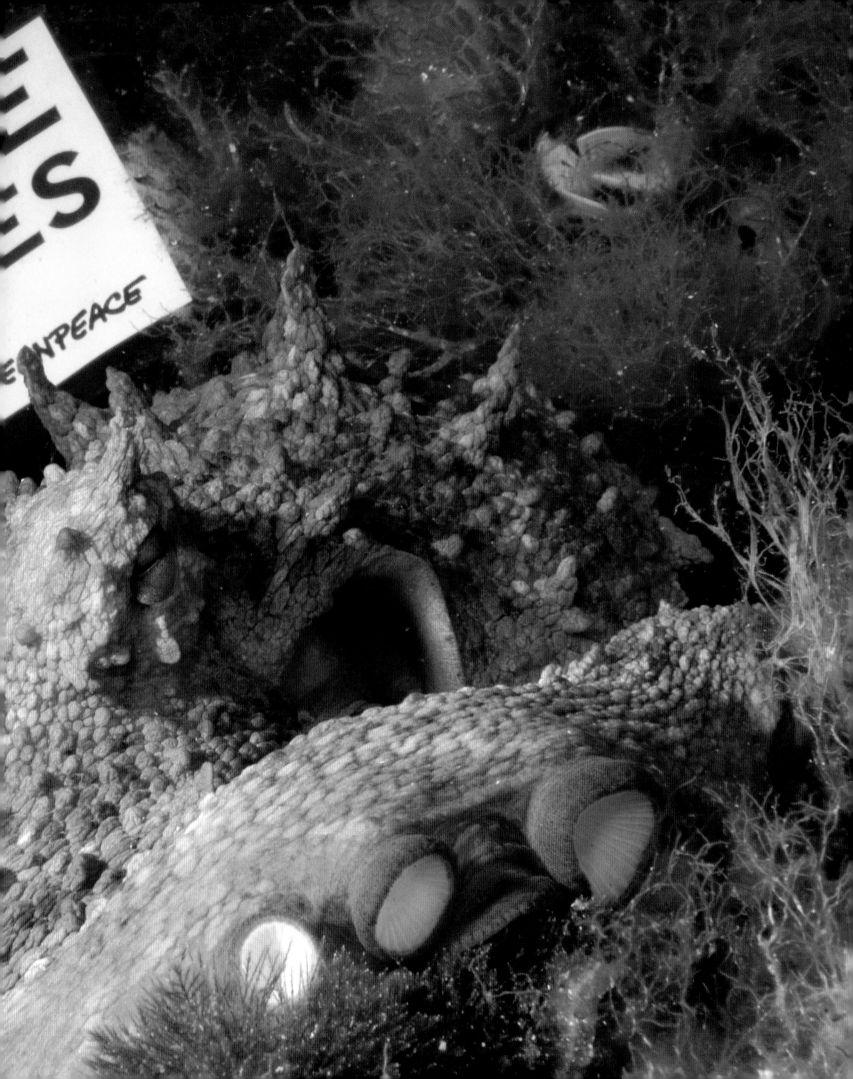

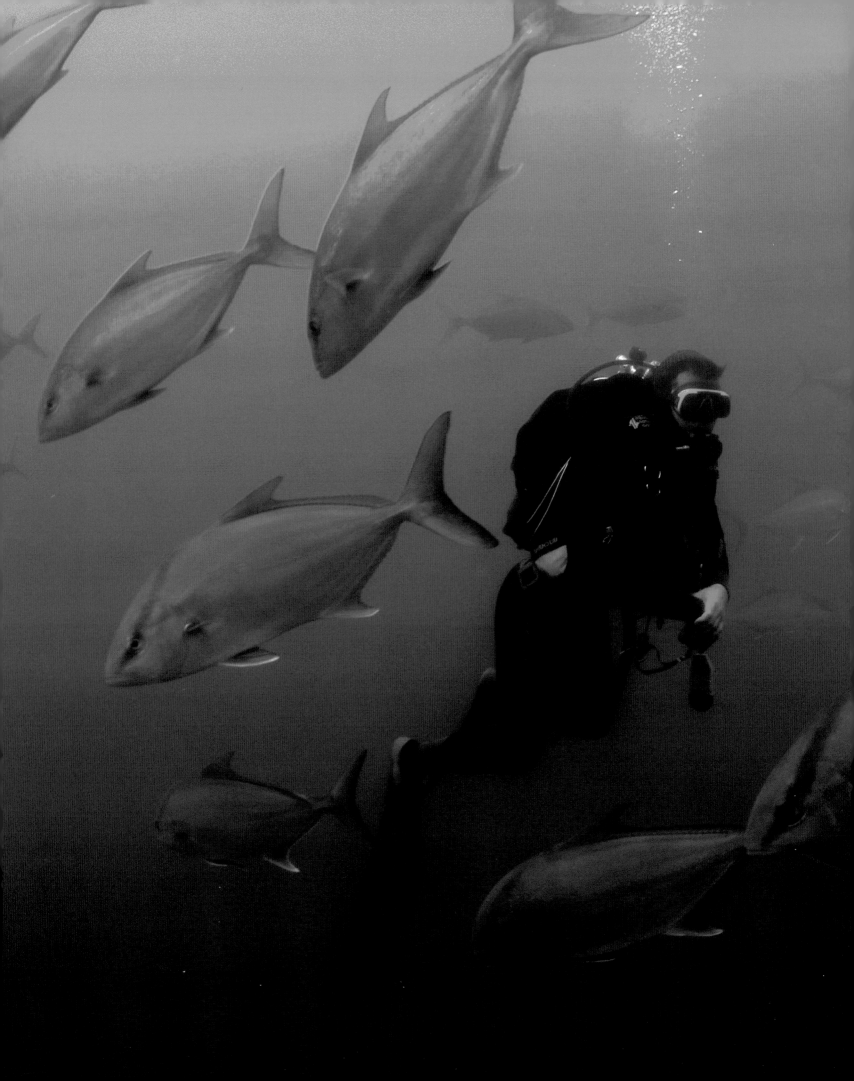

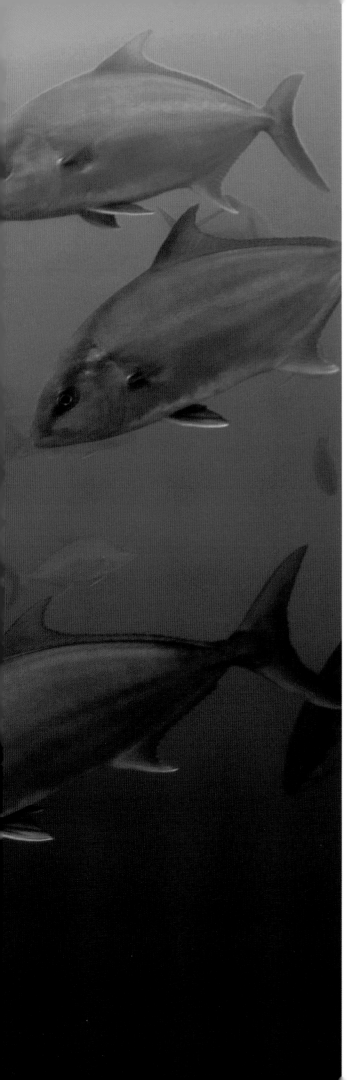

Feeding time around the Azores seamounts. Bottom-trawling on seamounts worldwide can drag up shoals considerably larger than these Almoco Jacks (left). The weighted nets smash the delicate corals that provide food and shelter for countless species and catch huge amounts of non-target species like our friendly octopus. Greenpeace is calling for a global moratorium on high seas bottom-trawling, which is one of the most destructive fishing methods.

Almost dwarfed by this giant tube worm 35 meters/100 feet below Montecristo in the Mediterranean (below), Greenpeace cameramen and women spent thousands of hours capturing images of Planet Ocean, above and below the waves.

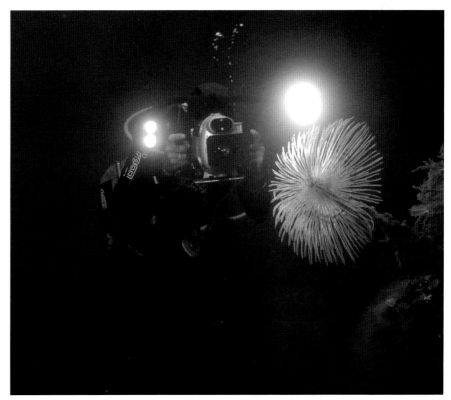

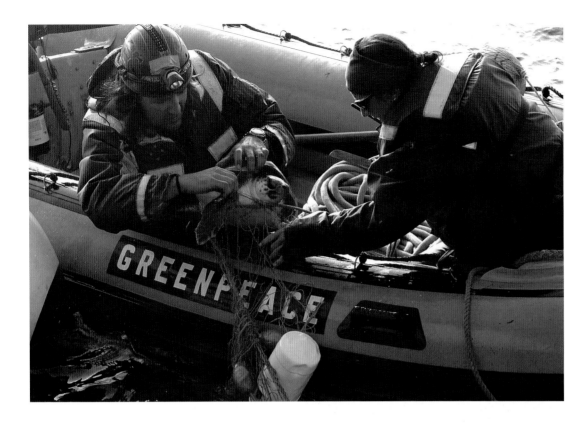

This turtle (above) was saved from drowning in an illegal driftnet…

…but the huge swordfish (right) was not so lucky. Driftnetting is banned, but plenty of evidence was found in the Mediterranean that the practice still continues.

The net result of tuna ranching in the Mediterranean is the imminent collapse of vital fish stocks (right).

[page 148-150] The banner says it all. During the summer in the Med, Greenpeace found more evidence of the scale of overfishing of tuna. Despite calls to dramatically reduce fishing quotas, the body responsible for managing the stock – the International Commission for the Conservation of Atlantic Tuna – set limits in 2006 at nearly double the scientific recommendation.

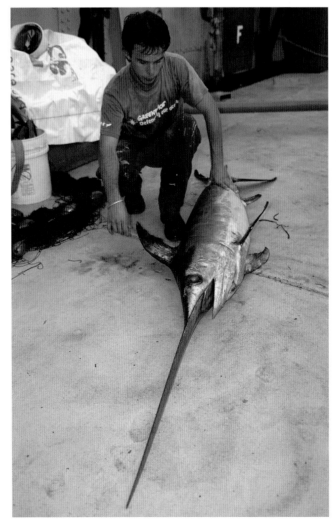

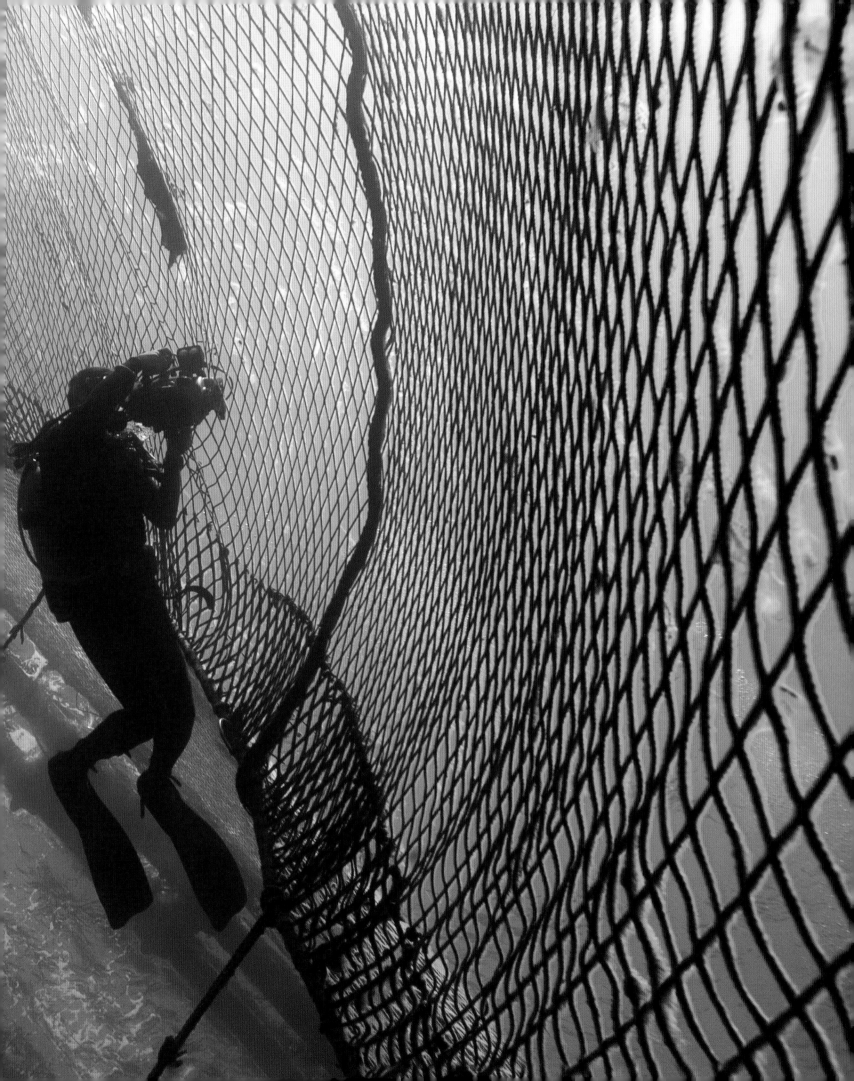

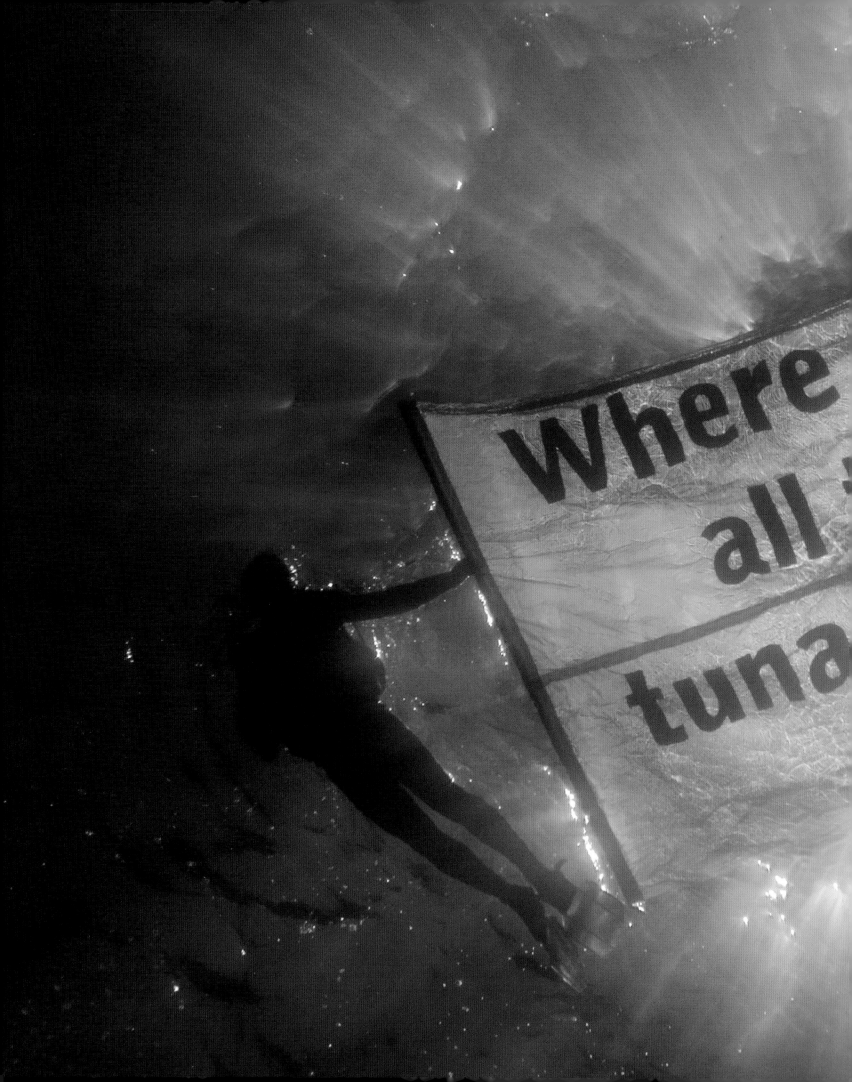

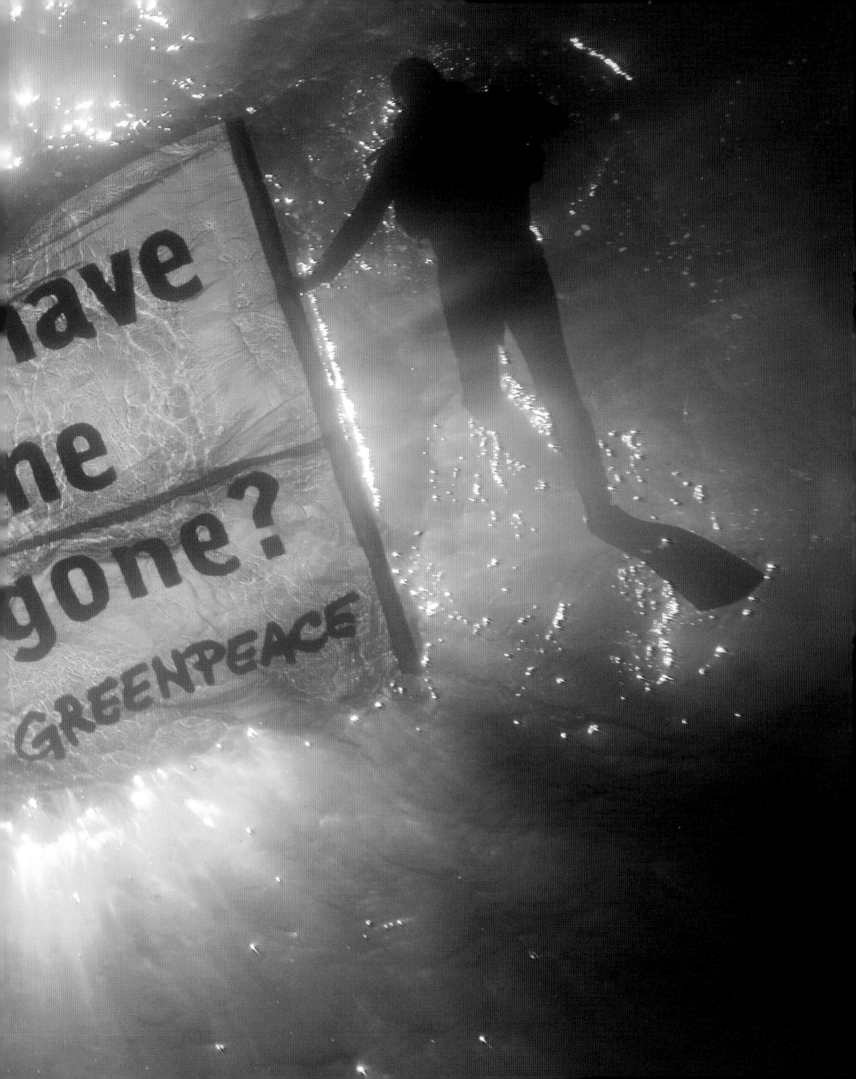

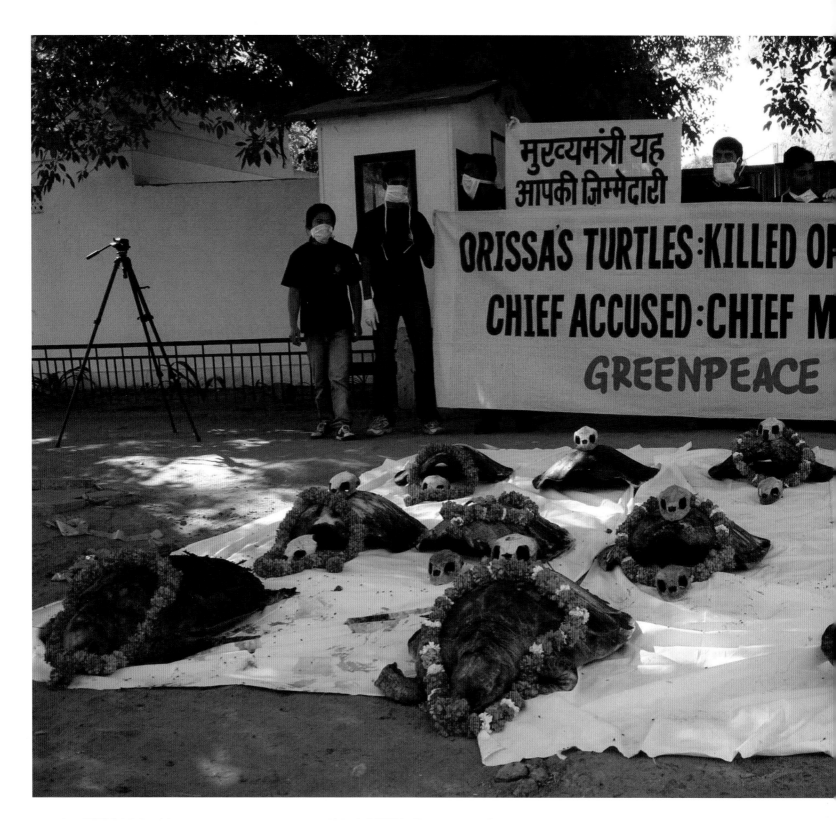

For exposing the deaths of thousands of turtles in Orissa, India, as a result of coastal development and reckless fishing practices, Greenpeace activists were – ironically – charged under wildlife protection laws and threatened with years in jail.

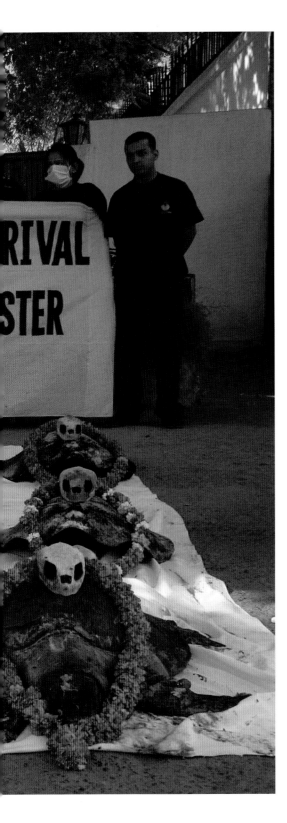

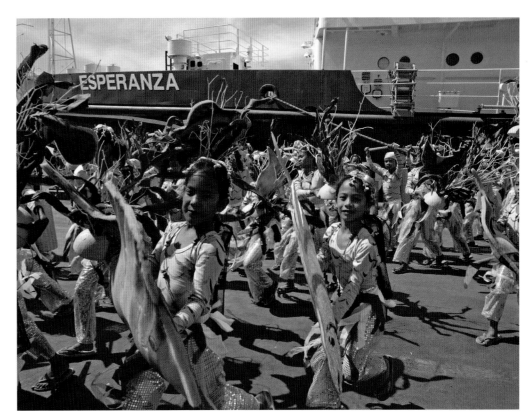

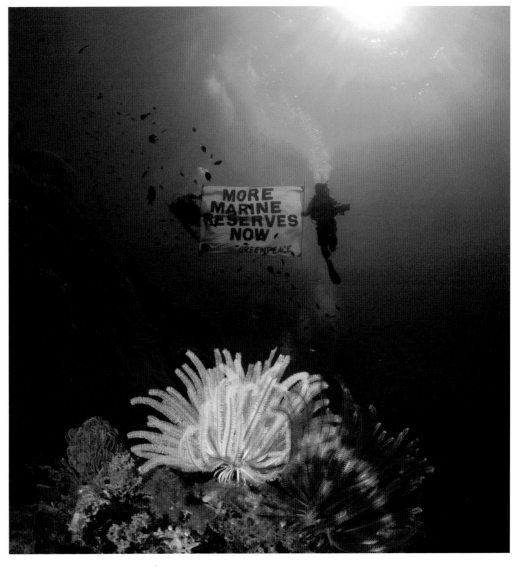

A warm welcome from the children of Cebu in the Philippines.

Supporting local communities in Apo Island, the oldest marine reserve in South East Asia, after seeing the benefits of the protection that has been in place for 20 years. The Defending Our Oceans campaign is calling for a global network of marine reserves covering 40 per cent of the world's oceans.

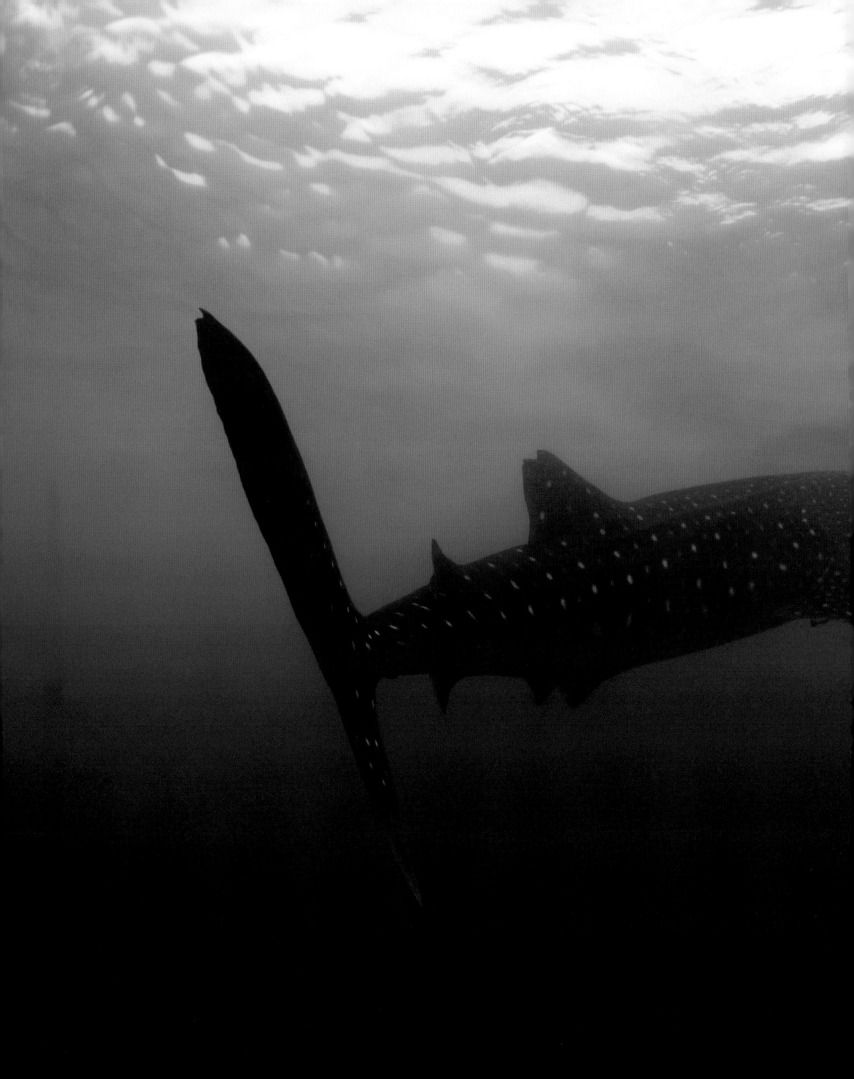

*Campaigning for oceans protection also
has its rewards – diving in Donsol in the
Philippines with the largest shark on the
planet, the gentle whale shark – is a rare treat.*

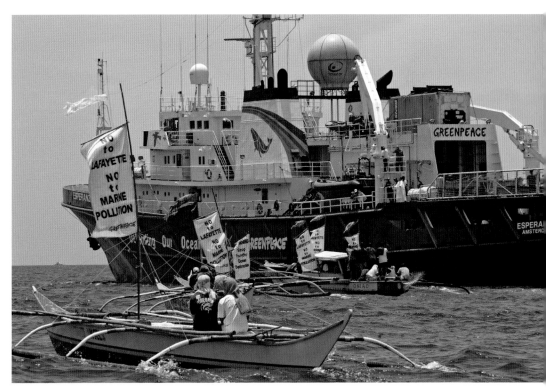

*Local communities fear that the whale shark
is threatened by mining activity on nearby
Rapu Rapu Island.*

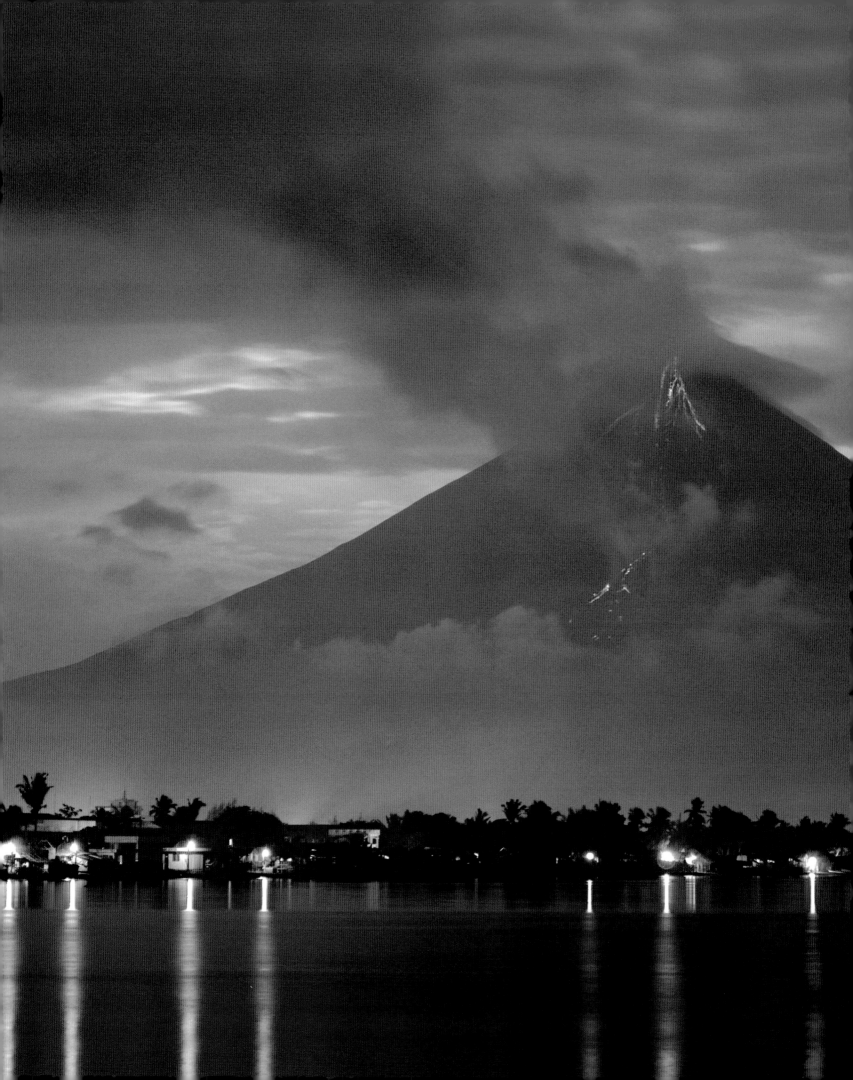

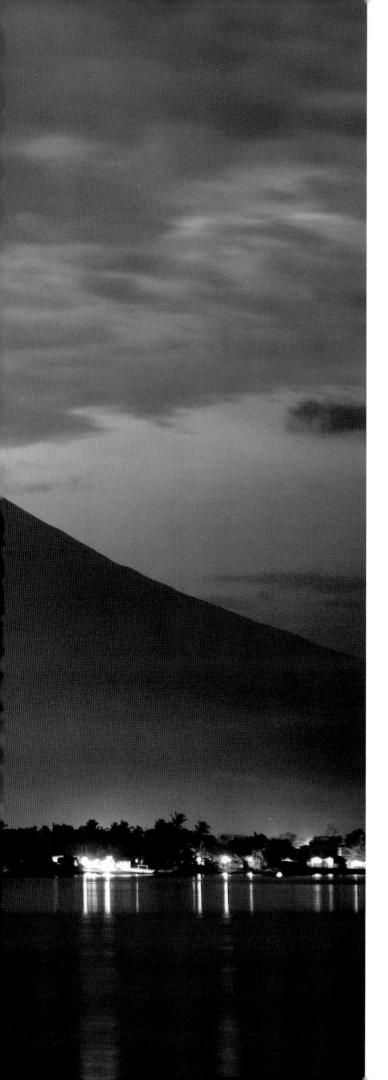

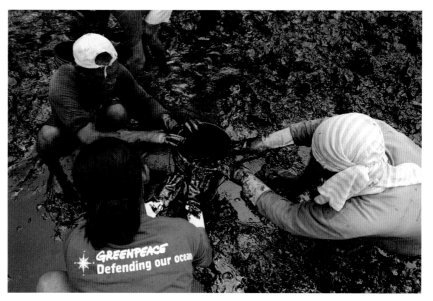

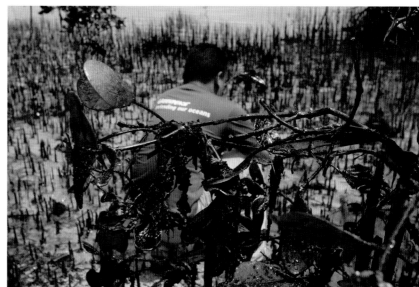

The menacing beauty of the Mayon volcano hung over the whole visit to the Philippines (left).

Tragedy struck with the worst oil spill in Philippines history (above). The Esperanza *was diverted to help with the clean up. Countless communities in Guiramas have had their ocean livelihoods ruined by the spill, from the Petron Oil Company chartered tanker, Solar 1.*

[page 156-157] All at sea again – in the biggest of the oceans, the Pacific.

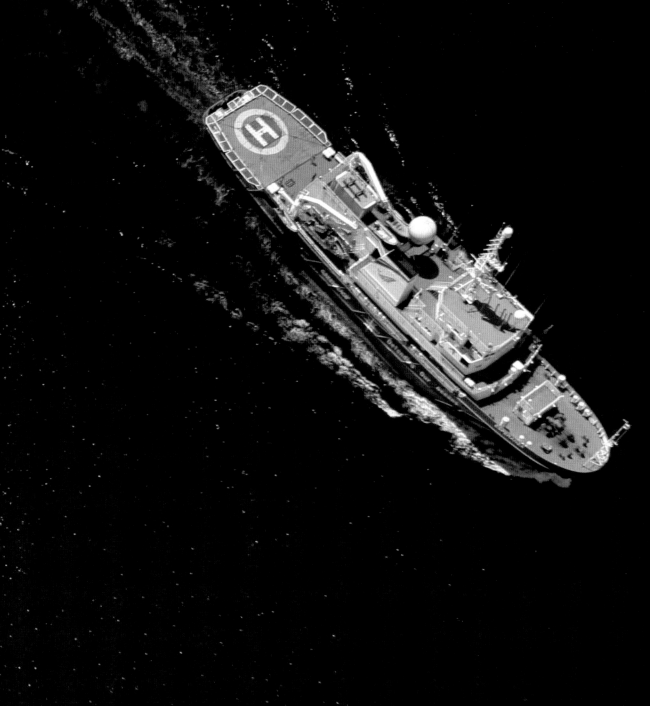

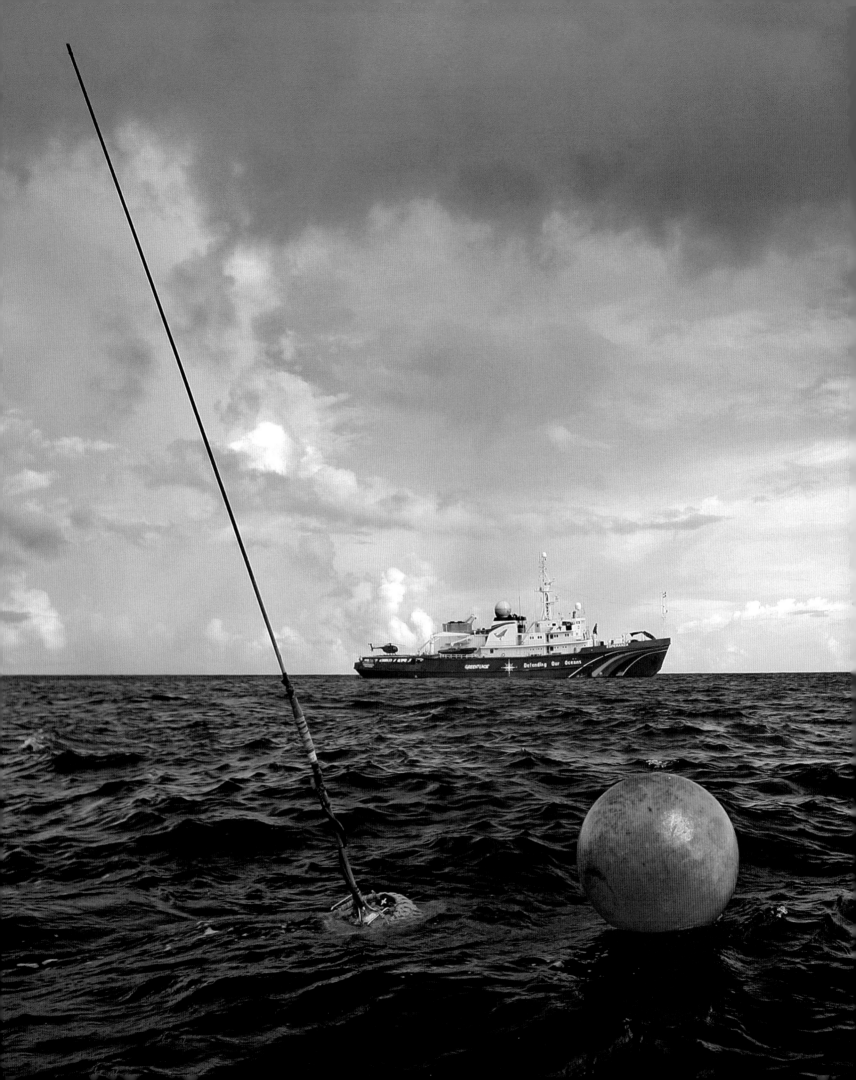

At the end of the line. Marker buoys for longline tuna fishing in the Pacific. As with the Mediterranean, tuna here are also under threat from overfishing. It's feared that Yellow Fin stocks could collapse in a matter of years if quotas are not dramatically reduced.

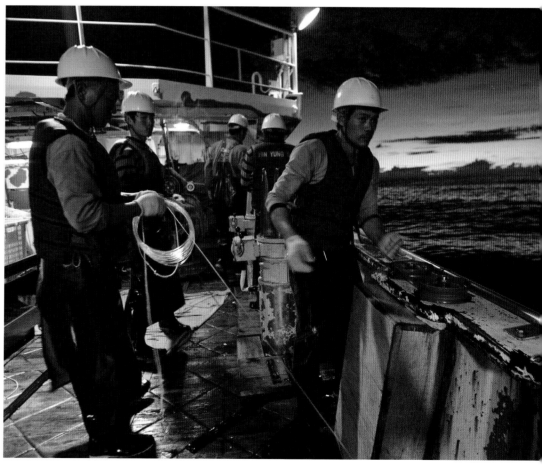

These longline fishermen in the Pacific only caught a handful of fish despite having a 100-kilometer/ 60-mile line baited with thousands of hooks, one possible indication that the fish are running out.

IS
THIS
YOURS?
GREENPEAC

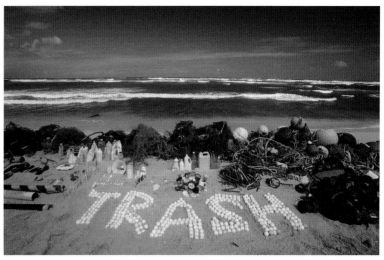

Is it art? No, it's rubbish. Even on the beaches of a newly designated marine reserve in Hawaii, the problem of ocean pollution is clear (above).

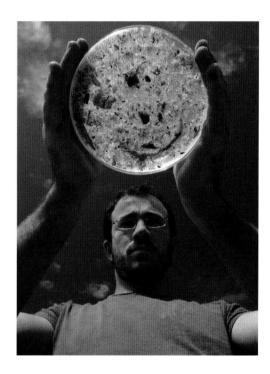

At sea, the picture is no better. A specially designed debris sampler has been testing our oceans throughout the Defending Our Oceans expedition. The results are disturbing. Every trawl brings in more evidence of how much of our garbage ends up in the ocean.

Even just holding a Greenpeace banner can be tricky when the currents are working against you and you are being bombarded by curious sea lions. The sea lion colony is next to the Espirito Santo seamount in the Gulf of California in Mexico. The Mexican Government declared the area a marine reserve while Greenpeace was visiting.

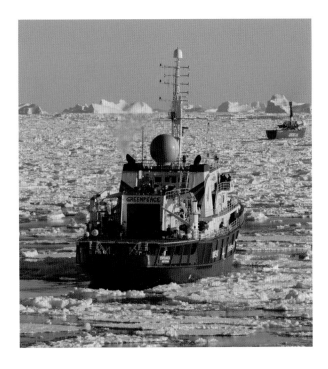

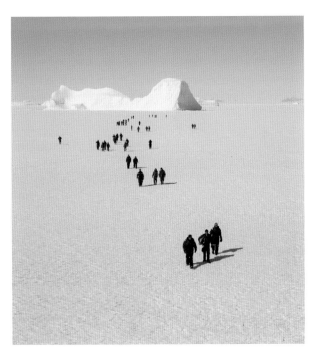

After 16 months at sea, the Esperanza returned to where
the expedition had started – the Southern Ocean Whale
Sanctuary (top). The Japanese government ships plan to hunt
endangered whales in the coming years.

Oceans protection begins on land, even in Antarctica. Written
with their own bodies, the message from Greenpeace activists
is a simple one (right).

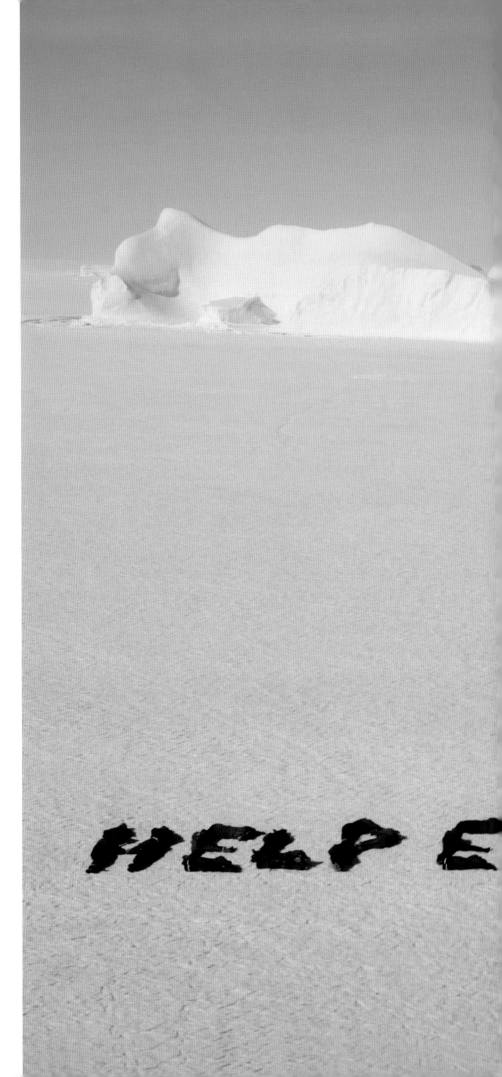

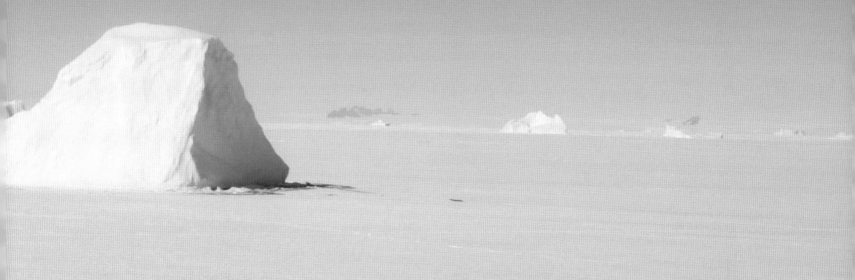

CONTACT ORGANIZATIONS

GREENPEACE OFFICES

GREENPEACE INTERNATIONAL
(STICHTING GREENPEACE COUNCIL)
Ottho Heldringstraat 5, 1066 AZ Amsterdam,
The Netherlands
Tel: +31 20 7182000 Fax: +31 20 5148151
Email: supporter.services@int.greenpeace.org
www.greenpeace.org/international/

EUROPEAN UNIT
(GREENPEACE EUROPEAN UNIT V.Z.W., in Belgium)
Tel: +32 2 274 19 00 Fax: +32 2 274 19 10
Email: european.unit@diala.greenpeace.org

GREENPEACE ARGENTINA
(FUNDACION GREENPEACE ARGENTINA)
Tel: +54 11 4551 8811 Fax: +54 11 4962 3090
Email: greenpeace.argentin@dialb.greenpeace.org

GREENPEACE AUSTRALIA PACIFIC
(GREENPEACE AUSTRALIA PACIFIC LIMITED)
Tel: +61 2 9261 4666 Fax: +61 2 9261 4588
Email: greenpeace@au.greenpeace.org

– **FIJI**
 Tel: +679 3312 861 Fax: +679 3312 784
 Email: greenpeace.pacific@dialb.greenpeace.org

– **PAPUA NEW GUINEA**
 Tel: +67 5 3215 954 Fax: +67 5 3215 954
 Email: greenpeace@au.greenpeace.org

– **SOLOMON ISLANDS**
 Tel: +677 20455 Fax: +677 21131

GREENPEACE BELGIUM
(A.S.B.L. GREENPEACE BELGIUM V.Z.W)
Tel: +32 2 274 02 00 Fax: +32 2 274 02 30
Email: info@be.greenpeace.org

GREENPEACE BRAZIL
(ASSOCIACAO CIVIL GREENPEACE)
Tel: +55 11 3035 1155 Fax: +55 11 3817 4600
Email: relacionamento@br.greenpeace.org

GREENPEACE CANADA
(GREENPEACE CANADA)
Tel: +1 416 597 8408 Fax: +1 416 597 8422
Email: members@yto.greenpeace.org

GREENPEACE CENTRAL AND EASTERN EUROPE
(GREENPEACE IN ZENTRAL-UND-OSTEUROPA)
Tel: +43 1 545 4580 Fax: +43 1 545 4588
Email: office@greenpeace.at

– **HUNGARY**
 (GREENPEACE MAGYARORSZÁG)
 Tel: +36 1 392 7663 Fax: +36 1 200 8484
 Email: info@greenpeace.hu

– **POLAND**
 (GREENPEACE POLSKA)
 Tel: +48 22 851 26 42 Fax: +48 22 841 46 83
 Email: infopl@greenpeace.pl

– **ROMANIA**
 Tel: +40 31 8058752 Fax: +40 31 8058752
 Email: info@greenpeace.ro

– **SLOVAKIA**
 (GREENPEACE SLOVENSKO)
 Tel: +421 2 5477 1202 Fax: + 421 2 5477 1151
 Email: info@greenpeace.sk

GREENPEACE CHILE
(FUNDACION GREENPEACE PACIFICO SUR)
Tel: +56 2 343 7788 Fax: +56 2 204 0162
Email: info-chile@cl.greenpeace.org

GREENPEACE CHINA
(GREENPEACE CHINA)
Tel: +852 2854 8300 Fax: +852-2745 2426
Email: greenpeace.china@hk.greenpeace.org

– **BEIJING OFFICE**
 Tel: (86)10 6554 6931 ext.132
 Fax: (86)10 6554 6932

– **GUANGZHOU UNIT**
 Tel: +86 20 8411 4603 Fax: +86 20 8411 1325

GREENPEACE CZECH REPUBLIC
(GREENPEACE CESKA REBUBLIKA)
Tel: +420 224 320 448 Fax: +420 222 313 777
Email: greenpeace@ecn.cz

GREENPEACE FRANCE
(GREENPEACE FRANCE)
Tel: +33 1 44 64 02 02 Fax: +33 1 44 64 02 00
Email: greenpeace.france@diala.greenpeace.org

GREENPEACE GERMANY
(GREENPEACE EV)
Tel: +49 40 306 180 Fax: +49 40 306 18100
Email: mail@greenpeace.de

GREENPEACE GREECE
(GREENPEACE GREECE)
Tel: +30 210 3840774 Fax: +30 210 3804008
Email: gpgreece@diala.greenpeace.org

GREENPEACE INDIA
(GREENPEACE ENVIRONMENTAL TRUST)
Tel: +91 80 51154861 Fax: +91 80 51154862
Email: info@greenpeaceindia.org

GREENPEACE ITALY
(GREENPEACE ITALY)
Tel: +39 06 572 9991 Fax: +39 06 578 3531
Email: info@greenpeace.it

GREENPEACE JAPAN
(TOKUTEI HI-EIRI KATSUDO HOJIN GURIINPIISU
JAPAN)
Tel: +81 3 5338 9800 Fax: +81 3 5338 9817
Email: info@greenpeace.or.jp

GREENPEACE LUXEMBOURG
(GREENPEACE LUXEMBOURG A.S.B.L)
Tel: +352 54 62 52 1 Fax: + 352 545 405
Email: greenpeace@pt.lu

GREENPEACE MEDITERRANEAN
(GREENPEACE MEDITERRANEAN FOUNDATION, in Malta)
Tel: +21490784/5 Fax: +21490782
Email: gpmed@diala.greenpeace.org

– **ISRAEL**
 Tel: + 972 3 629 8220 Fax: + 972 3 629 8210
 Email: gpmedisr@il.greenpeace.org

– **LEBANON**
 Tel: +961 1 755 665 Fax: +961 1 755 664
 Email: gpmedleb@diala.greenpeace.org

– **TURKEY**
 Tel: +90(212) 248 26 61 Fax: +90(212) 248 18 59
 Email: bilgi@greenpeace.org.tr

GREENPEACE MEXICO
(GREENPEACE-MEXICO ASOCIACION CIVIL)
Tel: +52 55 30 2165 Fax: +52 55 30 1868
Email: greenpeace.mexico@dialb.greenpeace.org

GREENPEACE NETHERLANDS
(STICHTING GREENPEACE NEDERLAND)
Tel: 0800 4 22 33 44 Fax: +31 20 622 12 72
Email: info@greenpeace.nl

GREENPEACE NEW ZEALAND
(GREENPEACE NEW ZEALAND INCORPORATED)
Tel: +64 9 630 63 17 Fax: +64 9 630 71 21
Email: greenpeace.new.zealand@nz.greenpeace.org

GREENPEACE NORDIC
(FÖRENINGEN GREENPEACE NORDEN, in Sweden)
Tel:+46 8 702 7070 Fax: +46 8 694 9013
E info@nordic.greenpeace.org

– **DENMARK**
 Tel: +45 33 93 53 44 Fax: +45 33 93 53 99
 Email: info@nordic.greenpeace.org

– **FINLAND**
 Tel: +358 9 622 922 00 Fax: +358 9 622 922 22
 Email: info@nordic.greenpeace.org

– **NORWAY**
 Tel: +47 22 205 101 Fax: +47 22 205 114
 Email: info@nordic.greenpeace.org

GREENPEACE RUSSIA
(STICHTING GREENPEACE COUNCIL)
Tel: +749 592 650 45 Fax: +749 592 650 45
Email: gprussia@ru.greenpeace.org

GREENPEACE SOUTH-EAST ASIA
(GREENPEACE SEA FOUNDATION, in Thailand)
Tel: +66 2 272 7100 Fax: +66 2 271 4342
Email: greenpeace.southeast.asia@
dialb.greenpeace.org

– **INDONESIA**
 (GREENPEACE SEA-INDONESIAN BRANCH)
 Tel: +62 (0)21 3101873 Fax: +62 (0)21 3102174
 Email: greenpeace.southeastasia@
 dialb.greenpeace.org

– **PHILIPPINES**
 (GREENPEACE SEA ENVIRONMENTAL TRUST INC.)
 Tel: +63 2 434 7034 Fax: +632 434 7035
 Email: greenpeace.southeastasia@
 ph.greenpeace.org

GREENPEACE SPAIN
(GREENPEACE-ESPAÑA)
Tel: +34 91 444 14 00 Fax: +34 91 447 15 98
Email: informacion@greenpeace.es

GREENPEACE SWITZERLAND
(STIFTUNG) GREENPEACE SCHWEIZ/ GREENPEACE
SUISSE/ GREENPEACE SVIZZERA
Tel: +41 1 447 41 41 Fax: +41 1 447 41 99
Email: gp@greenpeace.ch

GREENPEACE UNITED KINGDOM
(GREENPEACE LIMITED)
Tel: +44 207 865 8100 Fax: +44 207 865 8200
Email: info@uk.greenpeace.org

GREENPEACE USA
(GREENPEACE, INC.)
Tel: +1 202 462 1177 Fax: +1 202 462 4507
Email: info@wdc.greenpeace.org

OTHER ORGANIZATIONS

HUMANE SOCIETY (USA)
www.hsus.org

ENVIRONMENTAL INVESTIGATION AGENCY
www.eia-international.org

ENVIRONMENTAL JUSTICE FOUNDATION
www.ejfoundation.org

MINERAL POLICY INSTITUTE
www.mpi.org.au

INTERNATIONAL FUND FOR ANIMAL WELFARE
United Kingdom
info-uk@ifaw.org

**HURGHADA ENVIRONMENTAL PROTECTION AND
CONSERVATION ASSOCIATION**
www.hepca.com

DELPHIS
Mediterranean Dolphin Conservation
www.delphismdc.org

ALGALITA MARINE RESEARCH FOUNDATION
www.algalita.org

WWF
www.panda.org

SILLIMAN UNIVERSITY, PHILIPPINES
Institute for Environmental and Marine Sciences
http://su.ed.ph/marinelab/index/html

PHOTO INFORMATION AND CREDITS

2 Silhouette of Marco Carè, videographer *Greenpeace/Grace*

9 Archbishop Desmond Tutu visits the *Esperanza*, Cape Town *Greenpeace/Beltra*

10,11 Gotta Abu Ramad reef *Greenpeace/Carè*

12,13 A school of damselfish *Chromis chromis*, Aliaga, Turkey *Greenpeace/Grace*

14,15 Rainbow-wrasse *Greenpeace/ Newman*

INTRODUCTION

16 Divers entering a cave in the Mediterranean Sea *Greenpeace/Grace*

18 Small Labrid *Thalassoma pavo* fish, Mediterranean *Greenpeace/Grace*

18 *Serranus scriba* fish, Mediterranean *Greenpeace/Grace*

19 School of juvenile *sarpa salapa* fish, Mediterranean *Greenpeace/Grace*

20 Close up of an octopus eye, Mediterranean Sea *Greenpeace/Grace*

21 Octopus at night, Mediterranean Sea *Greenpeace/Grace*

21 Sand goby camouflaged on the gravelly sand and rubble bottom, Mediterranean Sea *Greenpeace/Grace*

22 Madeira rockfish *Greenpeace/Newman*

23 Dwarf scorpion fish and nudibranch eggs, Mediterranean *Greenpeace/Grace*

24 Padina algae against orange sponge, Mediterranean *Greenpeace/Grace*

25 *Sabella spallanzanii* tube worm, Mediterranean *Greenpeace/Grace*

26 Nudibranch or sea slug drifting freely in the water column, Mediterranean *Greenpeace/Grace*

27 A fire worm with poisonous white tufts or *setae*, Mediterranean *Greenpeace/Grace*

28 A California sea lion at the Los Islotes sea lion colony, Espiritu Santo Island, La Paz *Greenpeace/Hofford*

29 A group of California sea lions at the Los Islotes sea lion colony, Espiritu Santo Island, La Paz *Greenpeace/Hofford*

30 Gotta Abu Ramad reef, Egypt *Greenpeace/Carè*

32 Green Sea Turtle in a marine reserve around Apo Island, Philippines *Greenpeace/Ocampo*

34 School of Jacks, Apo Island Marine Reserve, Philippines *Greenpeace/Ocampo*

36 Samadai reef, Egypt *Greenpeace/Carè*

37 A small moray eel in a hole about 20 meters down, Apo Island, Philippines *Greenpeace/Ocampo*

37 Lion fish in a marine reserve around Apo Island, Philippines *Greenpeace/Ocampo*

38 A Macropipus swimming crab hides on the seabed, Mediterranean *Greenpeace/ Grace*

40 The tropical flutemouth fish, Mediterranean *Greenpeace/Grace*

BREATHING OCEANS

42 Sunset over Tarawa, Pacific *Greenpeace/Behring*

44 Icebergs in the Southern Ocean (x2) *Greenpeace/Davison*

46 A seagrass bed, Mediterranean *Greenpeace/Grace*

48 Coral reef in area affected by oil spill, Guimaras Island, Philippines *Greenpeace/Newman*

50 Diver on the Gotta Abu Ramad reef, Egypt *Greenpeace/Carè*

52 A king tide hits the South Pacific island of Kiribati *Greenpeace/Sutton-Hibbert*

53 Coastal Sunset, Majuro, Marshall Islands, Pacific *Greenpeace/Grace*

54 King tide in Betio, Kiribati *Greenpeace/Sutton-Hibbert*

PREDATOR OR PREY?

56 Whale shark, Legazpi, Philippines *Greenpeace/Newman*

58 A fisherman throws back a shark accidentally caught on the end of a bait line of a Korean longliner *Greenpeace/Hofford*

59 An Indonesian crewmember holds up a shark fin on the deck of the Japanese longliner in the Pacific *Greenpeace/Hofford*

60 A girl holding up a set of shark jaws from the Philippines on sale in a specialist shop in San Diego, US *Greenpeace/Hofford*

62 Humpback whale breaching in the Behring Sea *Greenpeace/Warshaw*

64 Harpooner at the bow of the catcher ship from the Japanese whaling fleet *Greenpeace/Davison*

66 The Japanese whaling fleet takes four harpoon shots to kill a minke whale in the Southern Ocean (x3) *Greenpeace/Davison*

68 A dead whale tethered to a catch boat ready to be delivered to the whaling mother ship *Greenpeace/Davison*

70 Tuna in nets in the Mediterranean *Greenpeace/Newman*

71 Tuna swimming in the Mediterranean *Greenpeace/Newman*

72 Frozen tuna, Tokyo *Greenpeace/Sutton-Hibbert*

74 Tuna inside cage being towed between fishing grounds in Libya and tuna farms in Sicily *Greenpeace/Newman*

75 Tug towing tuna cage between fishing grounds in Libya and tuna farms in Sicily *Greenpeace/Newman*

76 Jellyfish, Mediterranean *Greenpeace/Grace*

77 Mauve stinger jellyfish *Greenpeace/Newman*

78 Korean stern trawler with a deck full of green nets off West Africa *Greenpeace/Gleizes*

79 Crew freezing fish caught by a Chinese fishing boat with a history of pirate fishing off West Africa *Greenpeace/Gleizes*

79 Guinean fishery inspector arresting illegal Chinese fishing vessel inside Guinean Exclusive Economy Zone *Greenpeace/Gleizes*

80 Chinese workers in the hold of a fishing vessel unloading tuna, Pohnpei, Micronesia, Pacific Ocean *Greenpeace/Behring*

PEOPLE AND THE OCEANS

82 Sleeping crew on a Chinese longliner in port in Pohnpei, Micronesia *Greenpeace/Hofford*

84 Fisherman with local canoes or *pirogues* in Boublinet harbor, Conakry, Guinea *Greenpeace/Morgan*

85 Boat building, Boublinet harbor, Conakry, Guinea *Greenpeace/Morgan*

85 Fishermen at sea in *pirogues* near Conakry, Guinea *Greenpeace/Gleizes*

86 Polish fishing boat with nets for cod onboard in an area of the Baltic where it is illegal to fish for cod *Greenpeace/Aslund*

88 Local fishermen using 'sudsud' nets to catch shrimps in Donsol, Philippines *Greenpeace/Ledesma*

90 A traditional dance in Kiribati, Pacific *Greenpeace/Behring*

91 Greenpeace activists demonstrate to protect whale shark habitats in the Philippines *Greenpeace/Baluyut*

92 Children playing on the beach in Kiribati, Pacific *Greenpeace/Behring*

94 'Korakorea' girls who work as prostitutes on foreign fishing boats in Kiribati *Greenpeace/Behring*

95 A woman climbing between two Taiwanese boats while it is in Tarawa port in the Pacific *Greenpeace/Behring*

96 Woman waiting at Boublinet harbor, Conakry, Guinea *Greenpeace/Morgan*

96,97,98 Fish market, Boublinet harbor, Conakry, Guinea (x3) *Greenpeace/Morgan*

99 Child carrying smoked fish at Boublinet harbor, Conakry, Guinea *Greenpeace/Morgan*

100,102 Crew from one of the vessels in the 'zombie graveyard' of rusting Chinese fishing vessels, 60 miles off the coast of West Africa. (x2) *Greenpeace/Gleizes*

104 Chinese fishing trawler transferring its catches onto reefer boat, 75 miles west of Guinea *Greenpeace/Gleizes*

105 Local West African workers on Chinese fishing boat *Greenpeace/Gleizes*

106 Local boatman swims amongst plastic trash discarded in Manila Bay, Philippines *Greenpeace/Newman*

108 Plastic bag floating in the open ocean, Egypt *Greenpeace/Carè*

110 A large 'ghost net' inhabited by many various species of tropical fish floats in the Central North Pacific *Greenpeace/Hofford*

111 Fish swim inside an abandoned Japanese crate found in the high seas of the Central North Pacific *Greenpeace/Hofford*

112 The glazed eye of a dead swordfish entangled in an illegal driftnet in the Mediterranean *Greenpeace/Grace*

114 Oil pollution on beaches and mangroves, Guimaras Island, Philippines *Greenpeace/Newman*

114 Collecting oil from beaches, Guimaras Island, Philippines *Greenpeace/Newman*

115 A group of local fishermen working barefooted collect oil from beaches by hand, Guimaras Island, Philippines *Greenpeace/Newman*

SECRETS OF THE DEEP

116 Dolphins swimming around Samadai reef, Egypt *Greenpeace/Carè*

118 Hydrothermal vents around the Azores *Greenpeace/Newman*

119 Giant tube worm surrounded by algae, Mediterranean *Greenpeace/Grace*

120 Close up of a tube worm in Dauin Marine Reserve, Philippines *Greenpeace/Newman*

122 Clown Fish in an anemone, Apo Island Marine Reserve, Philippines *Greenpeace/Newman*

124 Filming in Apo Island Marine Reserve, Philippines *Greenpeace/Newman*

125 Deep water coral formations, Azores *Greenpeace/Newman*

126 Blue and yellow sea slug, Mediterranean *Greenpeace/Grace*

127 Sea slug feeding off a hydroid and leaving purple eggs at the top, Mediterranean *Greenpeace/Grace*

128,129 Salps in the Azores (x3) *Greenpeace/Newman*

130 Purple sea sponge, Philippines *Greenpeace/Ocampo*

131 Coral formations in the Mediterranean *Greenpeace/Grace*

131 Coral reef, Philippines *Greenpeace/Ocampo*

132,133 Elphinston reef, Egypt. Turtle. Crystal clear waters and unique coral reefs have made the Red Sea one of the world's prime diving destinations. Yet these reefs are threatened by problems such as overfishing, pollution and uncontrolled coastal development. *Greenpeace/Caré*

DEFENDING OUR OCEANS

134,136 Greenpeace ship MY *Esperanza* en route to the Southern Oceans *Greenpeace/Davison*

138 Crew in a Greenpeace inflatable looking up at the harpoon on a Japanese whale-catcher ship in the Southern Ocean *Greenpeace/Sutton-Hibbert*

139 Greenpeace activists use a modified fire pump in a small inflatable to obscure the view of the harpoonist on the *Yushin Maru No 2* of the Japanese whaling fleet *Greenpeace/Davison*

139 Greenpeace activists are hosed down by the crew of the Japanese whaling ship in the Southern Ocean *Greenpeace/Davison*

140 Greenpeace crew helping Chinese sailors left on board 'zombie graveyard' ships 60 miles off the coast of Guinea *Greenpeace/Gleizes*

141 Greenpeace crew observing an illegal Korean trawler inside the Guinea 12-mile protected zone *Greenpeace/Gleizes*

141 Greenpeace activists brand an illegal cargo vessel full of fish taken from Guinean waters *Greenpeace/Gleizes*

142 Underwater banner next to an octopus in the Mediterranean *Greenpeace/Newman*

144 A shoal of Almoco Jacks on the Dom João de Castro seamount, Azores *Greenpeace/Newman*

145 Underwater cameraman Marco Carè films a large tubeworm at about 33 meters depth at Montecristo *Greenpeace/Grace*

146 Greenpeace activists rescuing a young turtle from a driftnet in the Mediterranean Sea *Greenpeace/Grace*

146 Greenpeace activist examines a dead swordfish, drowned in a ghost net *Greenpeace/Grace*

147 Greenpeace diver in tuna net in the Mediterranean *Greenpeace/Newman*

148 Greenpeace divers with a large underwater banner in the Mediterranean *Greenpeace/Newman*

150 Greenpeace activists in India expose the number of dead turtles washed up in Orissa *Greenpeace/Gopal*

151 Welcome from local children in Cebu city, Philippines, for Greenpeace ship *Esperanza* and crew *Greenpeace/Newman*

151 Greenpeace divers holding underwater banner in Apo Island Marine Reserve, Philippines *Greenpeace/Newman*

152 Diving with a whale shark, Legazpi, Philippines *Greenpeace/Newman*

153 Flotilla of local boats accompanies Greenpeace ship *Esperanza* on a protest against pollution caused by the Lafayette Gold Mine on Rapu Rapu Island, Philippines *Greenpeace/Newman*

154 Mayon Volcano erupting above Legazpi City, Philippines *Greenpeace/Newman*

155 Local fisherman collecting oil from beaches by hand with Greenpeace activist, Guimaras Island. Philippines *Greenpeace/Newman*

155 Greenpeace campaigner Jasper Inventor studying mangrove plants coated with oil from tanker spill, Guimaras Island, Philippines *Greenpeace/Newman*

156 Greenpeace ship *Esperanza* crosses the Western Pacific through Palau territorial waters *Greenpeace/Hofford*

158 End of longline tracker buoys set by a Japanese longliner in the Pacific, with Greenpeace ship *Esperanza* in the background *Greenpeace/Hofford*

159 Fishermen reeling in bait lines on the deck of a Korean longliner *Greenpeace/Hofford*

160 Marine conservationist Charles Moore with discarded toothbrush floating in the 'trash vortex' in the Central North Pacific *Greenpeace/Hofford*

161 The word 'trash' is spelt out using washed up golf balls on Kahuku beach, Honolulu, Hawaii *Greenpeace/Hofford*

161 Greenpeace scientific researcher Adam Walters examining marine debris collected from the 'trash vortex' in the Central North Pacific *Greenpeace/Hofford*

162 A California sea lion at the Los Islotes sea lion colony, Espiritu Santo Island, La Paz *Greenpeace/Hofford*

164 Greenpeace ships *Esperanza* and *Arctic Sunrise* sailing into the ice in the Southern Ocean *Greenpeace/Sutton-Hibbert*

164 *Esperanza* crew walking across the ice in Antarctica *Greenpeace/Sutton-Hibbert*

165 *Esperanza* crew spells out the demand with their bodies on the Antarctic ice *Greenpeace/Sutton-Hibbert*

THE PHOTOGRAPHERS

JEREMY SUTTON-HIBBERT

1969, man set foot on the moon and Mrs Sutton-Hibbert gave birth to Jeremy in Scotland, where he grew up and on his 13th birthday received the gift of a camera. A few years later Jeremy subsequently became a UK-based freelance photographer for editorial, corporate and NGO clients for 14 years, until deciding the light was too grey and the winters too dark.

Deciding to bring color into his life he relocated to Tokyo, Japan, where he now lives and photographs for clients such as *Time, Italian Geo, Le Figaro, The Guardian* and Greenpeace International, amongst others. In recent years Jeremy's work has taken him to over 40 countries, as far-flung as Antarctica and Outer Mongolia. His personal and commissioned work, for which he has been the recipient of photojournalism awards, has been widely published and exhibited in Europe and USA.

Examples of his work, and his contact details, can be found by visiting his website
jsh@jeremysuttonhibbert.com
www.jeremysuttonhibbert.com

ALEX HOFFORD

Alex is an editorial-style photographer based in Hong Kong, covering the Asian region. He is British, was raised in Cambridge and educated in London.

Alex is a Greenpeace photographer and also an active anti-Shark Fin soup campaigner, having travelled to the Middle East and Africa to document shark-finning to gather material for a travelling educational photo and video exhibition, which will debut first in Hong Kong, and then go to China where Shark Fin soup is increasingly popular.

Since establishing his company in Hong Kong in 1998, Alex has carried out many assignments across Asia. Currently, he covers Hong Kong, Macau and Southern China for the European Pressphoto Agency (EPA), and has been published in *The New York Times, Time, The Guardian* and *The Observer*.
www.image-solutions.info

KATE DAVISON

Kate has been photographing for Greenpeace and other NGOs since the late 1990s. She is passionate about her work and her activism and uses her professional skills to communicate environmental and social issues to a wide audience.

With Greenpeace, she has taken assignments far and wide, from documenting the activities of the Japanese whaling fleet off the coast of Antarctica to trekking through the forests of Kalimantan in Indonesia to expose illegal logging operations.

She is London-based and her work has been widely published in UK and International press and magazines.
www.katedavison.com

NATALIE BEHRING

Natalie Behring is an American documentary photographer based in China. She has reported on editorial and news stories in China, Afghanistan, Israel and throughout Asia for leading magazines, newspapers and NGOs including *The New York Times, The Globe and Mail, Chicago Tribune, Newsweek, Focus, Discovery,* UNHCR, IOM, Greenpeace and many others. She has won awards in numerous competitions such as the National Association of Press Photographs and the Atlanta Seminar of Photojournalism.
info@nataliebehring.com www.nataliebehring.com

STEVE MORGAN

Steve Morgan is a UK-based photographer – his career has taken him from 'grip and grins' for local papers in Yorkshire to standing on stepladders in Downing Street; from famine-torn Somalia to under fire in Bosnia.

For much of the last 20 years, campaigns with Greenpeace have featured highly in Steve's work. From his first involvements documenting activists blocking toxic outflow pipes via nuclear testing protests, anti-whaling campaigns, deforestation, and climate change to detention in a 'maximum security federal correction facility' facing double felony charges and 5 years jail in California – it has been an interesting road. He lives with his wife and two children in Hebden Bridge, Yorkshire.
mail@stevemorganphoto.co.uk
www.stevemorganphoto.co.uk

GAVIN NEWMAN

Born in 1961 in London, England, Gavin always had a love of water. He learnt to dive and even hired an underwater camera to take photographs during the course. He also took up caving and soon combined the two. Gavin then began to join expeditions diving, caving and cave-diving all over the world. After college he worked as staff photographer on various water ski-ing and power-boat magazines before going freelance.

After several filming projects during caving and diving expeditions he diversified into film and video work as well as still images. Today he shoots both video and stills above and below water and enjoys the different challenges. Gavin's first independent film production 'Wookey Exposed', about cave-diving at the famous UK Wookey Hole caves, has won several international film festival awards and he also won an award for camera work on the BBC's prestigious 'Planet Earth' series.
www.gavinnewman.com

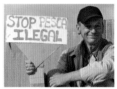

PIERRE GLEIZES

Pierre joined the crew of the *Rainbow Warrior* in February 1980, and worked as a photographer for Greenpeace until 1984. During this period, he participated in most of the sea campaigns: nuclear transports, Spanish whaling, Canadian seal hunts, nuclear waste dumping, chemical dumping, nuclear weapons testing in Mururoa, Nevada and the Soviet Union. When not on board, he created the Paris-based Greenpeace Photo International – the picture library that is now in Amsterdam.

Later, Pierre worked for 7 years as a photojournalist for the Associated Press, followed by a period of photoassignments for the British Environmental Investigation Agency. He now works as an independent photographer based in the Loire Valley, France, and his pictures are distributed by the French photo agency Réa. He has maintained links with Greenpeace through various trips and actions.
pgleizes@free.fr www.reaphoto.com

MARCO CARÈ

Marco was born in 1968 in Bologna, Italy. When he became a professional photographer he specialized in portrait, sports and fashion, working with the major fashion agency in Bologna. In 1996 he moved to Sicily, and opened his own creativity photo studio, working on a range of different projects as diverse as body painting and the European Rizla's calendar.

In 1999 he moved back to Bologna and began to focus more on sports photography as well as producing the popular Italian National Football Team's 2000 calendar.

In 2001, Marco moved to Sharm-el-Sheikh where he began to specialize in underwater photo and video work, following his life's passion: the marine world.

His first job for Greenpeace was in 2006.
subphotocare@hotmail.com

ROGER GRACE

Dr Roger Grace is a consultant marine biologist and photographer with many years' experience mainly in northern New Zealand. He is concerned about large changes that have been going on in our seas and around the coasts, and is an active promoter of the concept of marine reserves. His clients have included Regional Councils, Department of Conservation, sand extraction companies, Port Authorities, and Greenpeace International. He has worked as a photographer, both topside and underwater, on many ocean-based campaigns for Greenpeace since 1990.
gracer@xtra.co.nz

DANNY OCAMPO

Danny used to work for the Coastal Conservation and Education Foundation (formerly Sulu Fund for Marine Conservation) as Project Officer in Batangas and was in charge of establishing marine reserves in the region. He became a volunteer for Greenpeace in the early 1990s and joined the staff as a Genetic Engineering Campaigner in September 2004. Danny has been a diver since 1989, is a licensed Divemaster and has been taking pictures underwater since 1995.
docampo@greenpeace.ph.org

TODD WARSHAW

Todd Warshaw is a San Diego-based photographer with a background in journalism and a passion for producing creative images to tell a story that might otherwise not be visible. Todd's experience includes live photographic coverage of international events in over 30 countries. In addition he is well-versed in underwater and adventure photography in a wide range of conditions. Projects include being the official documentary photographer for the 2004 International Olympic Torch Relay for the Athens Olympics, and for the 2002 Salt Lake Olympics. Current clients include Greenpeace USA, Scripps Institute of Oceanography, Getty Images Sport, Land Rover, Jaguar of North America, *ESPN The Magazine*, *The Sporting News*, *Newsweek*, Alem International Management and Loyola Marymount University. His work has been published in countless publications around the world, and has been used in numerous ad campaigns.
www.toddwarshaw.com

DANIEL BELTRÁ

He started out as a staff photographer in his native Madrid for the Spanish National Agency EFE. After a four-year stint there, Daniel accepted Gamma Agency's (Paris) offer as its correspondent in Spain. For a decade, he covered hard news and feature stories for them around the world. He is fluent in English, French and Spanish.

In 1990, Beltrá began his collaboration with Greenpeace, becoming one of this NGO's main assignment photographers. He has documented several expeditions to the Amazon, the Arctic, the Southern Oceans, the Patagonian Ice Fields, among many others.

His work has appeared in publications such as *National Geographic*, *Time*, *Business Week*, *Der Spiegel*, *Geo*, *Paris Match*, *Stern*, and many others.

In 2006 Daniel was awarded 3rd Prize in the Nature Series category by the World Press Photo and the Golden Award in the Nature and Environment category in the China International Press Photo Contest, for his work on the Amazon drought.
www.danielbeltra.com

CHRISTIAN ASLUND

Christian Aslund is originally from Gothenburg, Sweden, but currently based in Stockholm. Since becoming a professional photographer and cameraman he has worked for Greenpeace across the globe, from the Arctic to Iraq, working on a range of issues and often sailing on Greenpeace ships. Away from Greenpeace, Christian has received commendations for his wildlife photography. He is a keen snowboarder, using his sport to expand his work and has become a highly accomplished winter sports photographer.
www.christian.se info@christian.se

LESTER V LEDESMA

Lester V Ledesma is happiest 'out in the field', writing and photographing stories that have appeared in international publications like *COLORS Benetton*, *Silverkris* and *Asian Geographic*. He is the 2002 ASEAN Tourism Association (ASEANTA) awardee for Excellence in Photography, and the Philippines' 2001 Kalakbay Travel Writer of the Year. His work has been exhibited in Singapore, Brunei, China and the Philippines.

Lester is based in Singapore, but feels more at home in Bangkok, Rome, and his native Manila.
lledesma@skylightimages.info

ABOUT THE AUTHOR

Sara Holden has worked for Greenpeace International since 2000. Prior to joining the international environmental organization in Amsterdam, she worked for Reuters Television as a political journalist in London and Northern Ireland.

The youngest of five children, she was born into a family that already had a maritime background. Her father was a sailor and her mother a nurse who met on a ship en route to South Africa. This book is dedicated to their memory.

Sara's first voyage was at the age of three, sailing from England to West Africa. She has sailed on Greenpeace ships most recently to the Southern Ocean Whale Sanctuary.

ABOUT GREENPEACE

In 1971 a small group of activists motivated by a passion for a green and peaceful world, set sail from Vancouver in an old fishing boat, the *Phyllis Cormack*.

Their goal was to protest peacefully against US nuclear testing in Alaska, one of the world's most earthquake-prone regions and home to endangered wildlife. Despite being intercepted, their protest sparked media coverage and a huge public outcry against the tests. Nuclear testing was ended in the area that same year, and the island eventually declared a bird sanctuary. These activists were the founders of Greenpeace.

Greenpeace is a global campaigning organization that acts to change attitudes and behavior to protect and conserve the environment and promote peace by investigating, exposing and confronting environmental abuse, challenging the political and economic power of those who can affect change, driving economically responsible and socially just solutions that offer hope for this and future generations and inspiring people to take responsibility for the planet.

www.greenpeace.org

ABOUT THE NEW INTERNATIONALIST

The *New Internationalist* (NI) is a magazine produced by New Internationalist Publications Ltd, which is wholly owned by the New Internationalist Trust. New Internationalist Publications is based in Oxford, UK, with editorial and sales offices in New Zealand, Australia and Canada. The New Internationalist was started in 1972, originally with the backing of Oxfam and Christian Aid, but has been fully independent for many years with some 75,000 subscribers worldwide. The NI magazine takes a different theme each month and gives a complete guide to that subject, be it global economics or health, the environment or education. The NI group also produces a One World Calendar and Almanac, and books including *The Bittersweet World of Chocolate*, the *No-Nonsense Guides* series and *Our Fragile World*.

www.newint.org